There is no doubt that Artemis is a

child prodigy. But why does someone of such brilliance

dedicate himself to criminal activities? This is a question

that can be answered by only one person.

And he delights in not talking.

Artemis Fowl novel

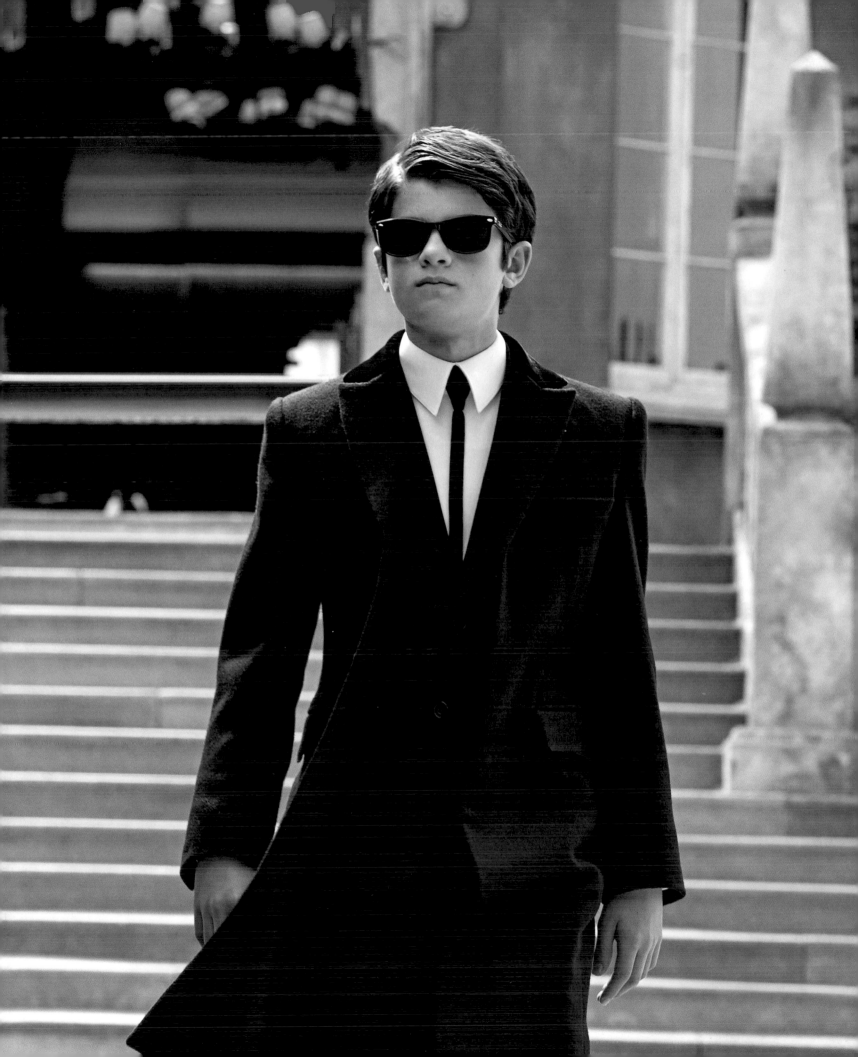

THE ART AND | MAKING OF

Disney
ARTEMIS FOWL

BRIAN SIBLEY

FOREWORD BY KENNETH BRANAGH

INTRODUCTION BY EOIN COLFER

A Welcome Enterprises Booke

Disney
EDITIONS

LOS ANGELES • NEW YORK

Contents

Foreword

Readers from around the world love Artemis Fowl.

Now, moviegoers around the world have an opportunity to join the adventure.

I first read Eoin Colfer's novel when my nephews, ages eleven and thirteen, insisted I discover this compelling boy genius.

So I did as I was told, and I found him funny and demanding, brilliant and brave, and always wildly entertaining.

This was just as well, for, about a week after I had read the book, I received a telephone call from Sean Bailey, president, Walt Disney Studios Motion Picture Production, asking if I was interested in directing the film of *Artemis Fowl*.

After that, things moved very quickly (much like the speed of Artemis's mind).

Fowl Manor, his family's ancient and magnificent home, began to be built in incredible detail on our movie studio back lot.

A location scout traveled to Italy, to Vietnam, and of course all over Ireland to find the marvelous locations in which the story could be set. Turbulent oceans and spectacular mountains, and all the mysterious places where the fairies might live: the Giant's Causeway, the Ring of Kerry, and the Hill of Tara.

A screenplay was written, fairy makeups were developed, the movements of goblins and sprites were researched, and a whirlwind of activity like the streets of Haven City, where the fairies live underground, were all brought together to realize the first cinematic adventure of the young criminal mastermind.

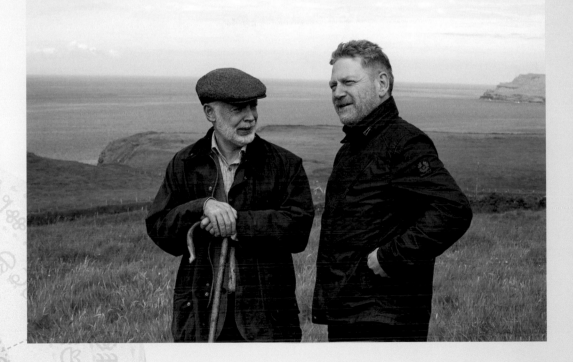

Kenneth Branagh (right) on location in Ireland with *Artemis Fowl*
author Eoin Colfer, who has a cameo role as a shepherd in the film.

Artemis Fowl is a boy who is different. And this is a story in which that difference can be understood, and allowed, perhaps even embraced.

He interacts with a group of strong, diverse male and female characters of all ages.

It was exciting to see Judi Dench as Commander Root, and her L.E.P. charge, newcomer Lara McDonnell, as Holly Short, make their fairy plans for outsmarting their human nemesis in this Irish boy wonder.

And, thankfully, with two friends by his side—embodied by Nonso Anozie as Domovoi Butler and Tamara Smart as Juliet—Artemis has an amazing extended family, and at least a chance to emerge from this first hair-raising adventure in one piece.

Any new film of this story relies, of course, upon the impact of the central character, and after exhaustive conversations with many excellent young actors across the world, we were thrilled to cast Ferdia Shaw in the title role.

He had read all the books, knew the legends and the characters, and brought to the role energy, wit, intelligence, and fun. His Artemis is great company.

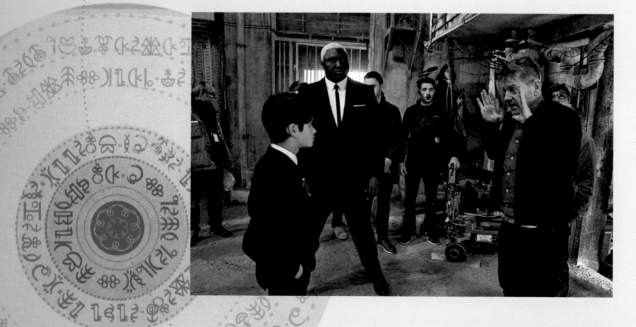

Kenneth directing Ferdia Shaw (Artemis) and Nonso Anozie (Butler); and, opposite, with Ferdia outside Fowl Manor.

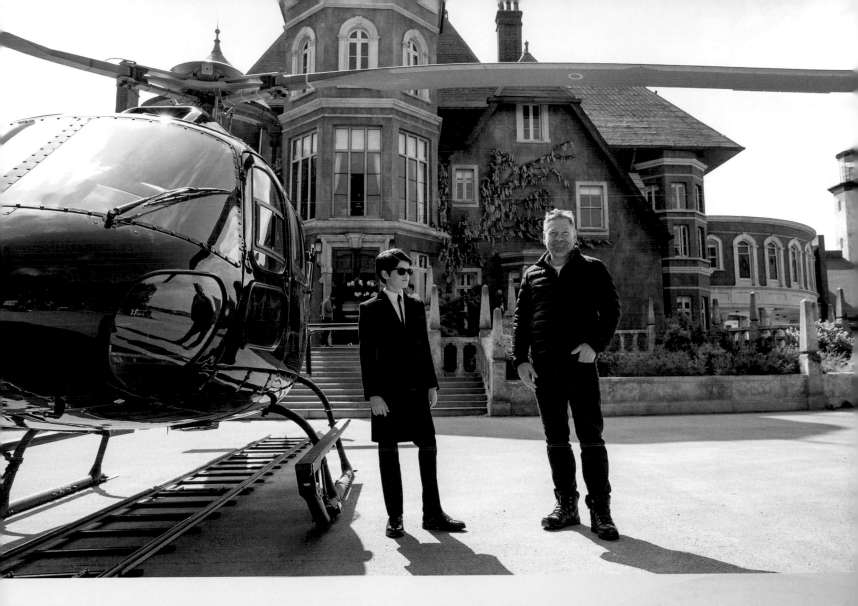

I truly hope you'll take the opportunity to join him as *The Booke of the People* is opened for the first time in the cinema. In its pages you'll find elves and trolls, lava chutes and Neutrino protectors, all wrapped up in a tale of devilish twists and cunning conundrums.

Will Artemis be able to survive it all? I'm sure if you asked him, he would simply say, with that unique confidence of his:

"But of course . . . I'm Artemis Fowl, and I'm a genius."

After directing the movie of his first adventure, and marveling at the time-bending search for his kidnapped father, I'm tempted to agree!

—KENNETH BRANAGH

Introduction

It gives me immense and giddy pleasure to write an introduction to this beautiful book. This is an introduction that I have been itching to write for almost twenty years. That's how long I have been dreaming that Artemis would find his way to the silver screen, and finally the dream has come true. And who is more qualified to make a dream come true than Disney? By my count this is the second time Disney has granted my wish. First they published the book and now they are bringing it to life.

Does that mean I have one wish left?

I'll have to consult with Aladdin.

An author often has no idea how his story will look on the big screen and it can be a nerve-racking process waiting for the first images to arrive. This was not the case with this project. Kenneth Branagh and Disney kept me involved every step of the way and I was constantly delighted with the design of the fairy world and the flow of the story, but it always seemed like an impossible dream. I secretly believed that a book written in a box room in the small town of Wexford, Ireland, could never make its way to international movie theatres, so while I was delighted that everyone was making such an effort, I was quietly certain the whole thing was doomed.

Some people call me a pessimist. I think they might be right.

I think the moment that my mind changed was the day that the Colfer clan visited the main set in Surrey in England. We parked outside a big gray warehouse that could have held anything from industrial equipment to mountains of grain. And while I had to admit that it was a sizable warehouse, I wasn't too impressed by big walls of gray concrete. But then we went inside and my mind was completely blown. I imagine I felt a little like Lucy Pevensie did when she found Narnia at the back of a wardrobe, or like Luke Skywalker felt when he unwittingly took part in a galactic episode of *Who Do You Think You Are?* and found out exactly who he was.

We walked through those everyday warehouse doors and into the beating heart of the fairy world. It is difficult to describe how I felt as the Fowl universe loomed all around. The design and art departments had reached into my mind and transferred what they found there into the real world. Not only that, but they had given those ideas a polish on the way out so that the sets, props, and costumes all around us were

more fantastic and detailed than they had ever been inside my head. It was all there: The Lower Elements Police operations center. Haven City. The lava chutes, complete with shuttles. Racks of fairy weapons, rails of fairy costumes. A huge troll and a delicate sprite. I was, to quote an adage, *lost for words*. My sons took a photo of me, as they had never seen that expression on my face before. Thankfully at that point we had to shut off our phones or I imagine their social media would have been stuffed with photographs of me looking dumbstruck, which is not a good look.

And there was more to come. The most important building in the entire series and the jewel of Disney's set: Fowl Manor.

It was so big that it was set away from the main building on top of a hill. As we drove up the avenue in a studio bus, the manor was revealed floor by floor and the detail and inventiveness was astounding. Yes, it was a manor as I had imagined, but the design and craftsmanship were at a level that I could not have dreamed up in a thousand years. Everything was carefully considered, from the hand-painted wallpaper, to the sky bridge across from the main building to the lighthouse, to the books on Artemis's shelves. And I knew for absolute certain as I walked through the main hall that this was a house where a criminal mastermind teen could absolutely dream up his plans to steal gold from the fairy folk.

We finished the tour with an exhibition of the art and design of *Artemis Fowl*, poring over many of the same photographs that are contained in this book, and if you feel even a fraction of the delight that I did, then you are in for a good time.

Eoin and Kenneth in Northern Ireland. Opposite: Eoin standing on the steps of Fowl Manor, the ancestral home of his young hero.

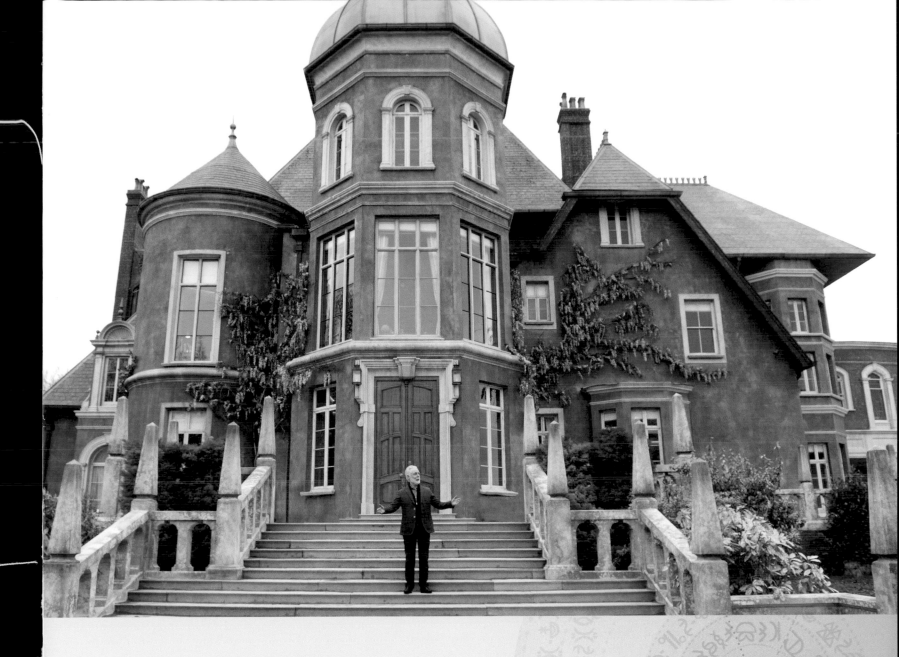

I have been watching movies for over forty years and I grew up during the golden age of special effects blockbuster series that have endured for decades, but I have never seen anything like the design for the *Artemis Fowl* movie. And as I looked at those photographs my pessimism drained out through my boots and I knew that this movie was a real thing forged by passionate people, and that it was destined to light up theatres worldwide and delight millions of people.

I also realized that Disney doesn't owe me another wish. What they have done with this movie counts as double.

—EOIN COLFER

ARTEMIS

FOWL,

WALT DISNEY,

AND THE

FAIRIES

> "Disney has the fairy story,
> in all its forms, **alive** in its DNA."
>
> —Kenneth Branagh, director

Chapter ①

Fairies will never be the same again! Forget all those images of ethereal creatures flitting around on gossamer wings! The publication, in 2001, of Eoin Colfer's novel *Artemis Fowl* changed all that by introducing the world to a surprisingly different and exciting portrayal of what life is *really* like in the kingdom of faery—and it is this astonishing domain that is now being brought to the screen in Disney's new action-and-magic-packed film.

Disney, of course, is no stranger to the inhabitants of fairydom: "Disney," says BAFTA-winning, Oscar-nominated director Kenneth Branagh, "has the fairy story, in all its forms, alive in its DNA and is constantly looking to evolve new ways to tell it."

Disney fairies can be traced back to the early days of the studio's animated films: in *Pinocchio*, the mischievous puppet had the Blue Fairy for a guardian; in *Fantasia*, an entire sequence was devoted to an exquisite ballet portraying the changing seasons, performed by woodland sprites. *Cinderella* had a magically gifted fairy godmother; Princess Aurora in *Sleeping Beauty* was looked after by a trio of good fairies (and had a fearful encounter with the bad fairy Maleficent); and among the many adventures of Taran, the hero of *The Black Cauldron*, was a visit to the underground kingdom of King Eidilleg and the Fairfolk.

Most famously, in *Peter Pan*, Tinker Bell, the feisty little Never Land pixie, was such a hit that she embarked on a showbiz career all her own: welcoming viewers to Walt Disney's weekly television series, beginning with *Disneyland*, and more recently, starring in the popular Disney Fairies films, set in the secret Never Land realm of Pixie Hollow.

In 1960, Walt Disney made an intriguing live-action film, *Darby O'Gill and the Little People*, which has an interesting association with *Artemis Fowl*. Set in rural Ireland and based on the stories of Herminie Templeton Kavanagh, it featured up-and-coming young actors Janet Munro and Sean Connery alongside two veteran Irish stage performers, Albert Sharpe and Jimmy O'Dea. Sharpe, who played the title character, Darby O'Gill, was a longtime member of the Abbey Players, whose celebrated productions made Dublin's Abbey Theatre the national theatre of Ireland, while Jimmy O'Dea, playing King Brian of the leprechauns, was a noted Irish comedian and variety performer.

Darby O'Gill featured special effects that, for their day, were cutting edge, such as an astonishing sequence where the human-sized Darby plays his fiddle in King Brian's underground palace, surrounded by dozens of cavorting, pint-sized leprechauns. The film was the subject of a considerable publicity campaign, including a special edition of the TV show *Walt Disney Presents* titled "I Captured the King of the Leprechauns."

This tongue-in-cheek "mockumentary" told how Walt had traveled to Ireland and, with the help of Darby himself, captured King Brian and persuaded him and his people to appear in the film.

Eoin remembers seeing *Darby O'Gill* and the impact it made on him as a young man: "I loved that film! It's based on a one-sentence story that's known to every child in Ireland and has a thousand variations in Irish culture, namely: 'Human captures leprechaun in order to win the crock of fairy gold.' *Artemis Fowl* was a very conscious attempt to create an updated version of this old tale—with one difference. In every other version, the story ends with the human character being foiled and the leprechaun getting away without having to give up his gold—but I wanted to tell it slightly differently: I wanted the human to *win*!" Although, as Eoin quickly adds: "Of course, that's not *quite* the end of the story, because although Artemis wins, he also learns something important from the experience. And that learning process is what makes Artemis Fowl a far more interesting character."

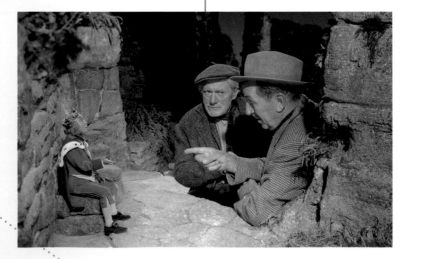

Walt (right) with Albert Sharpe (Darby O'Gill) and Jimmy O'Dea (King Brian) in the TV show "I Captured the King of the Leprechauns." Opposite: Poster for Walt Disney's 1960 film *Darby O'Gill and the Little People*.

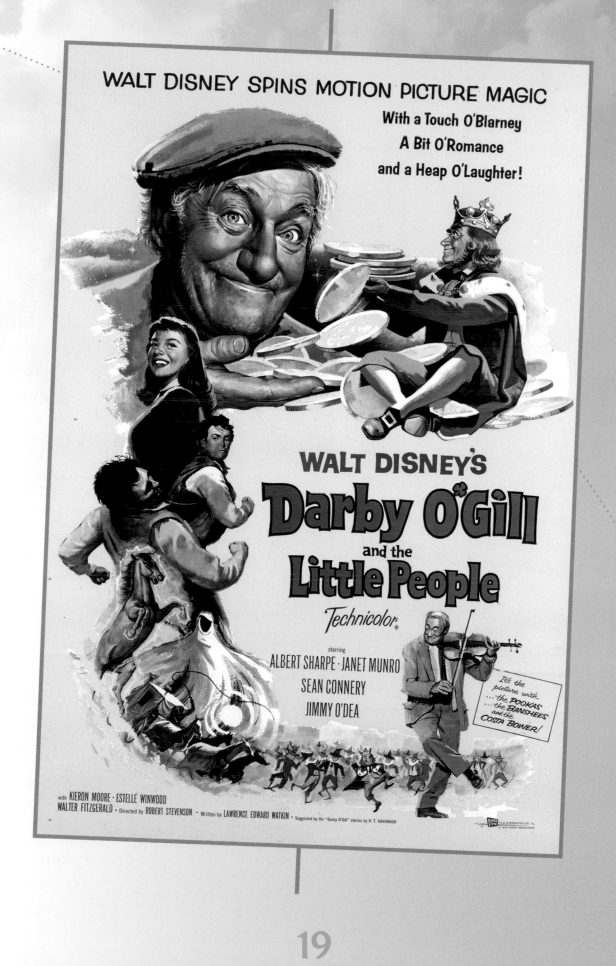

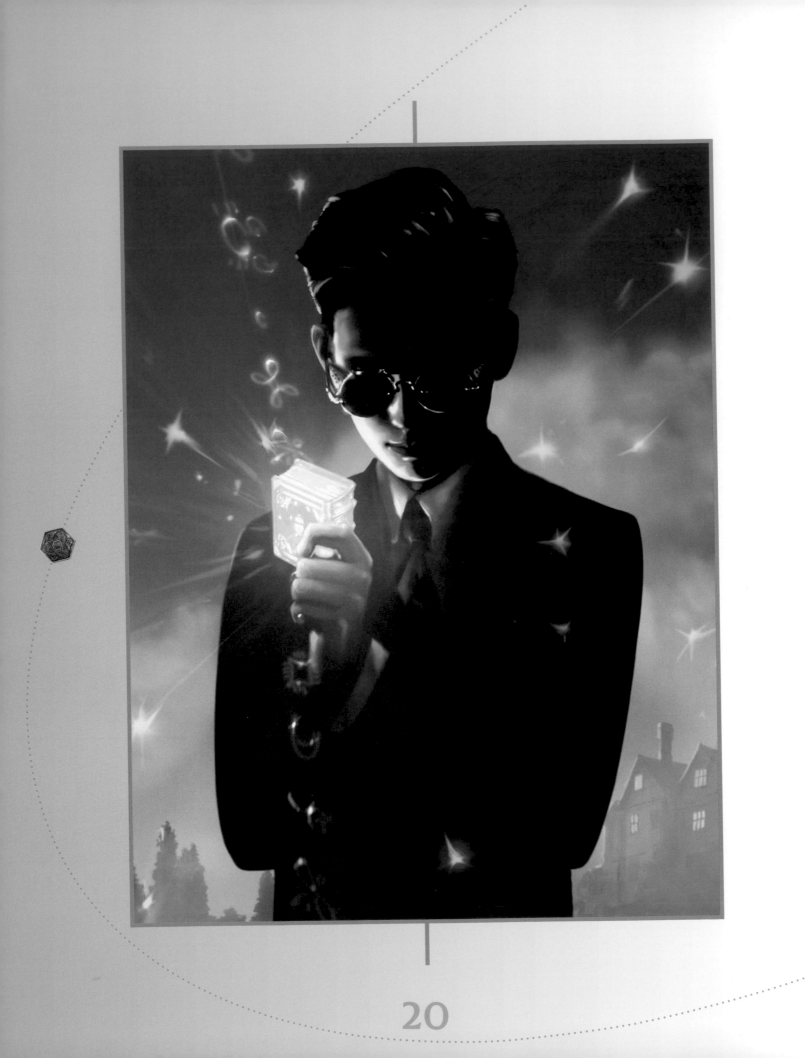

"Why don't I **splat** those two things together—fairies and technology—and see what comes out?"

—Eoin Colfer

As an Irish writer, Eoin has a healthy respect for the fairy mythology of his homeland. He explains, "There's a tradition that is centuries old—millennia even—of people telling stories about the fairies in Ireland and how they live under the ground. Today, there are still farmers in Ireland who will not cut the grass on what they call a fairy fort—which, in reality, is the buried remains of ancient human dwellings—because they believe very strongly that disrespecting the fairies will bring bad luck."

This is no exaggeration. As recently as 2017, the *Irish Times* published a story about how local people believed such contempt for the fairy world was the cause of various local misfortunes ranging from the subsidence of a roadway near Killarney to the financial collapse of Ireland's once-richest man.

Discussing these deep-set notions, Eoin says, "What I wanted to do was update and reimagine this concept of a fairy culture—*reboot* the fairies, if you like! I was teaching at the time and part of the Irish schools' curriculum was our wealth of fairy stories. I realized that kids still love these tales, but that they also love all the technology of contemporary life. So I thought to myself, 'Why don't I splat those two things together—fairies and technology—and see what comes out?'"

What came out was *Artemis Fowl*, the first of eight best-selling novels and now a major new film project that, as Eoin puts it, "splats together" the age-old mythic tales of the fairy folk with a technologically complex realm rivaling the most sophisticated advances achieved by twenty-first-century human society.

The 2009 incarnation of the *Artemis Fowl* novel cover depicts Artemis with the fairy manual, *The Booke of the People*.

It was an idea that certainly caught the imagination of Kenneth: "Of course, fairies aren't real," he says, adding, "or *are* they? Well, Artemis takes the notion that they *are* and then sets out to prove it. The result provides a chance for drama and comedy in two parallel areas of existence: Ireland, the land of myth, lore, and legend, and the world of fairies."

Kenneth first heard of *Artemis Fowl* when he picked up on his thirteen-year-old nephew's enthusiasm for the book: "My nephew told me I had to read it, so I did, and, literally a few weeks later, I received a telephone call from Sean Bailey, president of Production at the Walt Disney Studio, who asked: 'Have you ever heard of *Artemis Fowl*?' I was able to say that I *had* and that I'd been captivated by the characters and by these two fascinating and exciting worlds that collide with one another in a really intriguing fashion."

The fairy world as depicted in this film is, of course, a far cry from most of those depicted in the Disney classics. "*Artemis Fowl*," says Kenneth, "brings a sort of darkness into the fairy world, and because the central character is in part an antihero, he shakes the system and slightly subverts the genre. Disney has shown courage, imagination, and a forward-looking view of how their storytelling can develop to embrace a character like Artemis."

Apart from the boldness of the project, Kenneth is also acutely aware of the popularity of the books and the affection with which they are held by millions of readers. He says, "I want to capture in this film what excited me when I first read the book. Eoin has created an enormous, enthusiastic readership, but he has also created a beautiful and exhilarating challenge to us as filmmakers. We hope that, cinematically, in *Artemis Fowl* we will take you places you've never been before."

The full series of Artemis Fowl novels, with cover art circa 2009 to 2012.

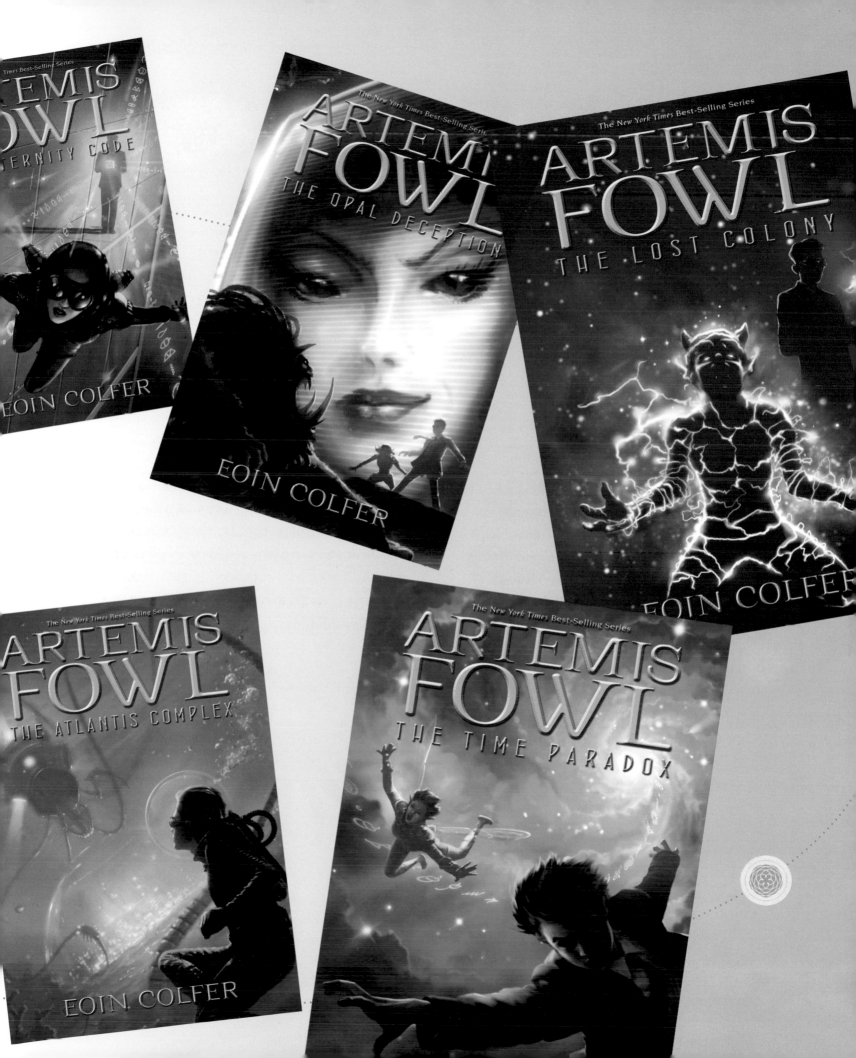

Fairy Powers

The fairies encountered by Artemis Fowl have a number of special powers, as author Eoin Colfer explains. . . .

SHIELDING

When fairies go aboveground into the human realm, they will often need to become invisible. They call this "shielding," and it is achieved by vibrating so fast that they move out of the spectrum of human vision. Obviously, this can only be achieved if you have a fairy physiology. Any creature other than a fairy would literally be shaken to pieces. Shielding uses up a lot of a fairy's magic power, so their scientists and technicians have devised specially adapted uniforms that require only a relatively small amount of magic before their suits take over the process. Because fairies need to keep their world hidden from humans, shielding is their most important power.

MESMER

Mesmer, as the name suggests, is the fairy's power to use its voice to mesmerize a human. However, as well as using its voice, the fairy also has to be able to have direct eye contact with the subject. Of course, Artemis, having read the secret *Booke of the People*, knows all about fairy powers and takes special precautions—in the form of mirrored sunglasses—to avoid being mesmerized.

Panels from the 2019 *Artemis Fowl Graphic Novel* by Michael Moreci and Stephen Gilpin.

BLOCK MIND-WIPE

The People have the power to wipe clean the memories of any humans who have inadvertently witnessed fairy activity. Whilst the mind-wipe is time-specific and effectively deletes any recollection of fairy encounters, it has the disadvantage of also removing other, non-fairy-related memories.

TIME FREEZE

Another weapon in the fairy arsenal is the time freeze—used as a last resort if they get into a situation where there's a problem that cannot be solved at speed. In such circumstances they can erect a bubble of magic in which time progresses very slowly to give the time they need to sort the problem, even though time *outside* the bubble goes forward at a normal speed. This is a very powerful tool and, because there can be serious repercussions, its use is rarely authorized.

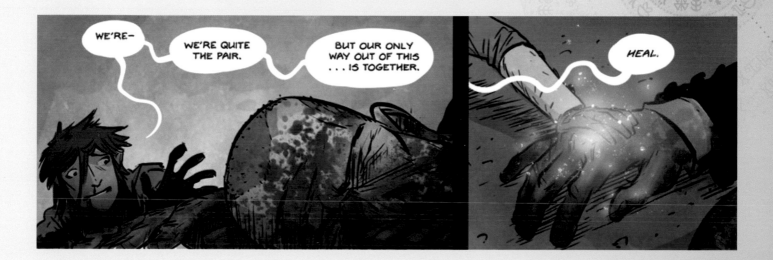

HEALING

Fairies see themselves as healers, and the power of healing is central to the fairy ethos. If a fairy is injured, the power to self-heal functions automatically, with magic taking over the job of antibodies and working a cure. By the laying on of hands, a fairy can also transfer this healing magic from its own body to any wounded creature and can even restore life to the recent dead.

Although fairies have these very remarkable powers, it has to be remembered that employing them also uses up their magic. Since their magic is part of the Earth's energy, they have to regularly "recharge" themselves or risk finding themselves "running on empty." As Artemis discovers, this regeneration process involves a mystic ritual with sacred words and the burial of an acorn, following which the Earth will replenish a fairy's powers.

ARTEMIS FOWL: ORIGINS AND INSPIRATIONS

> "When I looked that human in the face,
> I figured he was either a **genius** or **crazy**."
>
> —Commander Root, *Artemis Fowl* novel

Chapter ②

Artemis Fowl Jr. is far from being your average, run-of-the-mill youngster. He not only happens to be a twelve-year-old genius, but, following the disappearance of his father and with his distressed mother falling under fairy powers, Artemis has sole charge of the future of the family fortunes. He desperately needs to raise enough money to pay the ransom demanded by his father's kidnappers. But how is he to do that? Discovering that the fairy world about which he has read actually *exists*, he conceives a plan to capture a fairy and hold it hostage in exchange for the legendary fairy gold. Aided by Butler, the family's loyal servant and bodyguard, he sets this plan into motion.

Above: The young author, with clipped wing.

Eoin Colfer, the man responsible for creating Artemis Fowl, was born and raised in Wexford, a seaside town in Southeast Ireland. From his parents, who were teachers with a love of art, literature, and drama, Eoin inherited an early passion for books. As the second of five sons, Eoin shared a room with "four boisterous brothers," and it was books that came to his rescue. "I loved my brothers," he says, "but living so closely with one another could be a challenge and books were my way to escape."

Those books included classic tales of romantic adventure fiction such as Arthur Conan Doyle's *The Lost World*, along with Doyle's stories about Sherlock Holmes and Brigadier Gerard. Then there was H. Rider Haggard's *King Solomon's Mines* and, another favorite, Edgar Rice Burroughs's *Tarzan* books.

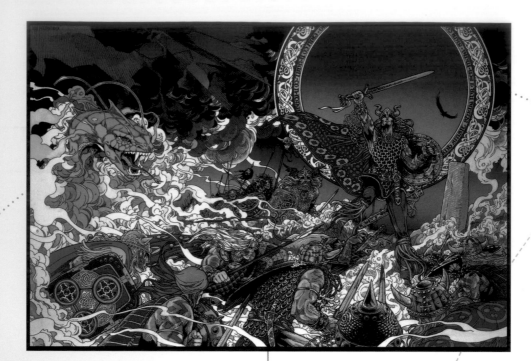

Nuada the High King
by Jim FitzPatrick.

Eoin also fell under the spell of the well-known Irish fantasy artist Jim FitzPatrick. "In his books," he recalls, "fairies were certainly not fay little creatures; they had their magic powers, yes, but they were big strapping guys—rough, tough, and well able to stand up for themselves. I had never seen fairies represented like that before." This discovery would prove vitally important to the creation of *Artemis Fowl*. As Eoin would later tell a London newspaper: "I was into fairies with axes; I was never into them flitting round the garden. Because the fairies of Irish mythology are not like that at all, they are very warlike. Always up for a fight."

Also on Eoin's reading list were J. R. R. Tolkien's *The Hobbit* and *The Lord of the Rings* and Stephen R. Donaldson's epic cycle of fantasy novels known as the Chronicles of Thomas Covenant. "Nowadays," he says, "I tend to buy *thin* books, but when I was in my teens, the bigger and fatter the book the better! I'd club together with friends to get these multibook series: we'd each

buy a volume and then swap with one another. Everyone got to read them, but no one ever had the full set!"

For Eoin, these stories were opening doors to other worlds. "When I was young," he says, "I was fascinated by the idea of different universes. At that age, the idea of there being a fragile membrane between reality and fantasy is very tempting, and you think that you could, *just possibly*, head off into another world on one of those adventures."

Artemis Fowl began as an idea born when Eoin came across an old photograph of his younger brother Donal smartly dressed before going off to church to take his first Communion. "I looked at this photograph," says Eoin, "and I thought, 'He looks like a ten-year-old Bond villain!'"

Donal Colfer, the
author's brother.

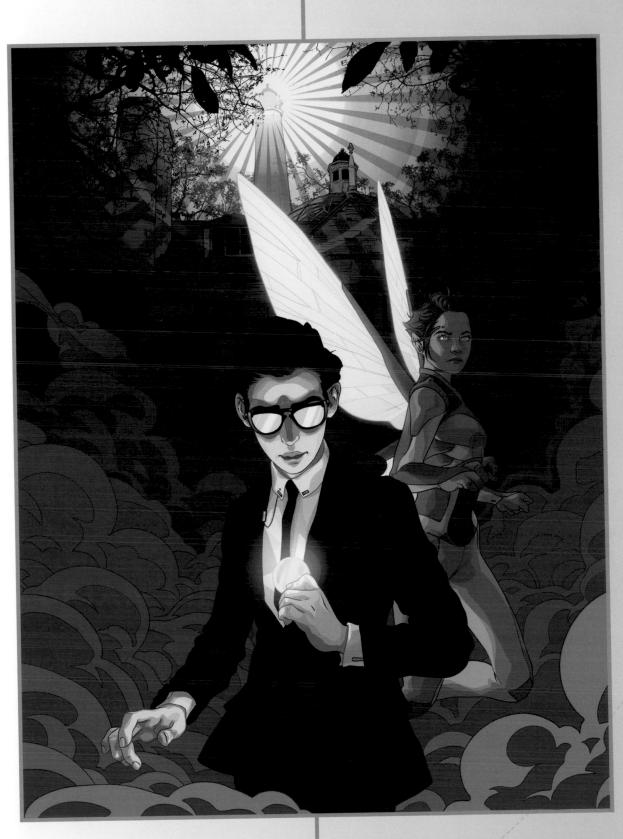

Artemis Fowl and Captain Holly Short in art for the 2018 iteration of the *Artemis Fowl* novel cover.

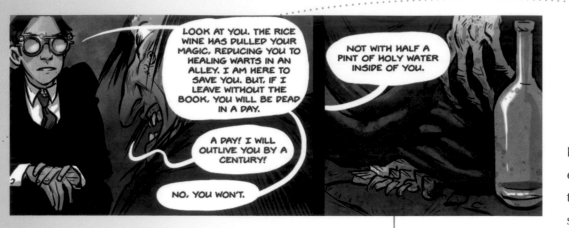

In writing his book, Eoin drew on his experience as a former school-teacher and his understanding of young people: "What I find kids love about Artemis is that he is 'in control' of his world, whereas most twelve-year-olds don't actually have any power over their lives. That's why my readers really like the idea of a youngster who has the kind of power that Artemis wields—even if he doesn't always wield it very wisely."

At the heart of the book and the film is the relationship between Artemis and the fairy Holly Short. "Where Artemis is cold and precise," explains Eoin, "Holly is very emotional and something of a maverick, a rule breaker operating on instinct and quite often going off book. But she is also very experienced, and she is really not impressed with Artemis, who thinks he's so smart but doesn't really know what he is dealing with.

Years later, Eoin was trying to write a fairy story. "At some point," he jokes, "all Irish writers are contractually obliged to write one! Well, I was trying to think what I could do with the concept of leprechauns. Suddenly, an idea just clicked in my head. I said to myself, 'Wow! Yes! Young Bond villain kidnaps leprechaun! *Boom!*' Originally, I thought I might at least get a short story out of that idea, but here we are, eight books and tens of millions of copies later! So, that proved quite a good idea—although my brother Donal reckons I owe him a lot of money!"

Describing Artemis's character in the books, Eoin confesses: "Artemis Fowl has a very complicated psyche, but I'm not really interested in clear-cut heroes; I prefer some complexity of personality and really wanted Artemis to have a somewhat troubled character, especially as he has to make difficult decisions and choices following his father's disappearance. So, rather than 'a hero,' I'd prefer to describe him as 'a hero in the making.'"

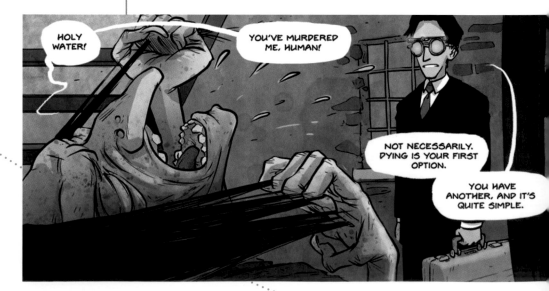

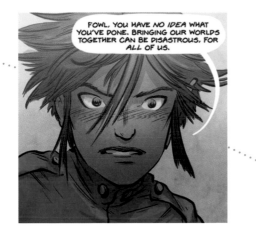

So, to begin with, there's a confrontational attitude between the two of them. But, despite being diametrically opposed in their beliefs, their attitudes and ways of working, as the story unfolds, they find qualities to admire in one another, and you know that somehow, they will come out of the fire at the end."

For Kenneth, seeing the relationship between Artemis and Holly as being pivotal to the film he wanted to bring to the screen, the challenge was to find a way of telling the twin stories of two characters from two very different worlds while keeping them both in balance: "There's Artemis's journey to finally accept that fairies might exist, understand how to communicate with them and, possibly, even how to master them, and at the same time, the story of Holly Short, who has her own battles with authority and is struggling to find a clear identity in a society where there is no more harmony than there is on Earth. Keeping two very lively stories going is challenging, but it's a strength of the book and a potential strength of the movie—if we can do it right! It invites our audience to stay very much alive: you come to a picture like this to engage, and keeping up with those two worlds is just part of that experience."

The drama that throws Artemis and Holly together is played out against a centuries-old belief in a secret fairy realm. An idea found in the myths, legends, folk tales, and ballads of many different cultures, it has inspired generations of writers from Chaucer and Shakespeare to Lewis Carroll, Hans Christian Andersen, Rudyard Kipling, J. M. Barrie, and many others.

In Eoin's homeland, Ireland, fairy tales date back to the Middle Ages and have provided inspiration for many notable writers and poets, among them W. B. Yeats, who collected and published Irish folk and fairy tales; the folklorist Lady Augusta Gregory, whose retellings of Ireland's ancient myths featured not just beings with magical powers but also powerful warrior figures; and James Stephens, author of the twentieth-century fairy classic *The Crock of Gold*.

Ask Eoin what he considers the appeal of fantasy literature and he'll tell you that it springs from people's need to believe there is more to life and the world than what we see around us: "For some," he says, "that need is satisfied by their gods, but for others it is satisfied by folklore, because *before* there were the gods there was folklore. It's like a genetic memory, and the continuing popularity of books like J. K. Rowling's Harry Potter series and Philip Pullman's His Dark Materials trilogy shows that the need for a belief in powers beyond human understanding is as strong as ever."

These pages and overleaf: Panels from the 2019 *Artemis Fowl Graphic Novel*.

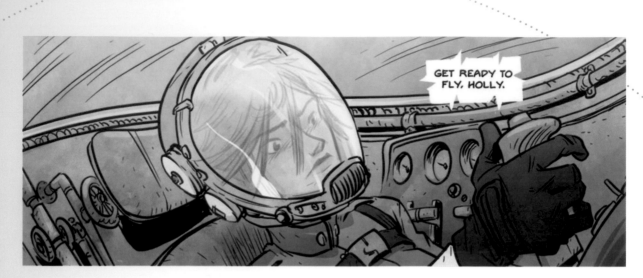

GET READY TO FLY, HOLLY.

WOOOSH!

Many popular fictional worlds are reached via a portal, such as Wonderland's rabbit hole, Narnia's wardrobe, or Hogwarts's Platform 9¾, but *Artemis Fowl* overturns that convention as screenwriter Hamish McColl explains: "In this story, the world of the fairies is very much part of *our* world but it is located in an alternative place—beneath our very feet! These fairies are beings that once lived in Ireland but who were driven *underground* by humans. One of the most delicious things that Eoin Colfer came up with was this sense that in all our worlds—yours, mine, even the most mundane, everyday world—there is magic within a fingertip's reach."

Fantasy literature often features the exploits of people from our human world being temporarily transported into an enchanted realm. In *Artemis Fowl*, however, it is the denizens of the "other world" who come up *into* our world from underground. Add to that premise something else that gives the books their unique formula: the idea that Artemis is going to have to pit his wits not against a traditional concept of fairy magic but against something totally unexpected. "What is really exciting," says Hamish, "is that these fairies have nothing in common with how we've previously thought of fairies; these are beings from a highly advanced, technically sophisticated culture that far outstrips that of the human race. Now, *that* is a super-fresh take on the normal fantasy portrayal of fairies, goblins, and trolls—and is pretty cool!"

That was, in essence, what excited director Kenneth Branagh about the film. He says, "Eoin Colfer has taken the many strands of Celtic history and mythology, mixed them with a uniquely modern lexicon of fairy possibilities, and then added the real-world setting which allows modern technology to come into play. Because of Artemis's intelligence, worldliness, and brain power, he is the perfect conduit through which these ancient, rich strains of myth can be reinvented in the here and now. Eoin explored these ideas, Disney embraced them, and I felt very comfortable with them."

Fairy Laws

The fairy world is subject to laws that were established some ten thousand years ago and cannot be broken. "These rules were put in place," says author Eoin Colfer, "to stop fairy interference in human affairs, which had become a problem and was causing trouble between the two worlds. Rule number one is that no fairy can enter a human dwelling unless it has been invited. If a fairy were foolish enough to enter without permission, there is an ancient hex that would cause it to be violently ill and, if it persisted, would result in the fairy losing its magic."

There are other laws specifically relating to wishes: "A fairy can grant a wish," explains Eoin, "but while it cannot be *forced* into granting one, it is something that *can* be bargained for—a loophole of which Artemis takes advantage."

As told in many ancient legends, if a human can successfully kidnap a fairy, then it is possible to hold the creature hostage until a ransom is paid in fairy gold. "It's not widely known," says Eoin, "but the fairy people always have available hostage funds and, if a human does manage to finagle it away from the fairies, then it is theirs to keep. Long ago, those ruling the fairy world decided that they didn't want any long-running issues with humans, so the rule is quite simple: whether the human gets the gold or the fairy gets it back, whoever gets it—*has got it!* End of story."

ARTEMIS FOWL: FROM BOOK TO SCREEN

"Originally, I thought if they're going to make a film, all they'll have to do is take out the quotation marks! But it turns out you can't make a **movie** like that!"

—Eoin Colfer

Chapter 3

The books about Artemis Fowl draw on an important Irish folk tradition dating back to the earliest times and set down in an eleventh-century Gaelic manuscript known as *Lebor Gabála Érenn*—or, in translation, *The Book of the Taking of Ireland*. Among this collection of poems and stories are accounts of a supernatural race, the Aos Sí, living underground beneath fairy rings and mounds or the roots of enchanted trees. It was from these magical beings that tales began growing up about a race of small, mischievous folk called leprechauns.

Until *Artemis Fowl*, the concept of leprechauns has tended to come with the quaint, fanciful image of a diminutive race of beings dressed in shamrock green and sporting top hats, knee breeches, stockings, and buckle shoes. Eoin, however, had other ideas.

"I was trying to think what to do with leprechauns," Eoin recalls, "and it occurred to me that the first three letters, *L-E-P*, sounded like an acronym for some kind of police force. Initially, I thought of 'Lower Earth Police,' but that sounded a bit too Middle-Earth-ish and reminiscent of *The Lord of the Rings*! Then I had a better idea: what if L.E.P. stood for 'Lower *Elements* Police'? However, that left me with what to do with the rest of the word. What could 'rechaun' mean? Well, change the letters *R-E-C-H-A-U-N* to *R-E-C-O-N*, and then it's obviously short for *reconnaissance*. So I had it: L.E.P.recon or Lower Elements Police Reconnaissance. The best day's work of my entire life!"

The task of L.E.P.recon officers is to monitor the whereabouts and actions of fairies who have gone aboveground into the human world—particularly if they are doing anything that might endanger the fairy people. It was a unique take on the all-too-familiar yarns about leprechauns.

Despite his big new idea, Eoin was still uncertain about whether *Artemis Fowl* would meet with success. Maybe it was his natural resistance to the fairy-tale notion of crocks of gold waiting at the end of a rainbow. As he explained in the book, although the Lower Elements Police *did* have a ransom fund available to pay off hostage takers, "no human had ever taken a chunk of it yet." He went on to point out that this knowledge hadn't stopped the Irish "from skulking around rainbows, hoping to win the supernatural lottery." Eoin was anxious to avoid any such misguided hope.

However, by the time *Artemis Fowl* reached the bookshops in 2001, it was being widely tipped for literary success and its hitherto unknown author for fame and fortune. Eoin was pitched into a series of interviews with journalists eager to understand the "Fowl Formula." "The very first interview I did," he recalls, "I was asked to describe the book. I like writing genre books, but I also like to bring something new to that process or to splice several genres together. *Artemis Fowl* was very much in the long tradition of fantasy adventures, but it was also a kind of a noir detective thriller as well as having elements of the big action movie. I was trying to give a simplified description to the interviewer, so, because it's about a siege and because the hero is more of an *anti*hero and there's quite a bit of wry humor involved, I thought of the films of Bruce Willis and said *Artemis Fowl* was basically '*Die Hard* with fairies'! It stuck, which just shows you the power of a good quote."

Panels from the 2019 *Artemis Fowl Graphic Novel*.

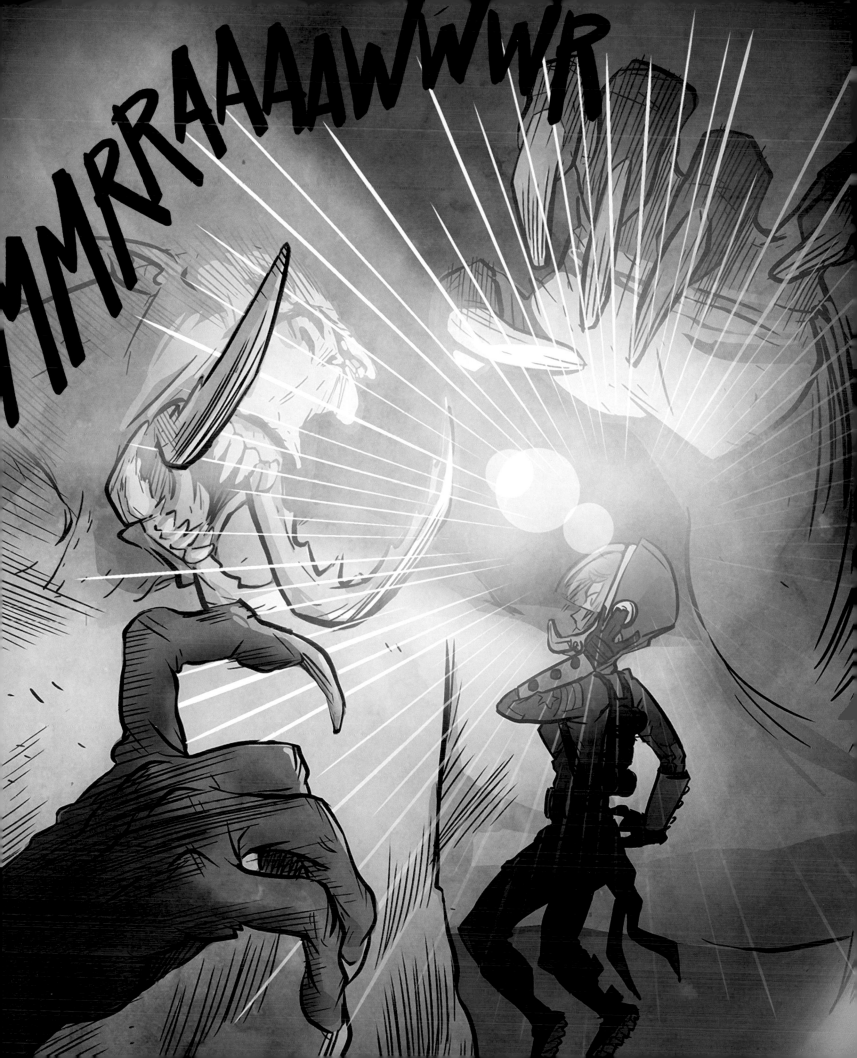

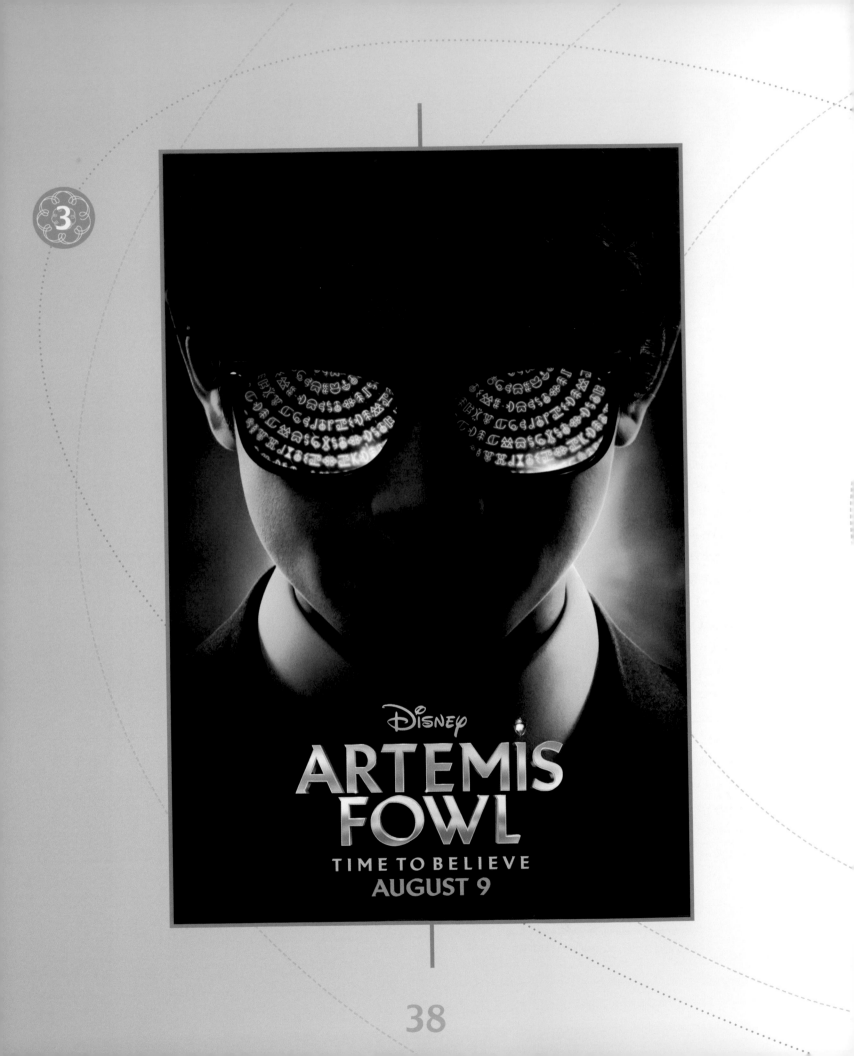

"pacy, playful, and very funny"
—Time

"fantastical as any shire"
—Entertainment Weekly

"an action-packed thrill ride"
—VOYA

Reviews of the book were hugely enthusiastic. "*Artemis Fowl*," wrote *Time* magazine, "is pacy, playful, and very funny, an inventive mix of myth and modernity, magic and crime." Another notable journal began its coverage: "We interrupt this *New York Times Book Review* for a special bulletin: There are fairies at the bottom of the garden. They are armed and dangerous." The writer concluded his review with the following prophetic statement: "What Colfer has done, and very ably, is to pitch a great movie idea. Pure gold, in fact."

Indeed, the movie rights to *Artemis Fowl* had already been optioned by Miramax Films. Eoin took it all in his stride, declining to trust in any predictions that Artemis was heading for Hollywood glory; after all, as he had already observed in the book: "Confidence is ignorance . . . if you're feeling cocky, it is because there is something you don't know."

Teaser poster for the 2019 release of *Artemis Fowl* featuring the story's hero with Gnommish letters reflected on his shades.

As so often happens with the movie business, there began a long waiting game. Eoin refused to get too hopeful: "I am very Irish in that I don't like to get too excited too soon about anything or it'll probably never happen! So, my whole approach was to keep calm and keep it quiet."

Almost a decade and a half later, news came when Eoin received a call inviting him to go to England to meet the film's director-to-be, Sir Kenneth Branagh. "It was," Eoin says, "only when I sat down with Ken in his office and he told me, 'I'm going to make this film,' that I started to believe it."

The author was delighted at the prospect of having the Disney name above the title; he observes: "The studio is synonymous with a high-quality, classy product. Disney understands that story is king and that you need an emotional commitment to the characters; you have to *care* about them."

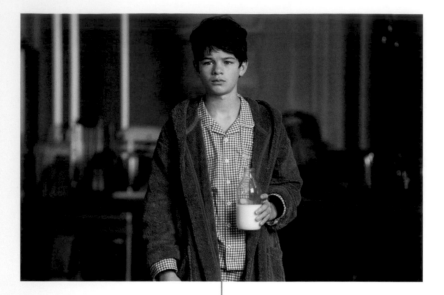

As for the director, the opportunity to engage with the author of the source material was an important plus for Kenneth: "Having directed so much Shakespeare, I've often found myself getting frustrated that I can't just ring up the playwright and involve him in the production—despite the risk that he might tell you off for getting it wrong! It's always a great thrill when you get to work with a living author."

This collaboration proved to be important when the story was adapted for film. Eoin reveals that a change in perspective was needed to make the Artemis of his book more sympathetic for a film audience: "It was such a small, subversive story and—at the beginning of the book—the central character is really not the nicest kid in the world! The thing a lot of readers liked most about Artemis was that he outsmarted his teachers, had a butler who he could tell what to do, and controls his own mini-empire. He was okay as a character in that book, but in a movie, he hardly had the appeal of a strong, noble hero."

The solution was to begin the film by revealing what Artemis was like before he became the character readers encounter in the first book, showing how the life of a smart, precocious, but otherwise normal enough youngster was altered by the mysterious disappearance of his father amid accusations that he was a criminal, the strange change in his mother's personality, and the realization that it is his responsibility to find a way to get his family back together again.

As Kenneth puts it: "We needed to have an emotional investment in Artemis himself. This is a wild romp of an adventure, driven by the remarkable intelligence of this kid. But while Artemis has his eccentricities, he also needed qualities with which we can identify as an audience, and the theme of loss of family and recovery of family provides that emotion. Artemis then becomes an original, stimulating kid whose differences are understood, allowed, and embraced."

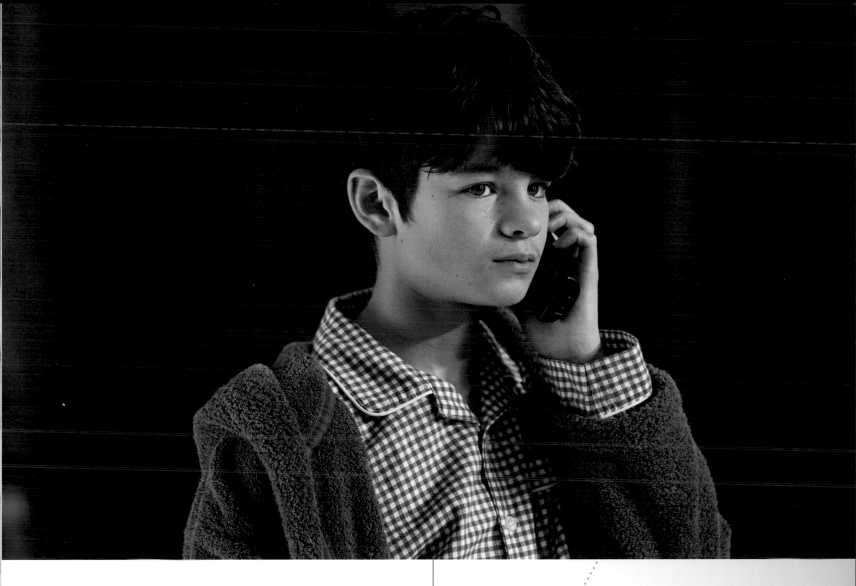

Among the creative talents involved in taking Eoin's story from book to screen was Irish-born playwright, screenwriter, and director Conor McPherson. His play, *The Weir*, took London and Broadway by storm and won The Laurence Olivier Award for Best New Play in 1999.

Once a script was in place, Kenneth began to put together his cast and crew, which, as is so often the case on his productions, included a number of talented people with whom he had previously worked—among them Nonso Anozie from *Cinderella* and Judi Dench and Josh Gad from *Murder on the Orient Express*. Behind the camera would be leading cinematographer Haris Zambarloukos, who had lensed Kenneth's *Murder on the Orient Express*, *Cinderella*, *Jack Ryan: Shadow Recruit*, *Thor*, and *Sleuth*.

"Because many of us have worked together before," says the director, "there's a camaraderie that comes through the movie: a real sense of family that is quite genuinely at the center of it." And that very particular sense of collaborative creativity accounts for the strengths of the final film.

In the Director's Chair:

KENNETH BRANAGH

"*Artemis Fowl* explores the idea of there being gateways between the human and the fairy world," says Kenneth Branagh. "And part of that story questions whether such gateways can be responsibly kept open and whether the two very different worlds can peaceably coexist, questions with social and political timeliness that are right out of the pages of our daily newspapers and ask us to consider our own views about tolerance and understanding those who are different from us."

The way in which the society in the fairy world of Haven City relates to that of our own world and times is an important aspect of Kenneth's approach to the film, as actor Joshua McGuire, playing Briar Cudgeon, explains: "When filming began, Kenneth discussed his vision for how the People should be portrayed. He was adamant that although *Artemis Fowl* features fairies, elves, and goblins with long ears and magic powers, they have exactly the same kind of emotions and political ambitions as humans. I believe that premise certainly helped inform our performances in the film."

Kenneth was born in Belfast, Northern Ireland, where he lived until age nine, when his family moved to England. Crediting his Irish origins for his "love of words," he confesses, "I feel Irish. I don't think you can take Belfast out of the boy." And Belfast certainly played an important part in an early success in his career when he played the title role in Irish playwright Graham Reid's 1980s trilogy of TV plays, *Too Late to Talk to Billy*, *A Matter of Choice for Billy*, and *A Coming to Terms for Billy*.

An alumnus of the Royal Academy of Dramatic Art, Kenneth had an early triumph in the title role of the Royal Shakespeare Company's 1982 production of *Henry V*, a play and a character that he would revisit seven years later with his film debut as director. He achieved further triumphs as actor and director with productions by the Renaissance Theatre Company, of which he was cofounder. Critical praise greeted his theatrical portrayals of Hamlet, Romeo, Richard III, and Macbeth, and in 2015, he founded the Kenneth Branagh Theatre Company as actor-manager.

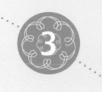

In cinema, following his acclaimed *Henry V*, he directed and starred in film versions of *Much Ado About Nothing*, *Hamlet*, *Love's Labour's Lost*, and *As You Like It*. His prolific filmography as actor and director includes *Dead Again*, *Mary Shelley's Frankenstein*, *Peter's Friends*, *The Magic Flute*, *Sleuth*, and *Harry Potter and the Chamber of Secrets*, in which he played Hogwarts's Defense Against the Dark Arts instructor Gilderoy Lockhart.

In 2011, Kenneth directed the superhero film *Thor* for Marvel Studios, a subsidiary of Walt Disney Studios. Three years later, he was in the director's chair for Disney's live-action film

Director Kenneth Branagh, with cinematographer Haris Zambarloukos (left), considers a shot on the beach below Fowl Manor.

Cinderella and, shortly afterward, began discussions about directing *Artemis Fowl*.

Kenneth's approach to the *Artemis* project was refreshingly direct: "The reason we're making this film," he says, "is Eoin Colfer! The project had been in development for some time when I was invited to become involved. I told the folk at Disney that my 'big idea' for the movie was to copy Eoin Colfer and, apart from that, just keep out of the way! I'm often drawn to the work of people who've already created something remarkable, and what's really required of the director then is simply a kind of 'translation' in order to

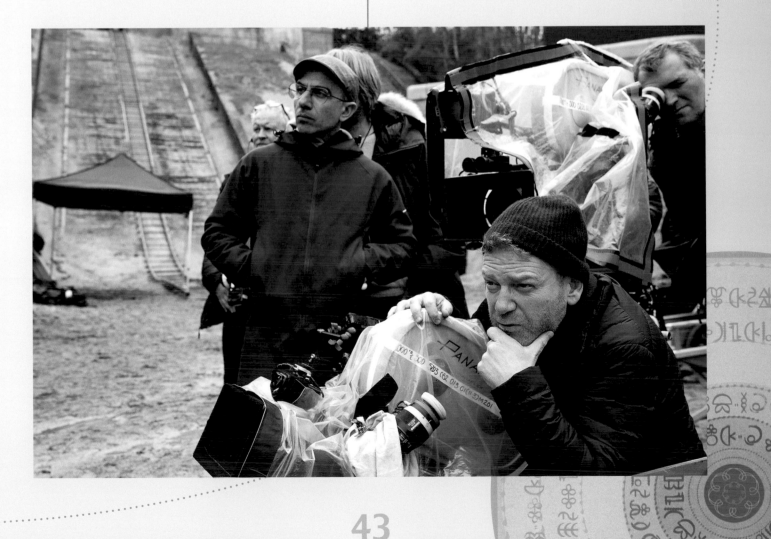

make the original work into a movie. Eoin has been nothing but open, inviting, and welcoming to that process of translation."

Screenwriter Hamish McColl describes the qualities that mark Kenneth as a director. "He is a great storyteller. Story and character are a twin passion. He has a deep love of actors and the craft of acting. He deals with everybody on equal terms, which conveys a sense of mission. The fact that everybody is chasing after the same thing makes for a happy team, and because of that, he gets the best from all of us. He has an exceptional technical team around him and a real ability to hold the bigger picture in his head at all times."

Nonso Anozie, playing Butler, describes Kenneth as "a workaholic": "If he could work twenty-four hours a day, I think he would, and that's an inspiration to have someone with that much energy, drive, and focus, because it makes you go the extra mile and deliver your A game. Ken knows what you are capable of giving and he will always push you a little further, and that's what makes him such a fine director."

Artemis Fowl presented its own unique challenges, one of which was the importance of achieving strong, believable portrayals from three young actors at the heart of the story. Once the roles of Artemis and Holly had been cast, Kenneth invited Ferdia Shaw and Lara McDonnell to join him and Dame Judi Dench in an icebreaking get-together where they did some baking. And what else would anyone working on a film featuring fairies choose to bake but *fairy* cakes?

"It was the most brilliant thing," recalls Judi Dench. "Because once the cakes were in the oven we chatted with Lara and Ferdia. The two of them are really special: full of mischief, but totally unaffected and not in the least precocious, interesting to talk to, and able to just be themselves. Perfect, I'd say."

"It was all very casual and relaxed," remembers Ferdia, "just getting to know each other. But," he says with a chuckle, "when we tried to eat the cakes they all fell apart in a gooey mess and dripped everywhere. Those fairy cakes were a disaster!"

Looking back at the performances of Ferdia, Lara, and Tamara Smart, playing Juliet, Kenneth says, "They've worked very hard and they've seen this film for the great opportunity and creative adventure that it is. As for the rest of us, we're very lucky to be able to be catching the progress and development of these young actors before our very eyes."

Kenneth Branagh directs Dame Judi Dench,
who plays Commander Root.

Tamara particularly enjoyed being directed by Kenneth and experimenting with how to find the best way to play various moments in the film. "We'd be doing a scene," says Tamara, "and Kenneth will just say, 'Okay, now I want you to do it completely differently. Do it really softly. Do it in an Irish accent, or an American accent. Now do it like you're an opera singer. Now ad-lib and improvise.'"

Apart from bringing his own expertise and vast experience of acting to the task of directing,

Kenneth kept a focus not just on creating a rattling adventure story but also on what that story might have to say to a contemporary film audience: "The story is about Artemis Fowl's discovery, engagement, battle with—and final acceptance of—the fairy world in all its variety—different people, powers, attitudes, likes and dislikes—all of which he processes and comes to understand. To bring a story like that to the screen really gives the audience a chance to hold a mirror up to life and ask how they might react, take on, and handle the different and the sometimes extraordinary."

CHARACTER SKETCHES: WHO'S WHO IN ARTEMIS FOWL

Chapter 4

ARTEMIS FOWL JR.

Ferdia Shaw

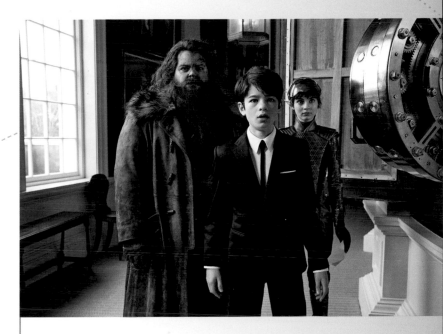

Artemis (Ferdia Shaw) with Mulch Diggums (Josh Gad) and Captain Holly Short (Lara McDonnell).

Ferdia Shaw was an admirer of the *Artemis Fowl* books long before he was being considered for the title role: "The books are just brilliant!" he says. "I had read them all and was absolutely a fan!" Although *Artemis Fowl* is the thirteen-year-old's film debut, Ferdia clearly has acting blood in his veins, since he is the grandson of Robert Shaw (star of many films, famously including *Jaws*) and Mary Ure.

When Ferdia first heard that there were open auditions for the part of Artemis Fowl, he was a first-year student at an Irish secondary school in the county town of Kilkenny in the Republic of Ireland. "A couple of friends told me that I should go for it," he recalls, "so I did. The first audition was held in Ireland, in Cork city, and it went really well." It was to be the first of five auditions for Ferdia, who was one of some 1,200 hopefuls.

That number dwindled with each new audition as the filmmakers got closer to reaching a decision. "For the first three," says Ferdia, "I was just thinking about each audition and wasn't really thinking about what might happen at the end. But once I got past the third session, when there were fewer kids auditioning, I began thinking, 'Yes, maybe I've got a chance!'" Two auditions later, the chance became a reality. "And that," he says, "was a lovely feeling!"

Among Artemis's diverse skills is a talent for music, which required the actor to play the violin. Fortunately, Ferdia already had experience with the instrument: "I'd been playing violin before I came onto the film, but, of course, I still needed to learn the piece—and in only four days! So, I had to go through masses of violin practice, working with the help of the well-known professional violinist Simon Hewitt Jones. It was pretty intense, but I think it turned out well in the end."

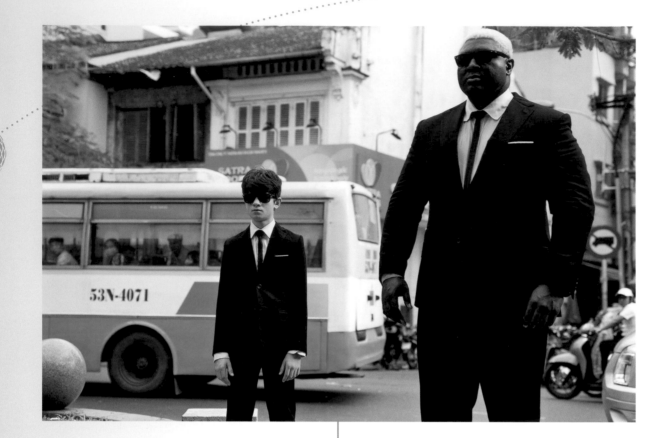

Artemis and Butler (Nonso Anozie) in Ho Chi Minh City, Vietnam, on the trail of a fairy and a copy of *The Booke of the People*.

Playing Artemis required the actor to develop important relationships with other characters, especially Butler, played by Nonso Anozie. "The Butlers and Fowls have been together for generations," Ferdia explains. "Butler is Artemis's manservant and protector, but he's much more than that—they are friends. In fact, in the absence of Artemis's father, Butler really becomes something of a father figure."

Lara McDonnell, who plays Holly, has great respect for Ferdia: "He'd read the books long before he was cast as Artemis. So, he knows the character really well and always wants to stay true to how he is depicted. Because he understands how Artemis thinks and behaves, he can instantly become the character the minute the camera turns on. Of course, Ferdia and Artemis are really different, because Ferdia is really nice and Artemis can sometimes be a bit annoying!"

Ferdia had first met director Kenneth Branagh at one of the later auditions in London: "I had seen him in *Harry Potter and the Chamber of Secrets*," he remembers. "I loved him as Gilderoy Lockhart, Hogwarts's Defense Against the Dark Arts professor." Then, with a laugh, he adds: "But meeting him in real life felt strange, because he was the same person, but looked so very different; it was amazing!"

Opposite: As originally conceived by author Eoin Colfer, Artemis has the look of a child-sized version of James Bond—always ready for action!

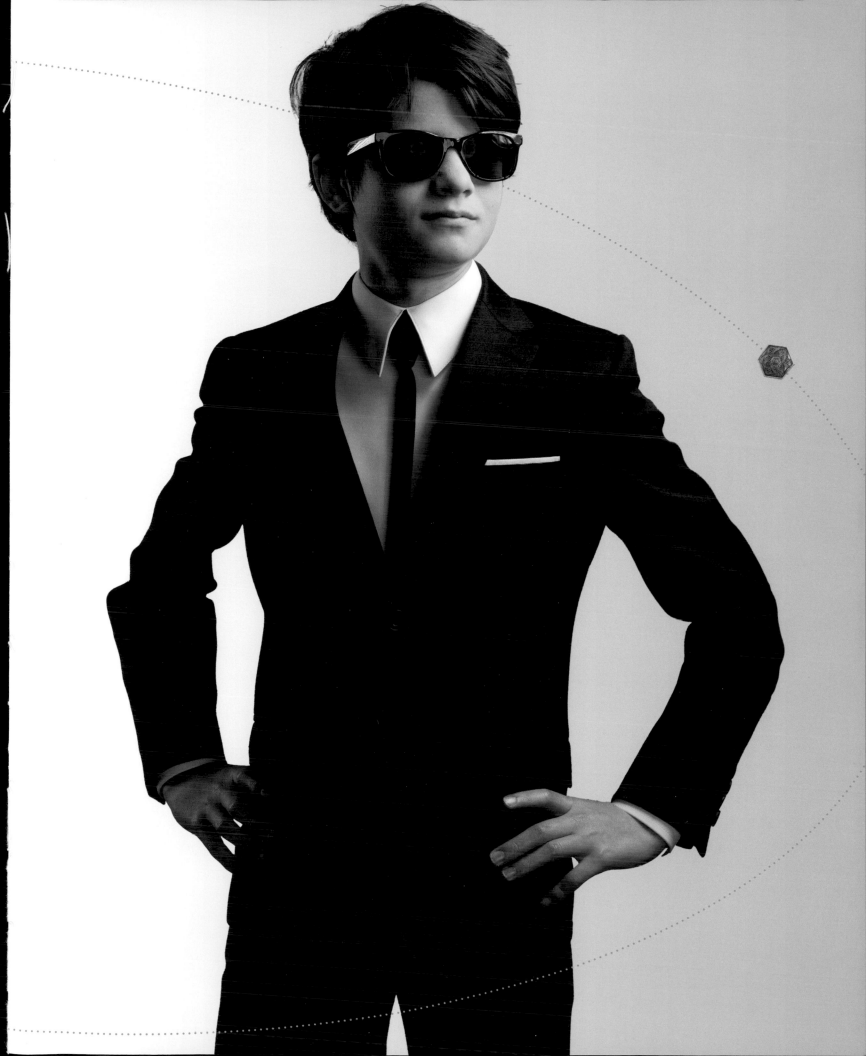

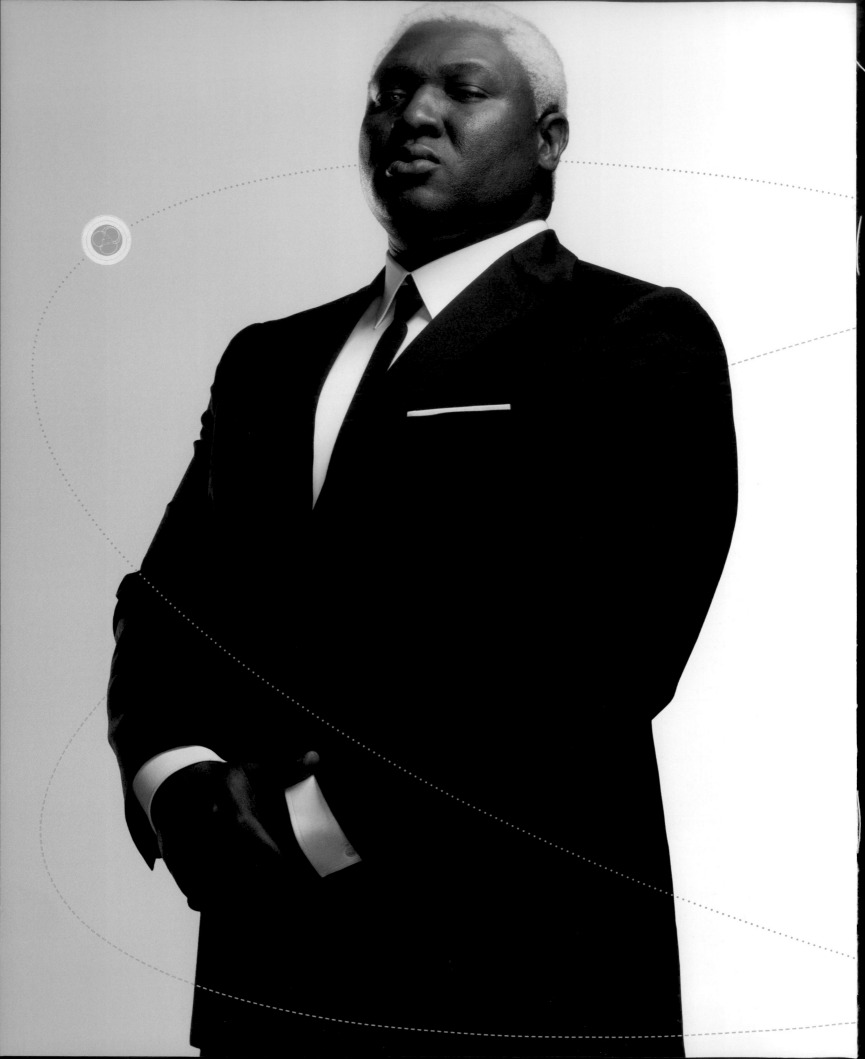

DOMOVOI BUTLER

Nonso Anozie

"Butler," says actor Nonso Anozie, "is a man for all seasons." Domovoi Butler is the loyal, long-serving retainer responsible for ensuring the smooth running of Fowl Manor. Descended from a long line of Butlers—all of them Butler by name and butler by profession—he is also a strong, fiercely trained bodyguard, charged with protecting Artemis and his family and maintaining the security of the Fowl empire.

Butler's first name, Domovoi, is a translation of a Russian word known in the cultures of many Eastern European countries to describe a spirit or "household lord" who protects a family and its home, with a special concern for animals and children.

In *Artemis Fowl*, Butler has a particular bond with the title character. "Butler's relationship with Artemis," says Nonso, "is many faceted. He is a protector and a teacher: someone responsible for ensuring that Artemis learns everything he needs to learn—not just academically, but also common sense, problem solving, and skills in self-defense. More than that, he represents something of a father figure to Artemis."

After graduating from the Royal Central School of Speech and Drama, Nonso took the lead in the Royal Shakespeare Company's 2002 staging of *King Lear*, grabbing enthusiastic reviews and, at age twenty-three, making theatrical history as the youngest actor to play King Lear in a professional production.

Having appeared in several films, including Mike Leigh's *Happy-Go-Lucky*, Nonso took the title role in the crime drama *Cass*. In addition to major roles in such successful television series as *Occupation*, *The Bible*, *Dracula*, *Tut*, and *Zoo*, Nonso appeared in the blockbuster HBO series *Game of Thrones* in the role of Xaro Xhoan Daxos, the mighty merchant prince of the great city of Qarth.

Artemis and Butler: young master and servant, but also loyal allies and devoted friends. Butler (opposite) has an imposing stature that contrasts mightily with that of his young charge.

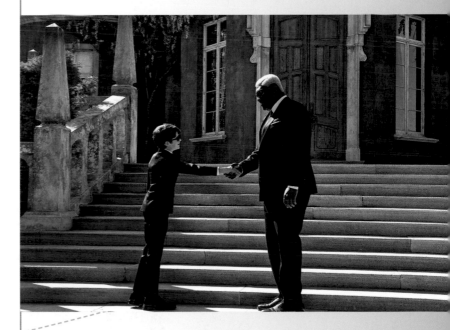

Overleaf: Artemis and Butler prepare to listen in on the fairy realm beneath an ancient, enchanted oak on the Hill of Tara.

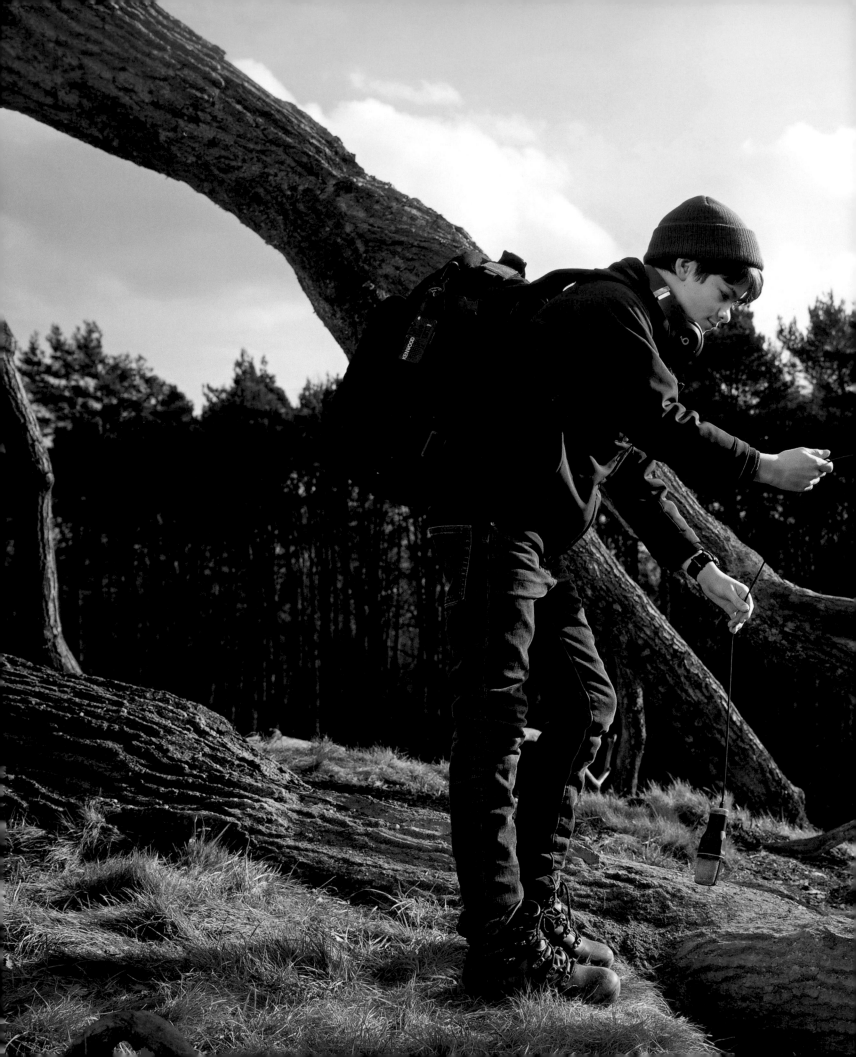

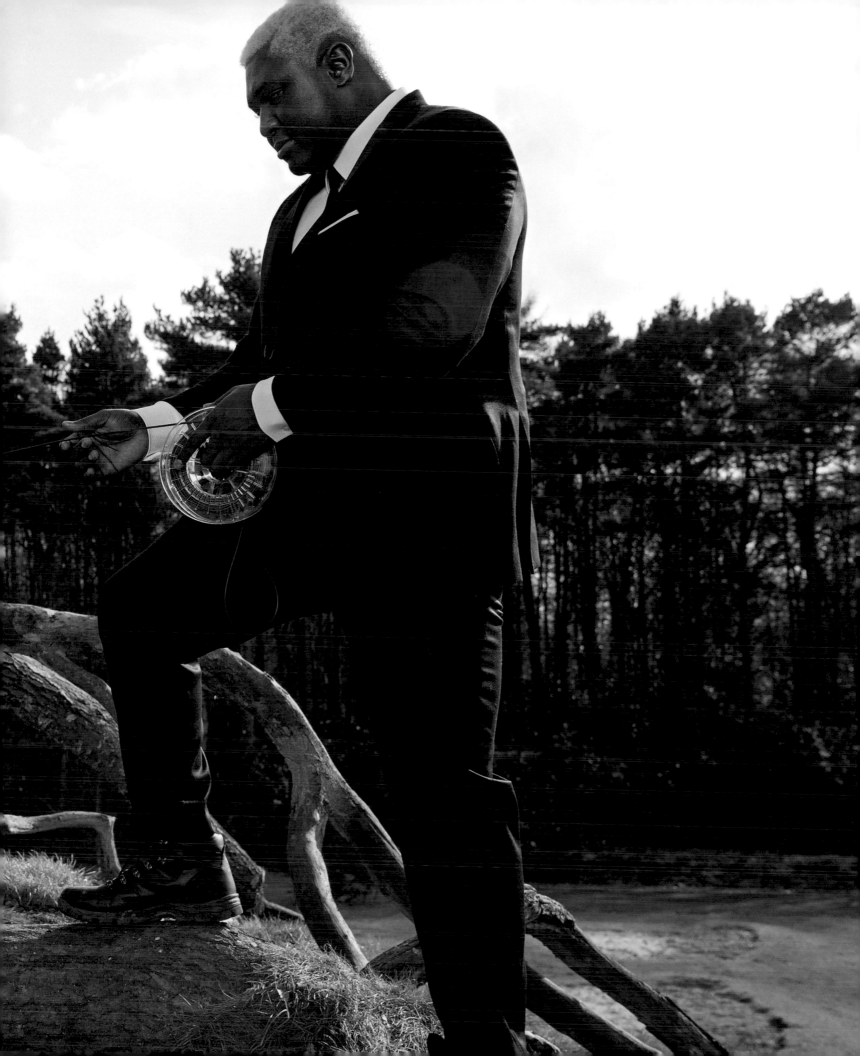

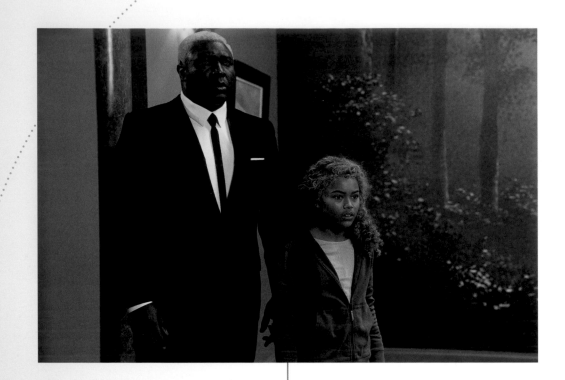

Butler with his niece, Juliet (Tamara Smart).

Nonso worked with Kenneth Branagh, playing opposite him in the National Theatre's production of David Mamet's play *Edmond* and being directed by him in Disney's 2015 live-action *Cinderella*, in which he played the captain of the guard and chief advisor to the prince.

Nonso first heard of *Artemis Fowl* many years before he was cast as Butler. In 2002, while studying at the Royal Central School of Speech and Drama, his work was noticed by Peter Elliott, who lectures on animal movement and is known for his work as a performer and choreographer for such films as *The Island of Dr. Moreau*, *Gorillas in the Mist*, and *Congo*. At that time, *Artemis Fowl* was going through one of several early development stages, and Nonso was asked to do an experimental workshop for a special effects green-screen sequence involving a troll attacking Fowl Manor. "That," says Nonso, "was when I became aware of

the books; but little did I know that, sixteen years later, I would be on a film set playing Butler fighting with that troll character!"

Talking about the challenge—and the excitement—of playing Butler, Nonso says, "When Artemis's father goes missing and there's no explanation as to why, it sets off a chain of cataclysmic events that throws the Fowls' lives into disarray, along with Butler's daily routine of keeping everything in order and under control. From then on he's running around, struggling to get some semblance of understanding of what's gone on and trying to get things back to normal. He is like a juggler attempting to keep too many balls in the air. As an actor that's great fun to play, because you get to see a man who is normally in total control frantically scrambling to keep on top of things."

One of the pleasures of the role for Nonso is the contrasting physical appearances of the characters of Butler and Artemis, which was a key to the actor's understanding of their relationship: "I like their juxtaposition of size. Butler looks as if he could squash Artemis with one thumb, and yet they talk together as though they are equals. Artemis understands that Butler is his elder and that he has some authority over him, especially when it comes to his safety, but at the same time, they're the best of friends with a closeness that is almost like brothers."

That is a perception shared by screenwriter Hamish McColl: "There's a strong, warm relationship between the two characters and there's a lot at stake for them both; for Artemis, to crack the case and for Butler, to protect Artemis. Nonso's

performance is terrific; he is very good at quietly conveying a deep love of the Fowl family and Artemis in particular."

Butler's bond with Artemis carries over into that established by the actors: "I feel like I've been working with Ferdia Shaw forever," says Nonso. "Because we have so many scenes together, I was brought in to read with him and two other boys at their final audition. Ferdia immediately stood out: even though there was innocence about him, he had a little glint in his eye and he was also super bright—he's a really intelligent and very funny kid. There's an old saying in the acting profession: 'Never work with animals and children,' but even though Ferdia's young, he has a maturity way beyond his years."

Juliet, Butler, and Artemis with the fairy gold paid as a ransom for Captain Holly Short.

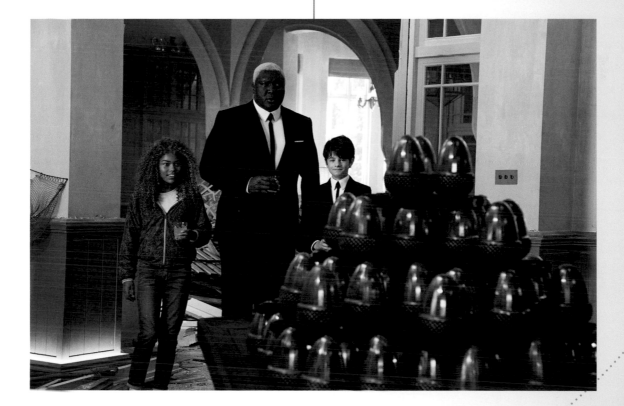

JULIET BUTLER
Tamara Smart

Auditioning for film roles can often be a discouraging experience for actors, but sometimes, as Tamara Smart discovered, disappointment can turn to unexpected success. "Originally," she recalls, "I tried out for Holly and had an e-mail telling me that I hadn't been cast. But Kenneth Branagh said that he wanted to see me again, so I went for another audition—this time for Juliet—and got the part!"

Although Tamara was only thirteen when she was cast, she was already an experienced actress and all too familiar with the stresses of auditioning. After studying with Razzamataz, a UK-based theatre school, she was one of a number of youngsters going for the part of Enid Nightshade in the BBC's television adaptation of Jill Murphy's children's book series The Worst Witch. The then eleven-year-old went through four months of auditions before securing the role, a process that she described at the time as being "nerve-racking, but at the same time very exciting."

As well as appearing in three seasons of *The Worst Witch*, Tamara appeared in the BBC's high-octane 2018 drama series *Hard Sun* before beginning her journey to Fowl Manor. "When my agent first asked me if I wanted to audition for *Artemis Fowl*, I thought, 'Okay, let's give it a try!' But it was only later on, once I'd gone through numerous auditions, that I realized just how big and exciting the project was. I was so happy to be part of it."

Juliet is Domovoi Butler's niece, and he is training her as a bodyguard so she will be able to serve the Fowl family as he does and as the Butlers have done for many years. Describing Juliet's personality, Tamara says, "She has been brought up as a strong, athletic, confident person who is never scared of doing whatever's necessary to protect those for whom she works. She is very determined, doesn't argue, and always gets on with the job. I find her a very interesting character—especially the sister–brother bond she has with Artemis. They have obviously grown up together and are very close, but when Juliet finds

Juliet on lookout duty as the residents of Fowl Manor await an attack from the fairy troops of the Lower Elements Police.

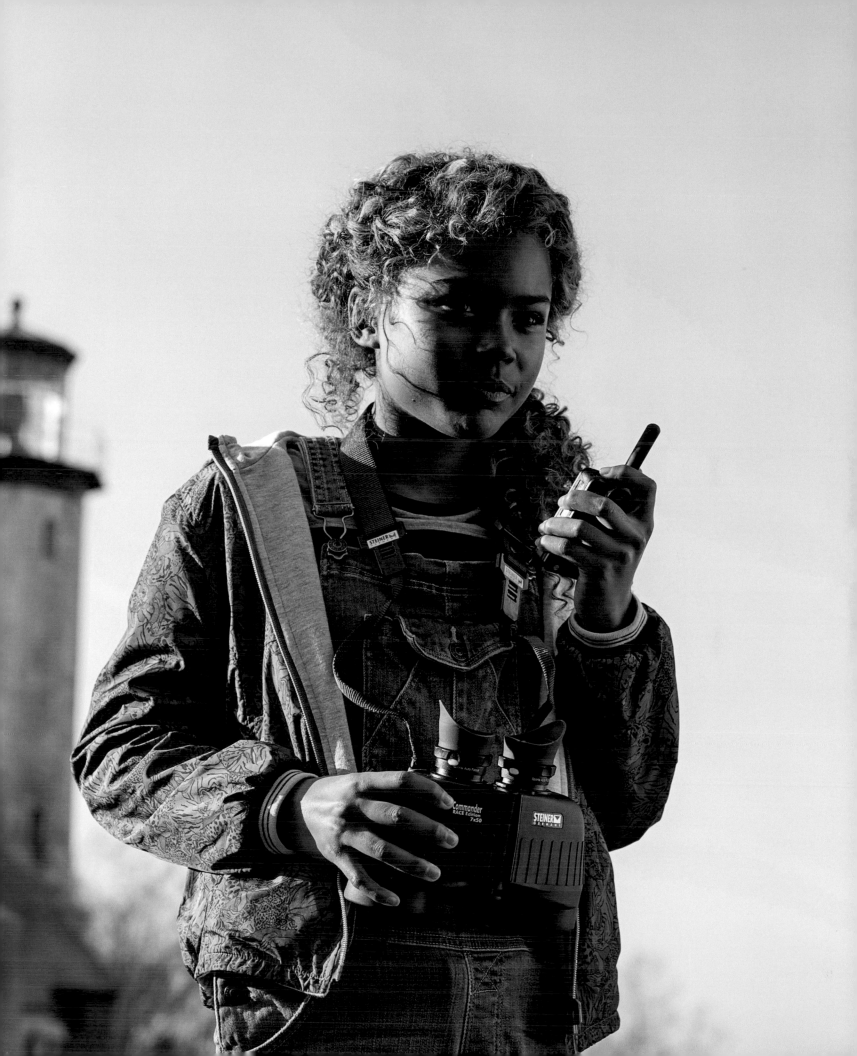

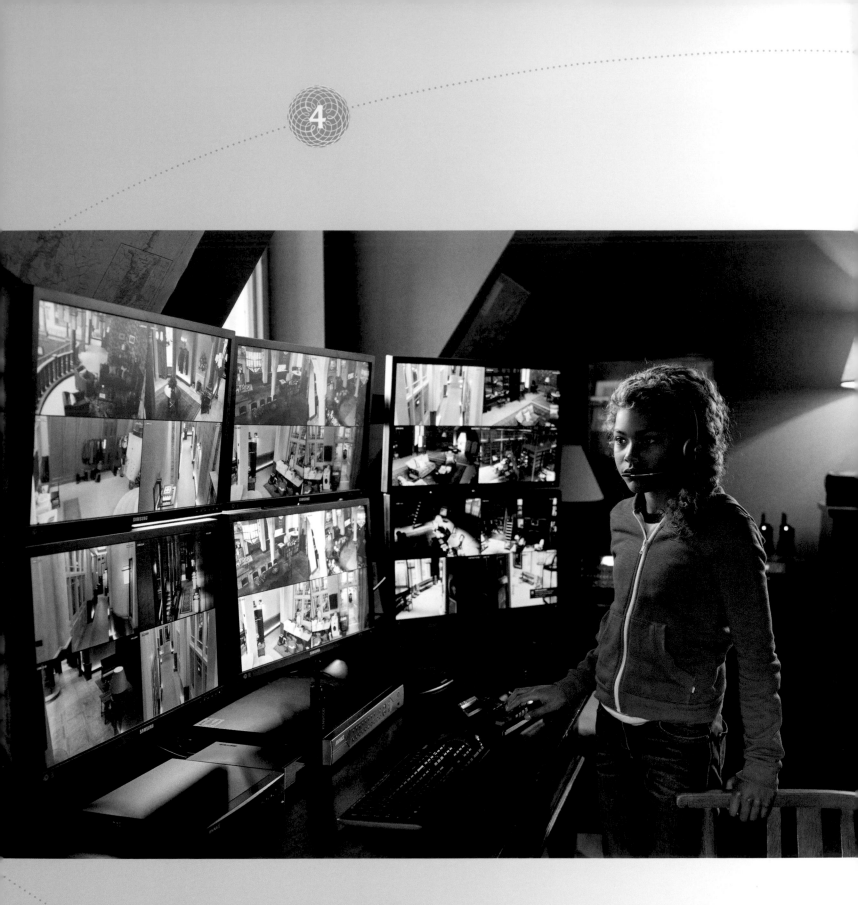

Juliet checks security camera feeds for activity in Fowl Manor.

out that fairies are *real*, it kind of wakes her up and she realizes that Artemis is not a normal boy."

As Juliet, Tamara had to perform several action sequences, including, on only her second day of filming, a scene in which she is practicing kendo with Butler. This involved two weeks of rigorous stunt training, first with an instructor and then with Nonso Anozie. It was a somewhat daunting challenge for a young girl to have to take on a heavyweight giant like Nonso: "It was scary to begin with," she says, laughing, "but after we'd trained and rehearsed it was really exhilarating and I got more energy and adrenaline with every take. Of course, everything we did was totally safe—but, as they always say, 'Do not try this at home!'"

Working closely with Nonso, Tamara gained more than just some useful moves in martial arts: "He feels a bit like a big brother and he's a really wise man. I've learned a lot from him: acting tips and much more, and I think I've improved from his wisdom."

Tamara also has an interesting take on her young costars: "I really like the unique way Lara portrays Holly. She has molded the character to what she wants it to be: strong and confident, but she's not afraid to play the character's vulnerability. And acting with Ferdia is rather like working with a unicorn! He can be so funny and he's been sharing jokes with me and teaching me to juggle and speak Irish, but he's a really good actor and can snap into whatever aspect of Artemis's personality—rude, tough, or soft—that is required for a scene."

Summing up how she feels about Juliet Butler, Tamara says, "To me, Juliet is an inspiring character. I think she's made me far more brave and brought out the best in me. A lot of girls my age are very insecure about themselves, and I don't want them to be. We all need to believe that we can do anything we want to, and I think that Juliet's character says, 'I am my own person and I am important.' I want people to believe that."

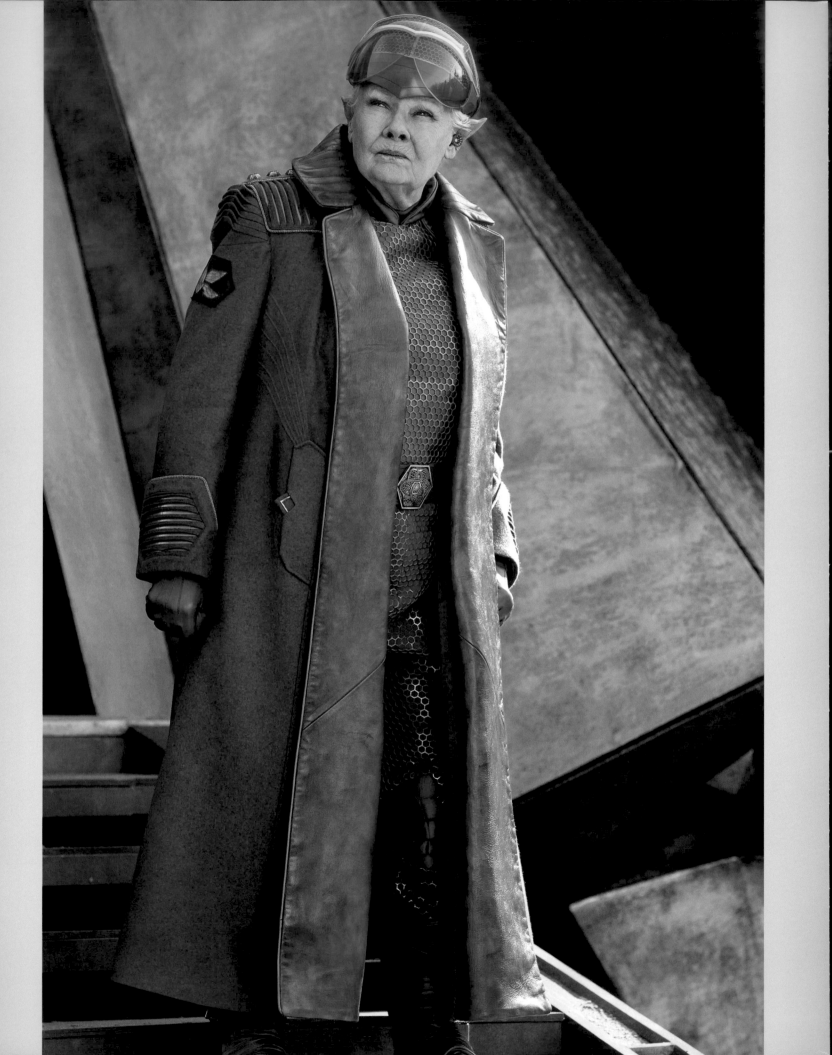

COMMANDER ROOT

Judi Dench

A steely-eyed Commander Root (Judi Dench) prepares to lead the fairy forces in their assault on Fowl Manor.

Ask Dame Judi Dench about her involvement in *Artemis Fowl* and she will tell you: "I play 802-year-old Commander Root of L.E.P.recon—and if you're surprised, you can't imagine how surprised I am!" To explain her surprise, initially shared by fans of the *Artemis Fowl* books, it has to be understood that, in an update from the original source material, the male character of Root has been reimagined for the film as a female leader.

As Kenneth Branagh explains: "When Eoin Colfer's books were first published, nearly twenty years ago, the representation of Holly as the only woman officer in a man's world of the L.E.P. was a story that was important to tell in a certain type of way. Now, the world has changed and we want the same kind of immediacy with the zeitgeist; as a result, Holly is no longer the only woman in the L.E.P. force but has her own passionate engagement with a very impressive commander who has the job not because of tokenism or unique ambition but because—in our fairy world—diversity across gender and cultural backgrounds is something that is very much in operation and reflects all the appropriate movements in our own world."

The role of Commander Root now calls for a strong, wise, and determined female leader, capable of handling difficult, often unprecedented, situations. Who better to take on such a role than Judi Dench, with her wealth of experience in playing powerful leadership figures?

Screenwriter Hamish McColl shares his view on Judi's characterization, which takes the form of a no-nonsense personality with a brusque manner and a gruff, rasping voice: "What Judi brings to playing Root's veteran, seen-it-all-before character is a huge sense of experience. From her long, hugely varied, and rich career she brings a kind of anchor of wisdom to the character."

For moviegoers, Judi is probably best known for three iconic roles: her multi-award-winning portrayal of Queen Victoria in the film *Mrs. Brown*; her appearance as an earlier monarch, Elizabeth I, in *Shakespeare in Love*, for which she received an Oscar; and her time as M, the head of British intelligence unit MI6, in seven James Bond titles, from *GoldenEye* in 1995 to *Skyfall* in 2012.

4

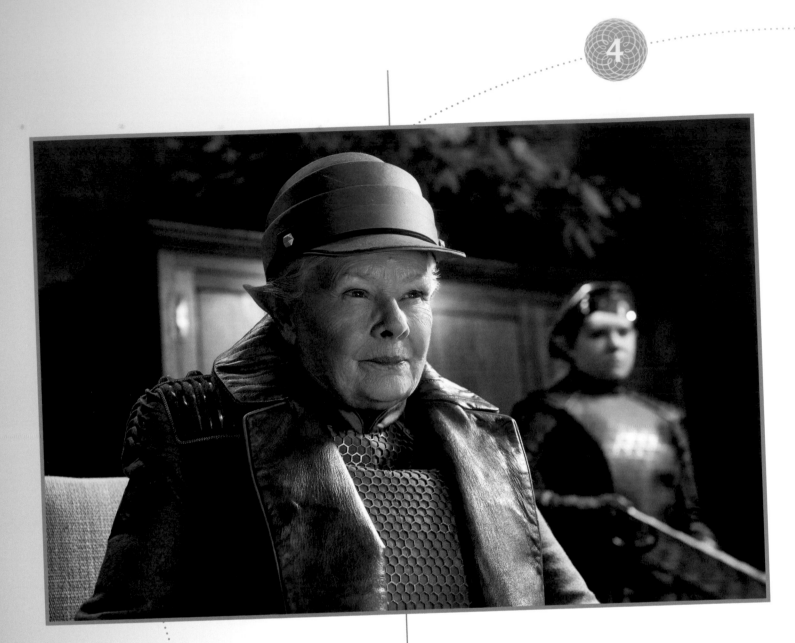

Judi has given many highly praised film performances, among them her roles in *A Room with a View*, *Iris*, *Notes on a Scandal*, and *Philomena*. However, it was in the theatre where she first established her reputation, making her professional acting debut in 1957 with the Old Vic Company in London. Across a crowded career, her acclaimed stage roles have ranged from Shakespeare's Beatrice, Cleopatra, and Lady Macbeth to Sally Bowles in *Cabaret* and Desirée

Armfeldt in Stephen Sondheim's *A Little Night Music*. She also had great success with two long-running, much-loved British television comedy series: *A Fine Romance*, with her late husband, Michael Williams, and *As Time Goes By*.

Judi began directing in 1988 with a production of *Much Ado About Nothing*, starring the man who is now her director on *Artemis Fowl*—Kenneth Branagh. They have continued to work together on stage, film, and television as fellow actors or as

actor/director. Before beginning their latest collaboration, Kenneth had directed Judi as Princess Dragomiroff in his 2017 film version of Agatha Christie's *Murder on the Orient Express*. Reflecting on their professional relationship, Judi says, "We hit it off from the first time we met, probably because we're both apt to get sent out of the studio for laughing and behaving badly! Also we found that our birthdays were next-door to one another in December—mine on the ninth and his on the tenth—and that really sealed the knot."

The trust between actor and director is total, as Judi explains: "I was in his production of *The Winter's Tale*. Ken walked into my dressing room on the last afternoon and said, 'Judi, would you be interested—' and I said, '*Yes!*' It was only then that he told me what the project was, and that's how I got to play the Princess Dragomiroff. After *Murder on the Orient Express*, he came to see me, walked into my kitchen, and said, 'Would you like to—' and I said, '*Yes!* Yes, I *would*! That's fine!' And so, now I'm playing Commander Root in *Artemis Fowl*."

Discussing Commander Root's relationship with Holly Short, Judi acknowledges that Root can, at times, be quite hard on the young officer: "Root sees in Holly the potential to be a very good captain; she's game, daring, and fearless. And I think that Root understands and respects that."

In the view of Hamish, what Judi brings to Root's relationship with Holly is a sense of perspective: "With the kidnapping of Holly by Artemis, the future existence of the fairy world is suddenly precarious. With her over-eight-hundred-years' experience of life and an understanding of the long history of the fairies, Root sees beyond the immediate to the wider issues, and that is what she conveys to Holly."

Judi is rather keen on her appearance in the film: "I'm given this absolutely wonderful green costume with a greatcoat that you can see has its origins in the military." Then Judi adds with a chuckle, "I thought it was frightfully exclusive until I walked onto the set and found about sixty other people wearing something similar! And then I have a rather splendid hairdo and, like all the fairies, my elf ears, which are amazing. All of which help to make you feel more like a character in the perfect way that costume, hair, and makeup should."

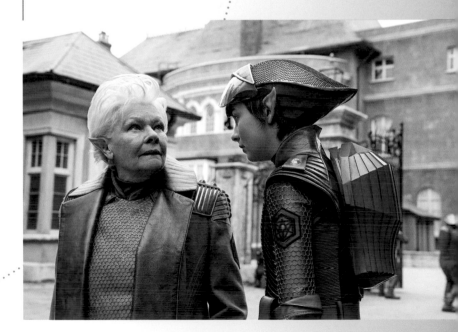

Commander Root has her own, very individual, means of transport, as Judi explains: "I've got this wonderful vehicle I go around on, rather like a Segway or, maybe, a Swagway. . . . Anyway, it looks like a mobilized weighing machine and it saves having to walk!"

Joshua McGuire, who plays Briar Cudgeon, recalls his first meeting with Judi: "Obviously, it's unbelievably daunting, but she instantly puts you at ease by seeming to be as keen and anxious to do her best as you are. There's absolutely no sense of resting on her laurels; she's as much on the starting line as anyone else, and that is so calming and reassuring to someone like me, facing his first day with Dame Judi!"

Despite her age—she celebrated her eighty-fourth birthday in 2018—Judi is as excited about every aspect of acting as any youngster at the beginning of her career and has clearly never lost a sense of the fun of filmmaking. Talking about working on the set for Haven City, where Commander Root has her headquarters, she

recalls one of many unusual encounters: "Haven City is mysterious and full of incredible people. On my first day on the set, I met a character who was seven foot, two inches tall. He was a tree creature, and there are actually four of them, two male and two female. I'm not very tall, so I said to Ken afterwards: 'I'd like a scene where the quite short Commander Root is trying hard to be really quite cross while standing in the middle of those four very, very tall people!' But I don't think he's going to allow it. Alas."

Her playfulness is doubtless what endears her to Kenneth: "Judi brings such subtlety, fun, and energy to the film," he says. "And, in her look, she has a sense of rock-star chic! Her portrayal of this Napoleonesque Irish curmudgeon is astonishing, but it also goes hand in hand with the portrayal of a very compassionate, intelligent, all-seeing character who is full of secrets as well. The result is a formidable, passionate female fairy who rules the roost with great foresight."

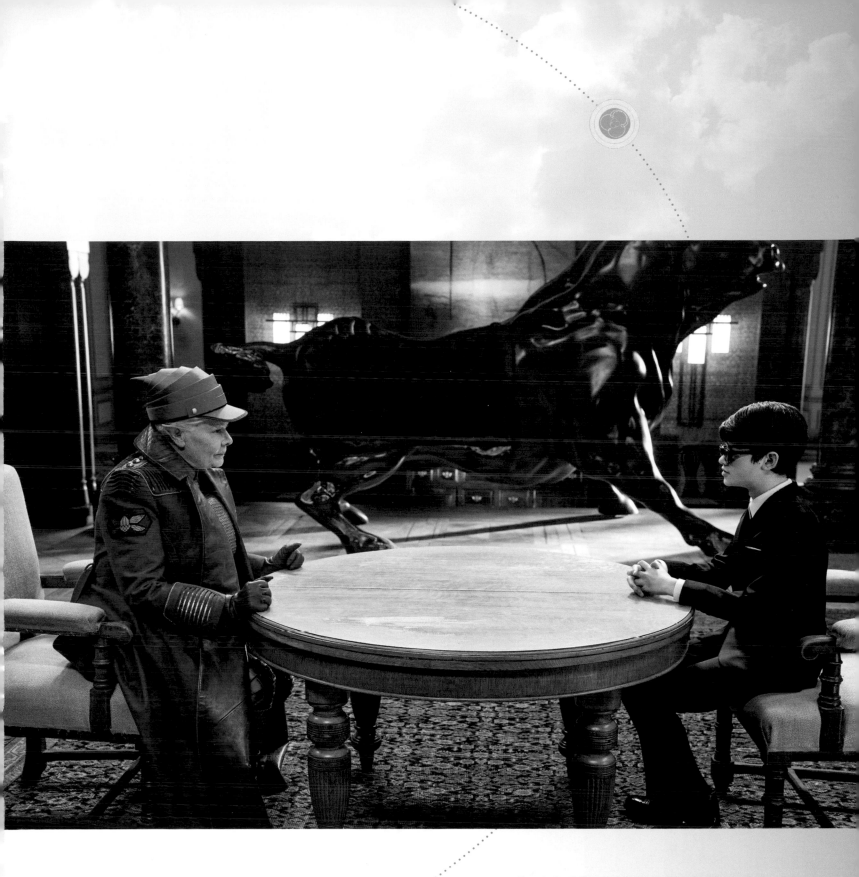

Face to face! Commander Root confronts Artemis to discuss his demands for a ransom payment in fairy gold in exchange for the release of Holly Short. In the background is the magnificent bull sofa.

CAPTAIN HOLLY SHORT
Lara McDonnell

A fairy with something to prove:
Captain Holly Short (Lara McDonnell).

"Time is different in the fairy world," says Lara McDonnell, "and their life span isn't like ours. So, in reading the books, I'd always thought Holly was, maybe, in her late teens, just out of the L.E.P. Academy and eager and ready to go. But, even though she doesn't look it, Holly is in her eighties. So, I'm playing an eighty-something fairy as if she were fourteen. It sounds really weird, but it makes sense when you see it!"

So what is it that makes Holly Short such an attractive character? "She is feisty," says Lara, "has a quick mind, and is really smart! Holly absolutely adores getting in on the action, but she's stuck doing a mind-numbing, clock-in-clock-out job in prisoner transport. She feels her talents are really underestimated, especially when she sees others getting promoted that she thinks don't deserve it. She always wants to do the right thing in any situation—even if she has to disobey orders and no matter what the cost."

Talking about the fact that Artemis kidnaps Holly and holds her to ransom for fairy gold, Lara laughs: "That is really bad luck for Holly! And, not being a big fan of humans, she can't believe that something so ridiculous could happen to her! But, in the end, the situation allows her to prove just how good she is at her job."

Lara is intrigued by Holly's relationship with her kidnapper: "She despises Artemis because he is arrogant and, to make matters worse, he is also smart! He's researched and planned everything and knows exactly what he's doing. But what Holly really can't get over is that the fairy world has been put in danger not just by a human, but by a human *child*! So, no wonder she's inclined to hate him!"

It is, however, a relationship that develops through the film: "You come to realize that, despite coming from completely different worlds, they actually have a lot in common. For one thing, they're both trying to prove themselves and show that they are worthy of something more. Not only that, but they're willing to do whatever needs to be done to achieve what they believe to be right, and they come to realize that the only way they can both get what they want is if they work together."

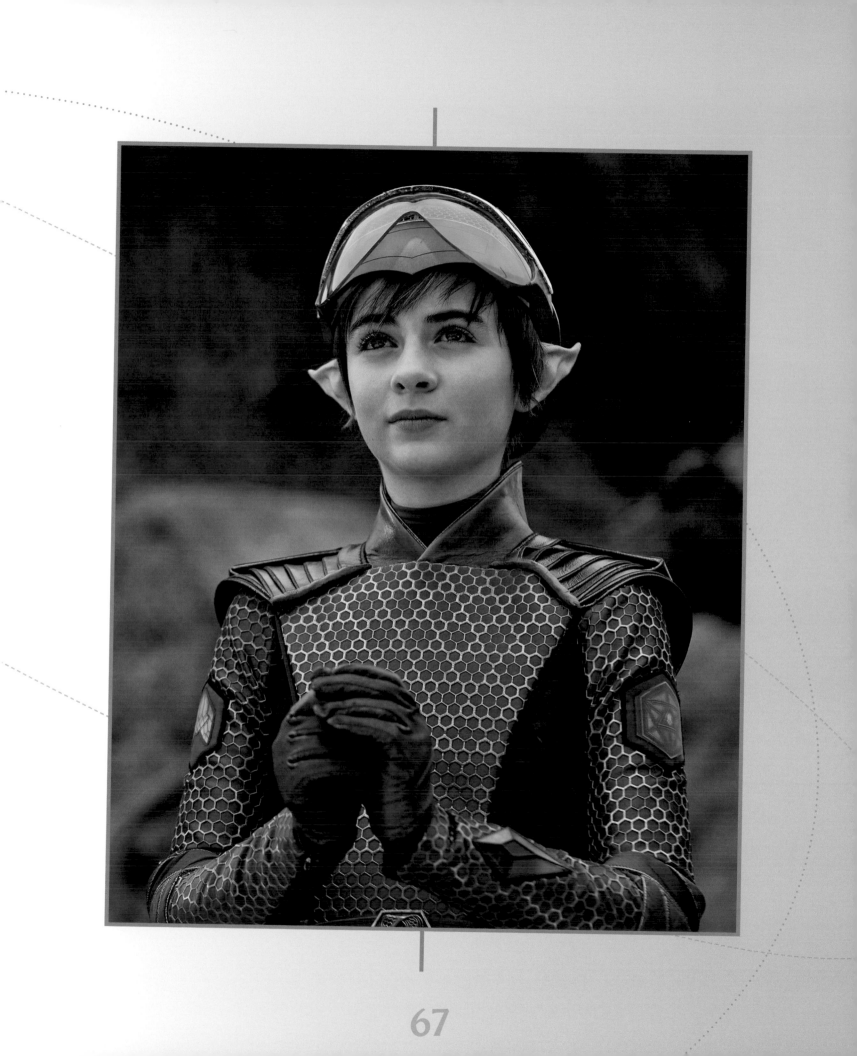

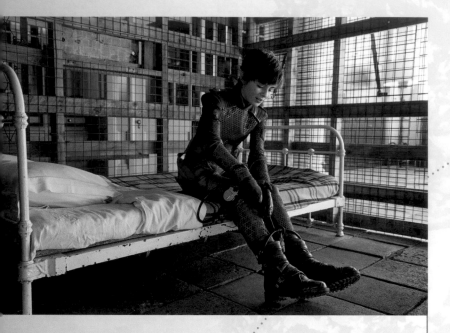

Holly trapped and caged in the kitchen at Fowl Manor.

Even though Holly's family background makes relationships with the other fairy characters difficult, there are those who are trying to be supportive. "Because Commander Root is Holly's boss," says Lara, "she has to tread carefully. The commander can be quite hard on Holly, but only because she wants her to do well, to overcome the gossip and rumor and show that she really can be an amazing officer. Foaly the centaur is probably the closest person Holly has to a friend; they really 'get' each other and are comfortable exchanging witty banter and insults with one another."

Describing Holly's relationship with Artemis, Ferdia Shaw says, "It doesn't start out very well, but as the story goes on, they reach a kind of admiration for each other because Artemis certainly has regard for Holly's fighting skills and she respects his intelligence!"

Holly and Artemis share a common anxiety about the fact that their fathers are both missing and the subject of gossip and accusations. "In Holly's case," says Lara, "there are rumors that her dad exposed the fairy world to humans by trading with them and selling fairy secrets. As a result, Holly is undermined because of what her father is supposed to have done, and she's conflicted because she has no way of knowing if there is any truth to the stories and desperately wants to believe in his innocence."

Like Holly and Artemis, Lara developed a strong bond with her fellow actor Ferdia. "We met at one of the auditions," Lara recalls, "in July 2017, so we've spent a lot of time together pretty much from the beginning of the project. We have a lot in common—we both like Harry Potter, *Star Wars*, and sci-fi and fantasy generally, and of course, we're both big fans of the Artemis Fowl books. During filming we lived in the same hotel, worked on set and did schoolwork together, and in between, just hung out with one another. All that is very useful because there's real chemistry

4

between Holly and Artemis and, as actors, we want that to read on-screen. Ferdia and I are comfortable around one another, and he's now like my younger brother."

"She is great!" says Ferdia of Lara. "She's very experienced, professional, and always ready for anything. When I first met her, I was a hundred percent sure she could be Holly, no question, simply because there was absolutely nothing *not-Hollyish* about her!"

Like Ferdia, Lara was born and lives in the Republic of Ireland—appropriate for an actor playing an Irish fairy—and she is very proud of sharing her nationality with Eoin Colfer. "Ireland as a setting for the story is really important to the book," says Lara. "Think of somewhere really magical and Ireland immediately comes to mind, because of our mythology and, in particular, our legends about the fairy folk. As Irish people, we are very much in touch with our history and folklore."

Although playing Holly Short is Lara's first major film role, she is no newcomer to acting, having made her film debut in the 2014 rom-com *Love, Rosie* before spending a year in London's West End in the title role of the stage musical

Matilda. In 2016, Lara appeared as the young Anne Brontë in Sally Wainwright's BBC television film about the three Brontë sisters, *To Walk Invisible*. The following year, she was seen playing Cillian Murphy's daughter, Alannah, in the Irish film *The Delinquent Season*.

Ask Lara how she would describe *Artemis Fowl*'s appeal, and she is quick to respond. "It is a film for everyone," she says. "It has the kind of magic and fantasy that will appeal to everyone who loves being taken into a completely out-of-the-ordinary world where your imagination can run wild. Not only that, but it has action and comedy and characters like Artemis and Holly who are going through emotional journeys to which children and adults will easily relate. As for fans of the books, maybe I'm biased, but I think they will love it. As I put it, even if I weren't in it, I would still really want to go and see it!"

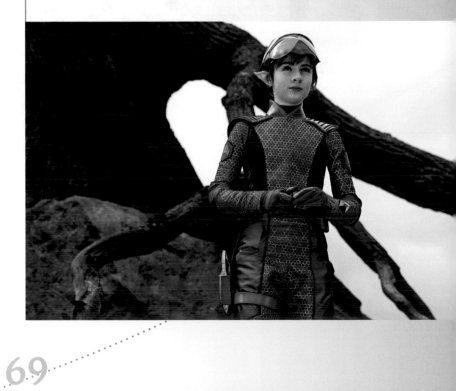

Holly stands poised in front of the ancient fairy oak.

FOALY

Nikesh Patel

Foaly, the chief technical officer of the Lower Elements Police (L.E.P.), is an especially interesting character in that he is a centaur: a creature known from Greek and Indian mythology that has the upper body of a man and the lower body and legs of a horse. He doesn't have any of the magical powers of the fairies, but he is a technological wizard who has devised many of the systems and inventions used by the L.E.P. in its work. Author Eoin Colfer describes Foaly as "the fairy world's equivalent to Q of the James Bond films."

Playing Foaly is British actor Nikesh Patel, known for his compelling portrayal of Aafrin Dalal, a young clerk working for the office of the British viceroy of 1930s India in the television series *Indian Summers*. Nikesh began acting when he took the title role in a university production of Shakespeare's *Othello*. After training at the Guildhall School of Music and Drama, he worked in theatre before securing a regular part in the second season of the TV series *Bedlam*, followed by further appearances on television and roles in the films *London Has Fallen* and *Halal Daddy*.

Being cast as Foaly provides Nikesh with an opportunity to play a character that is totally unique: a half-human, half-horse techno geek working for a top-secret fairy organization! "Foaly is an innovator," says Nikesh. "He creates, designs, solves problems—*a lot of problems*—and is just really curious about how things work and what makes them tick."

"Nikesh," says screenwriter Hamish McColl, "brings a relish and charismatic vitality to a character who is deeply enthusiastic about all things scientific." However, as Nikesh sees it, Foaly doesn't feel that he receives sufficient credit or respect for his work. "I think he feels that he is more intelligent than others and he doesn't have the time to try to make them understand. Because Foaly believes that if you shackle someone you won't get the best out of them, he doesn't like to be bound by rules."

Nikesh wonders whether Foaly's nonconformist attitude may be a result of his centaur characteristics: "It's possible that the more tempestuous side to his nature comes from his horse ancestry, although humans can also be pretty aggressive when they want to be. Nevertheless, my guess would be that Foaly finds the company of humans a bit more stimulating than that of horses. He probably finds horses to be quite dull company. After all, there's only so much whinnying you can get through in a day! But he finds people really intriguing: they're a complete mess, of course, but still fascinating."

Although Foaly has a difficult relationship with Commander Root, Judi Dench, when not in character, is clearly intrigued by Haven City's chief technical officer: "Foaly is simply wonderful! He's really going to blow people's minds. Being a

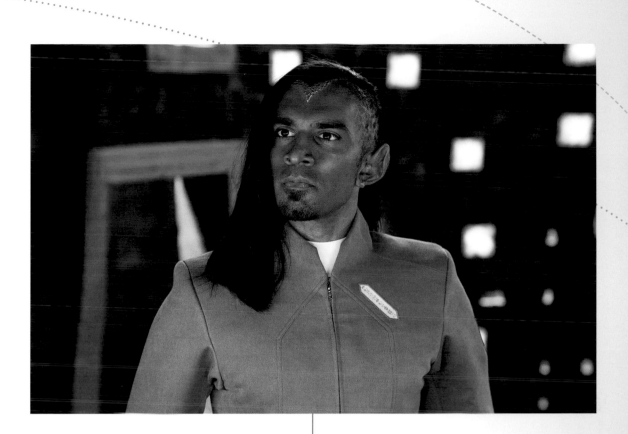

Foaly the centaur (Nikesh Patel) is half man, half horse, and is the L.E.P.'s Chief Technical Officer.

centaur, he's very, very beautiful; he has a shaved head and wears his hair like a mane. And then he has—or, rather, he *will* have on film—the rear end of a horse, complete with four legs and wonderful hooves. He is thrilling!"

Lara McDonnell gives Holly's take on Foaly: "He's very knowledgeable and really good at what he does. In his words, he loves science. So, Foaly is smart and *knows it*! He's proud of his accomplishments, and Holly admires that, but sometimes, he can be a bit of a show pony!"

Of the centaur's attitude toward Holly, Nikesh says, "Foaly clearly has plenty of time for Holly, sees her as someone with a good head on her shoulders, who is really going places. Also, I suspect that he quite likes the fact that Holly is a bit of a rebel who doesn't kowtow to authority."

Nikesh also has a view on how Foaly might think about the central human in the story: "Although Artemis is young, Foaly is impressed by the boy's cleverness. In fact, he probably considers him the only person he has encountered who is as intelligent as he was at that age. However, he also recognizes that Artemis poses a very real threat to the fairies of Haven."

Summing up Nikesh's performance, Hamish says, "Foaly has boundless enthusiasm for his work and an innate goodness of character that you see in Foaly's fondness for Holly. He also has an interesting, long-suffering relationship with Root, being both allies and yet slightly combative—largely on Root's part! All these aspects of Foaly's personality Nikesh succeeds in getting across while also managing to be on four legs rather than two!"

MAJOR BRIAR CUDGEON
Joshua McGuire

Describing his character in *Artemis Fowl*, Joshua McGuire says, "Briar Cudgeon puts himself first and is a complete opportunist: any way in which he can get ahead of everyone else in the easiest way possible, he will go for it!"

Joshua was born and grew up in Warwick, not far from Shakespeare's birthplace at Stratford-upon-Avon, where, at age thirteen, Joshua made his stage debut as Prince Arthur in the Royal Shakespeare Company's production of *King John*. After training at the Royal Academy of Dramatic Art, he appeared in the premiere production of Laura Wade's *Posh* and Noël Coward's *Hay Fever* before returning to the Bard and taking on his most demanding role, Hamlet, at Shakespeare's Globe Theatre in London. A few years later, in 2017, he would costar with Daniel Radcliffe in the fiftieth anniversary production of Tom Stoppard's *Rosencrantz and Guildenstern Are Dead*, a play that puts two minor characters from *Hamlet* center stage.

Joshua's film appearances include Richard Curtis's 2013 rom-com *About Time* and, the following year, Mike Leigh's *Mr. Turner*, in which he gave a critically acknowledged portrayal of the art critic John Ruskin. He first met Kenneth Branagh when he was cast in a small role in *Cinderella*. "As a result of that brief encounter," says Joshua, "Ken decided I might be suited to play a maniacal elf! Briar is certainly not the nicest character, but it's been great to work with Ken and have a chance to stretch my acting legs."

For Joshua, one of the most enjoyable aspects of that experience has been the flexibility of Kenneth's directing style: "He is very open to ideas, willing to change an approach to a scene from shot to shot. For example, in the sequence where Briar Cudgeon takes Commander Root prisoner, Ken had the camera keep rolling while suggesting a succession of insults for me to throw at Root. Thankfully, Judi wasn't there the day I filmed that shot, for which I was grateful, as some of the comments I used weren't really appropriate for shouting at a dame!"

Briar Cudgeon (Joshua McGuire), Commander Root's tricky opponent in the L.E.P.

Describing Briar Cudgeon, Joshua says, "He is intelligent, but easily rattled and makes bad decisions. His resentment at the success of others comes out as anger and, blinded by that anger, he sets the path he follows in the movie." That resentment, described by Joshua, is seen in his attitude to Captain Holly Short: "Cudgeon is really not an admirer of Holly or her father, whom he considers to be a traitor, and he is frustrated when Holly receives what he believes to be undeserved favoritism."

Cudgeon also has a strong dislike for the human race: "He is really *not* a fan of humans, and any opportunity that comes his way to humiliate and defeat them, he'll grab with both hands!" However, Cudgeon's animosity is principally directed toward Commander Root: "There's a lot of bad blood between them," reflects Joshua. "Root is very successful, but Cudgeon thinks she is an irresponsible, out-of-date leader, and is looking for any chance to undermine her. Essentially, he wants to be in charge, and when, eventually, he gets that opportunity, he seizes it too readily and doesn't use it well."

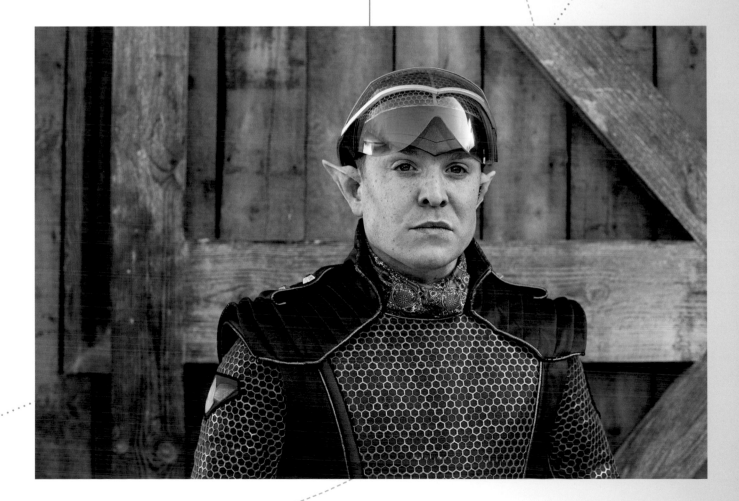

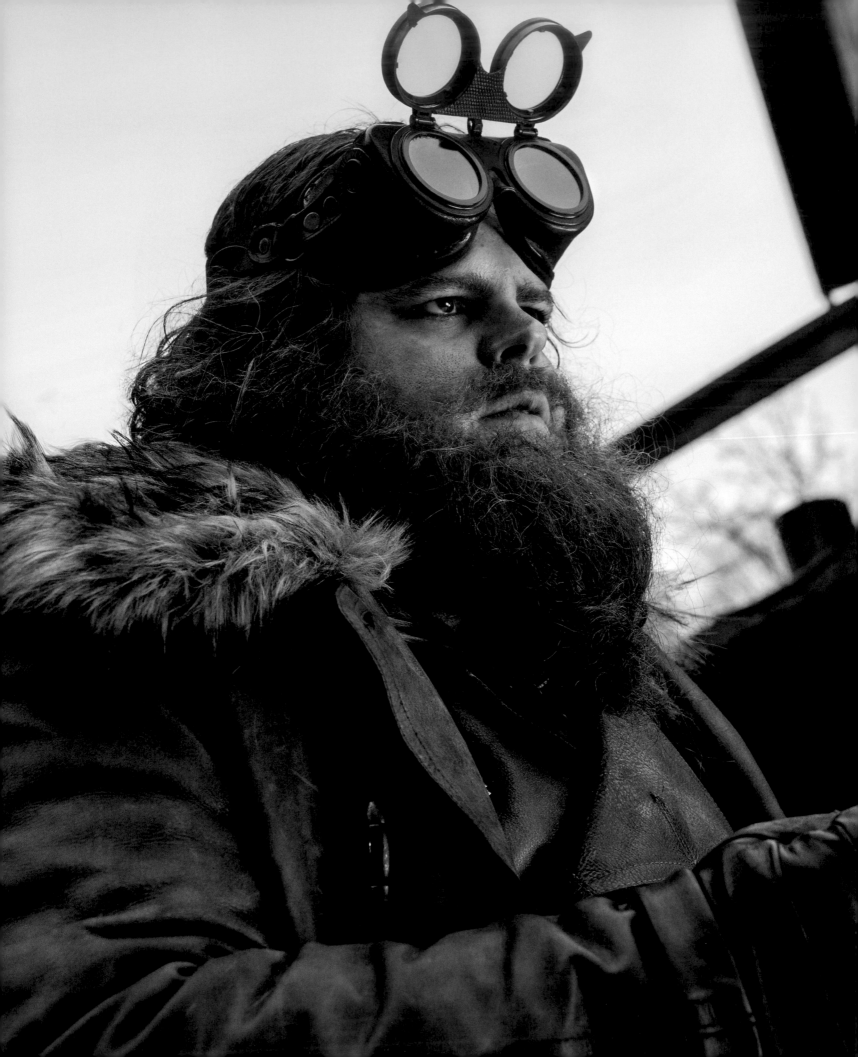

Josh Gad

MULCH DIGGUMS

"I think that there are certain words to describe Mulch Diggums," says Josh Gad. "He is a loner; he is out for himself in many ways; he is a thief—some might say a kleptomaniac. But, being a dwarf, he's also an excellent miner. Despite the fact that, a lot of time, Mulch seems to be totally out for himself, he also has an uncanny ability of doing the right thing at the right time—or appearing to do so—and that's a really fun thing to play."

An actor, comedian, and singer, Josh received a Tony Award nomination for originating the part of Elder Cunningham in the stage musical *The Book of Mormon*. Disney film fans will know him from his portrayal of LeFou, bumbling sidekick to Gaston, in the 2017 musical *Beauty and the Beast* and as the voice of Olaf the snowman in the animated films *Frozen* and *Frozen 2*.

In fact, Josh has provided the voices for a variety of animated characters, as well as played numerous TV and film roles—including Hector MacQueen in Kenneth Branagh's film version of Agatha Christie's *Murder on the Orient Express*, alongside fellow *Artemis Fowl* star Judi Dench. Judi recalls, "We didn't have any scenes together in that film, but we locked eyes across a train carriage, you know how you do! Josh especially loves improvising, which is something a lot of American actors are good at but which I can't do at all. But he's a very funny man and simply wonderful at it. I mean, spectacular!"

Artemis Fowl provided Josh with a quite different experience from filming the Christie murder thriller: "Ken really welcomes nonstop creative input from his cast, and on this film he welcomed improvisation. In fact, he would push me in that direction. So, I would usually do one or two takes of a scene as in the film script, and then Ken would let me do my own thing, play with it and go down a rabbit hole . . . or a Mulch Diggums hole in this case."

Mulch Diggums (Josh Gad) is a giant dwarf with a light-fingered attitude to what is and is not his property.

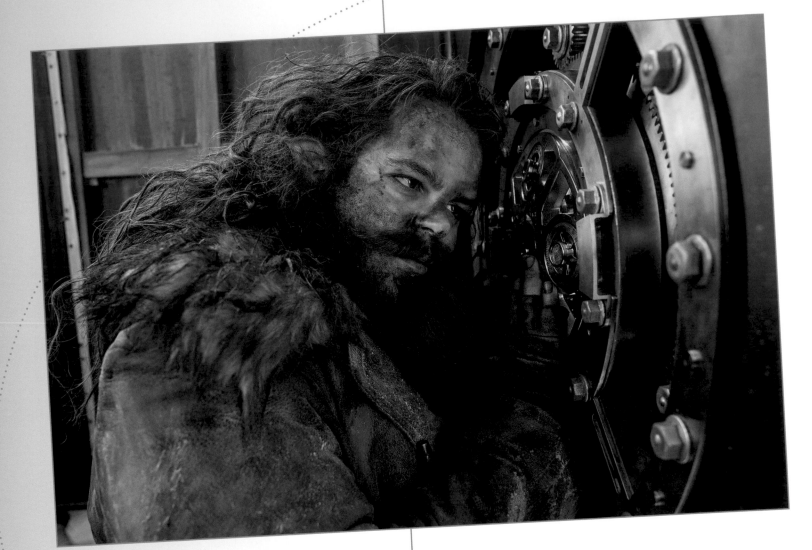

Mulch Diggums demonstrates
his safe-cracking skills.

That is a talent that won the admiration of
fellow actor Nonso Anozie: "Josh Gad's not just an
amazing actor, he's a really funny man. You can't
do anything but laugh around this guy—on and
off set—because he's got a line for everything.
He's not someone who is trying to be funny, he
just naturally *has* that funny bone."

Josh hadn't read the Artemis Fowl books
when Kenneth asked him to consider the role of
Mulch Diggums, but he quickly remedied that:
"I immediately dived into the stories and realized
what an incredible world this was and that Mulch
was an amazing character that I couldn't possibly
turn down."

Opposite: Mulch and Holly with the fairy gold
that is about to be handed over to Artemis.

Part of Mulch's appeal for Josh was, undoubtedly, his highly individual talent as a miner. Author Eoin Colfer recalls how the character came to be created: "He started life as a two-page aside: a dwarf who digs holes and steals stuff, all very simple. Right up until I started typing the words, he was going to dig those holes with a shovel, and then I had the idea that he could unhinge his jaw and actually eat all this dirt and then shoot it out the other end at high speed. That instantly made Mulch more interesting, and he became one of the main characters in the book. It also probably increased my audience of young readers—especially boys—by five hundred percent!"

It's a view of Mulch that Josh shares: "Well, of course, his digestive system is definitely something that plays into the story in a very visceral way, both in terms of the plot and its comedic effect. Mulch has a talent for depositing his leftover soil as he goes. And, as they say, what goes in must come out!"

Mulch's skill with tunneling and excavation helped Josh arrive at the voice he uses for the character: "Mulch is somebody who's constantly eating through the earth, and I thought that would have an effect on his vocal cords. My voice is naturally higher pitched, so I started studying people with lower voices until I'd found a more grounded and earthy way for Mulch to speak."

Another important aspect to Mulch's character is that he is a "giant dwarf"—or at least is larger than what is conventionally considered dwarf-sized. His fellow dwarfs maintain he is a gnome, to which Mulch's response is: "My grandfather on my mother's side was a gnome, so I am a little

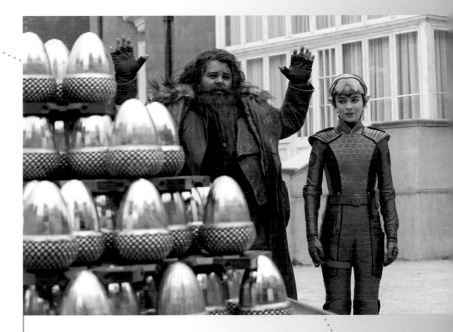

gnomish . . . but technically and in my soul I am a dwarf, a big one—a giant one, but a dwarf nonetheless."

Josh felt that this gave Mulch something in common with both Artemis and Holly: "All three of them are outsiders who are yearning for something they don't have. In Mulch's case, that is a wish that he could be like his family and other dwarfs, and that gives him a degree of vulnerability. Of course, all Mulch's relationships are about how you can help Mulch. He is your friend so long as you have something to offer him. But I think he has a special place in his heart for Holly because she is somebody who is an outsider, trying to fit in, despite everybody else looking over their shoulder and saying, 'You don't belong.' Mulch definitely responds to that, and as much as he's helping Holly because he has to, I think there's a part of him that genuinely cares about her, and wants to make sure that she's okay."

Making Horse Sense of Foaly

One of the most unlikely challenges facing the *Artemis Fowl* filmmakers was that of transforming actor Nikesh Patel into a centaur, a fabulous creature with the head, arms, and torso of a human and the body and legs of a horse. Legends about centaurs feature in Greek and Indian mythology, and most of those depicted fall into one of two categories: savage warmongers or wise teachers. Most famous of the latter is Chiron, the centaur said to have taught a number of the Greek heroes, including Theseus, Achilles, and Jason. Centaurs have survived into modern fantasy literature, including C. S. Lewis's *Chronicles of Narnia* and Eoin Colfer's adventures of Artemis Fowl.

Tasked with Nikesh's equine metamorphosis are animation supervisor Eric Guaglione and a team from Framestore that has previously worked on such Disney movies as *Beauty and the Beast*, *Christopher Robin*, and *Mary Poppins Returns*. "We came onto the project at a very early stage," recalls Eric, "so we've had time to consider Foaly's character, how he thinks and acts, and how all that translates into the way we design his physicality—the way in which the proportions and the mechanics of a horse might fit together with his human body."

Having read the script and the original book to get an understanding of what the author had in mind, Eric and his colleagues began a discussion with the director and actor, and an approach to Foaly's look began to emerge. "Nikesh," says Eric, "has a wonderful physique that's well suited to the broad-shouldered centaur type of the myths, and that helped us in shaping Foaly's appearance. But he also has a great take on the character as a quirky, millennial computer master; so, rather than thinking of Foaly in the classic image of a somewhat stern, adult horse with a human body, we're aiming to take the idea of a centaur in a completely different direction. This centaur is young, smart, spry, and playful." The clue, perhaps, is in his name: not so much a horse as a *foal*.

A pensive Foaly (Nikesh Patel) in L.E.P. headquarters.

It's easy to talk about turning a man into a man-horse, but just how do you set about *doing* that? To begin with, you have to help the actor be aware of the horsiness that will be part of him in the finished film. "Nikesh wore 'kangaroo boots,'" says Eric, "to raise him up and give him some bounce. We also gave him an extension to his backside that sticks out to the full length of what would be his horse body. The purpose was partly as a visual aid for us as effects artists but also as a reminder to Nikesh that he has a physicality beyond his own body and that he can't move and turn around in his human form in quite the same way as he would with a second set of legs behind him! Rather than these restrictions hindering Nikesh's acting, they have aided and enhanced his performance."

4

> "Artemis is just an ordinary boy with an ordinary family who just happens to have a **lighthouse** in the garden!"
>
> —Jim Clay, production designer

Chapter 5

Production designer Jim Clay describes his challenge when beginning work on a film: "I start my working process with two things: a one-hundred-page script dense with words and an empty sketch pad. And somehow I have to translate all those words into drawings on those blank sheets of paper."

Eoin Colfer understands Jim's dilemma. "When I write a book," he says, "the relationship between me as author and the reader only exists in our heads; whatever I see in my mind's eye when I'm writing isn't necessarily how a reader will picture it, and at no point are either of our visualizations ever a reality. So, to walk into Fowl Manor, a place I invented in a tiny spare bedroom twenty years ago, and find it is now in the real world is mind-blowing!"

A two-time BAFTA winner, Jim is responsible for designing several iconic films, including Neil Jordan's *The Crying Game*, John Madden's *Captain*

Corelli's Mandolin, and Alfonso Cuarón's Oscar-nominated *Children of Men*. Before beginning work on *Artemis Fowl*, he was responsible for the sumptuous designs for Kenneth Branagh's version of *Murder on the Orient Express*.

Hamish McColl, who worked with Jim on *Johnny English Reborn*, is full of admiration for the designer. "His contribution is always without parallel, creating the most amazing excitement on screen through his work. Jim Clay is a master of his craft."

Jim was familiar with the Artemis Fowl books long before hearing about the film. "My son was an avid reader of the series as it was being published," he says. "I read some of them with him and I remember thinking at the time, 'This would make a really amazing movie!'" Little did he know that, a decade and a half later, he would be facing the daunting task of helping bring Artemis's world to the screen.

Overleaf: Concept art of Fowl Manor

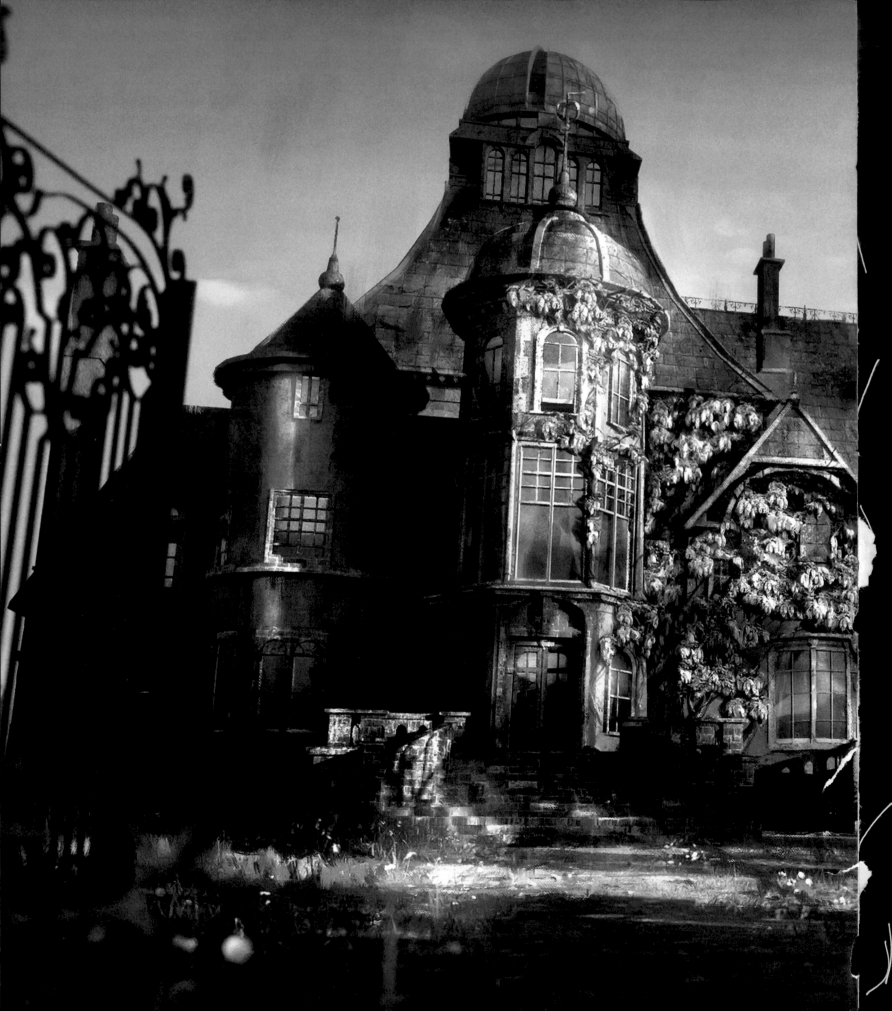

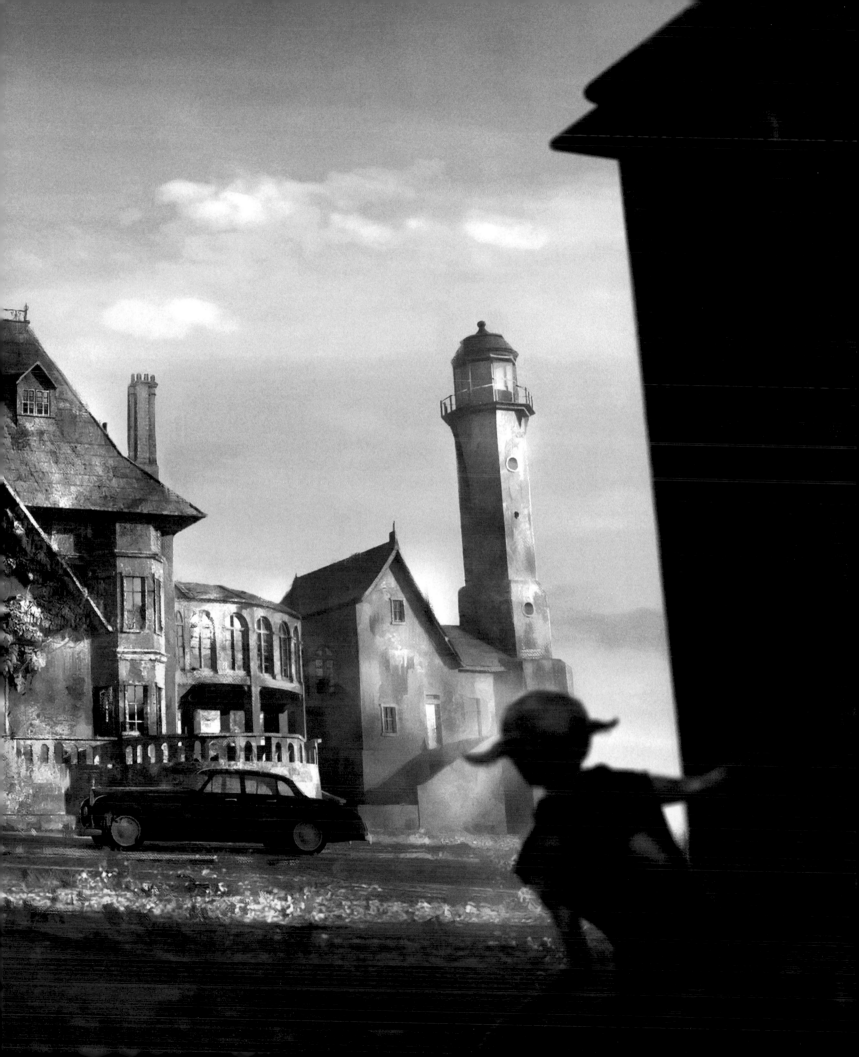

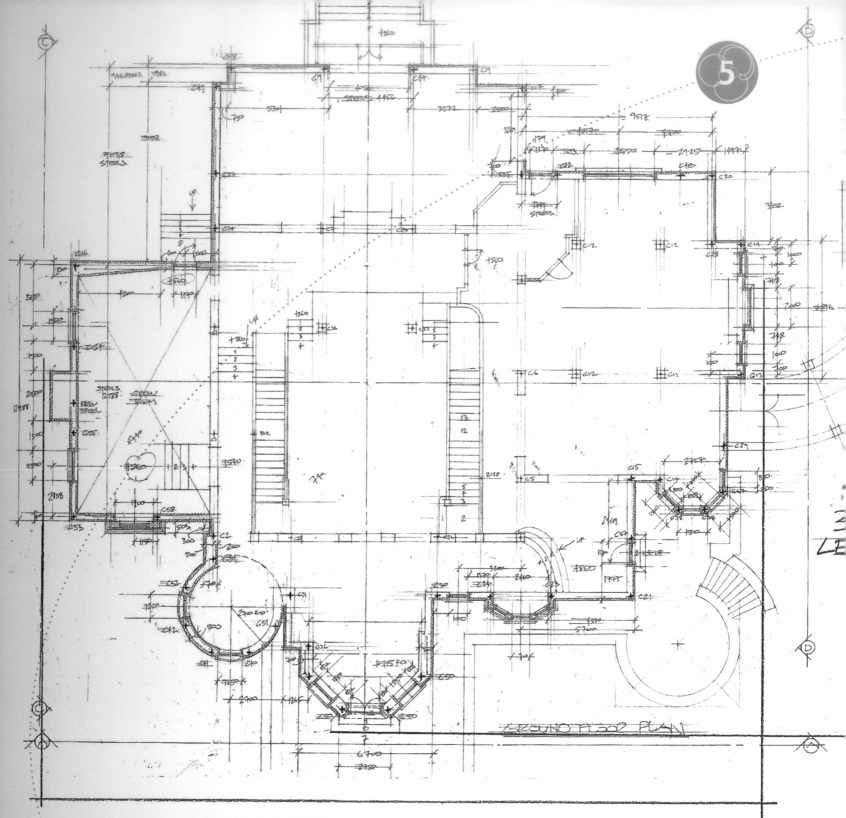

Architectural plans for Fowl Manor (above) and the final design for the building's facade (opposite).

The first design priority was Fowl Manor, where a high proportion of the film takes place. "The challenge," says Jim, "was to create a house that would provide plenty of interesting screen time and accommodate all the action sequences involving stunts and visual effects—including a rampaging fourteen-foot-high troll creating havoc!"

Jim describes the creative brief for Fowl Manor: "It has to be in rural Ireland; it must be

historic, eclectic, and contain elements that relate to the story of the Fowl family. It shouldn't be too gothic or scary, but a warm family home that is also a bit weird! We wanted the setting to reflect the fact that Artemis was a normal boy—or as normal as a boy can be with a lighthouse in his garden!"

The initial plan was to find a suitable house to represent Fowl Manor, where exterior shots of the house could be filmed, while the interiors would be constructed as a series of traditional studio sets. While scouting locations in Ireland, Kenneth fell under the spell of the country's beautiful and often dramatic landscape. "We spent a lot of time on the coast of Ireland," he recalls. "What you feel there is a powerful sense of place, steeped in ancient myth and lore and legend, rich in possibilities. I wanted to use the massive, epic scale of that landscape as Fowl Manor's environment."

Having decided that the house was to be located on a cliff top, the quest to find a suitable building to stand in for Fowl Manor was abandoned in favor of a far more ambitious proposal, as Jim explains: "We decided, instead, to build the whole house, for real—inside and out—as a single vast, totally accessible set that could then be digitally located onto the Irish coastline."

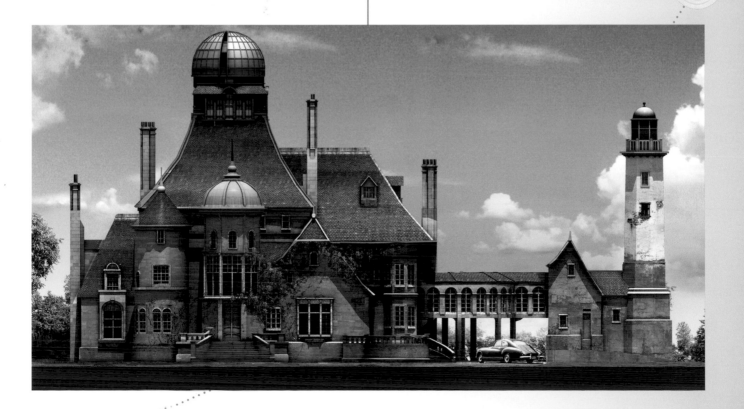

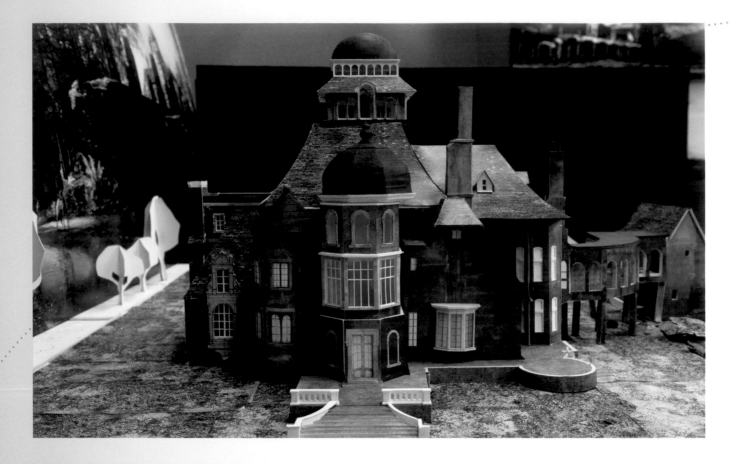

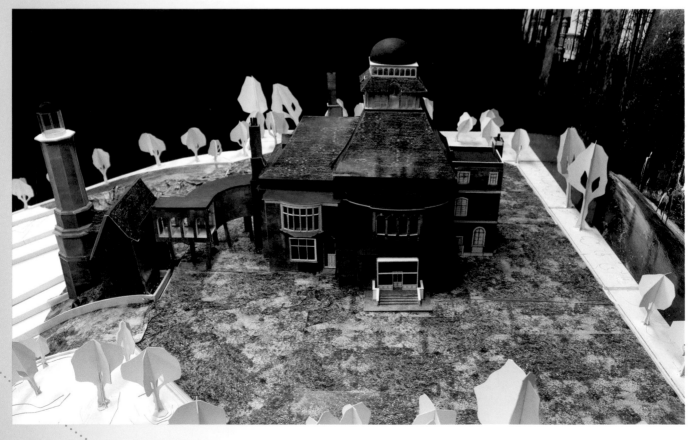

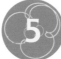
This decision also played to the director's strengths: "Ken's shooting style," says Jim, "is very fluid; he likes to have the freedom to film shots that pass through doors and windows, from exterior to interior and from room to room."

As Kenneth expresses it: "Having a real house meant that we could stage scenes that went from five hundred yards outside the front door and traveled with people as they walked in through the front door, up the stairs, and into one of the bedrooms. Also, in a film that would deal largely with magic, deception, special powers, and supernatural elements, to root the environmental experience of the characters and the audience in something so three-dimensionally real seemed like a great place to start."

There was, as he goes on to explain, a very particular benefit from having this unique, outside-and-inside Fowl Manor location: "It's always good, in making a film like this, to maintain one's sense of wonder while working on it, and the very fact of a spectacularly large, detailed, well-built house full of surprises, set in an environment around which we could continually work, really transported me every time I arrived on set—or, as I should say, *every time I arrived at Fowl Manor*!"

Opposite: Scale models, created prior to building the sets, present views of the front and rear of Fowl Manor.

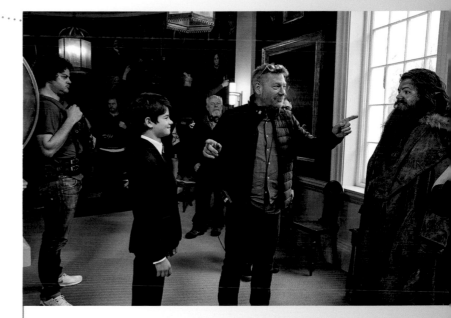

Kenneth Branagh with Ferdia Shaw (Artemis) and Josh Gad (Mulch Diggums) inside Fowl Manor.

This was one of the most ambitious, imaginative, and exciting production decisions to have been embarked on in recent filmmaking—and one that will, unquestionably, impact the look of the film and the response of audiences. The decision was made possible by the fact that the film was to be shot at Longcross Film Studios in Surrey in South East England. Although not as well-known as some other British studios, several notable films have been made at Longcross, including *Skyfall*, *Hugo*, *War Horse*, and Disney's *John Carter*.

Once an important Ministry of Defense site, Longcross is fortunate in having not just four main soundstages and numerous workshop, office, and canteen facilities but also a two-hundred-acre back lot, including extensive woodland and a one-time landscaped golf course that offered potential locations for the construction of Fowl Manor.

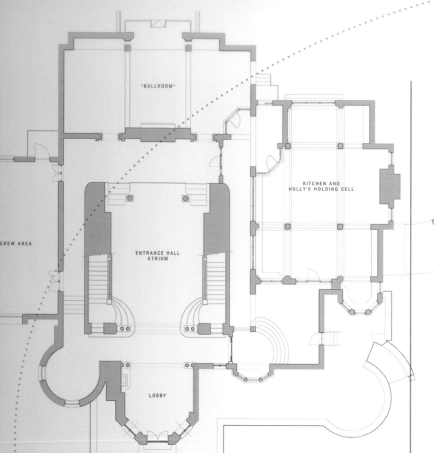

Architectural plans of Fowl Manor's ground floor.

An architect by training, Jim began—as he puts it—"loosely sketching" possible looks for the exterior of the building and drawing up a floor plan detailing the rooms featured in the script and their relationship to one another. "Fortunately," says Jim, "Ken can read a plan—not something every director can do—so he was not only able to visualize walking through the completed building, but immediately began planning his shots."

Those early pencil sketches were followed by more detailed sketching, sometimes with water-color added, before a talented team of concept artists worked up the initial ideas into elaborate treatments, depicting the settings with greater visual precision. On every big movie there are a lot of people who have input into how the film is going to look, but once the director and produc-ers have approved the concepts, the design team creates three-dimensional models of the sets and detailed construction plans.

Through discussion between director and designer, an eclectic style began to emerge for Fowl Manor, as Jim explains: "We wanted to convey a sense of the long history of Artemis's family. So, we borrowed architectural features and influences from a variety of countries that might reflect the Fowl family's travels throughout Europe from the eighteenth century to the present day. It's a big house, but we didn't want it to feel ridicu-lously privileged. Ken described it wonderfully as a house that is rich with ideas rather than rich with possessions."

The conception of Fowl Manor, says Jim, just kept on developing: "Having located the house on a cliff, next came the idea of having a lighthouse alongside, which then meant that we needed a boathouse and a harbor below and, after that, it became an island with a bridge connecting it to the mainland."

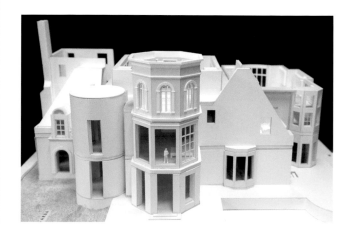

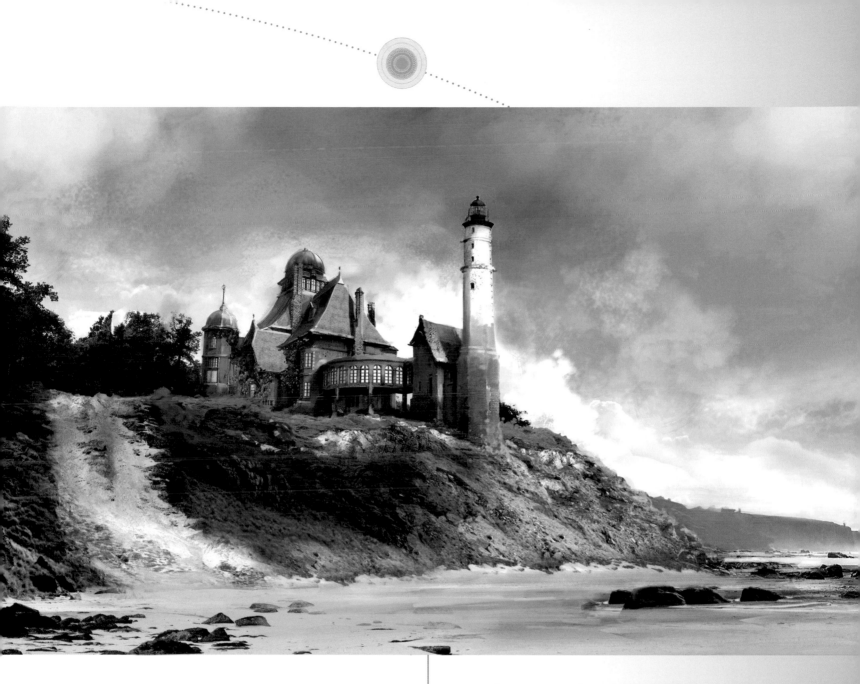

Cutaway models of various parts of Fowl Manor
and a color rendering of how the house would
look within its location on the Irish coast.

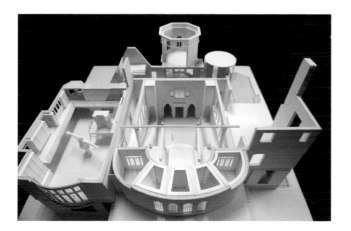

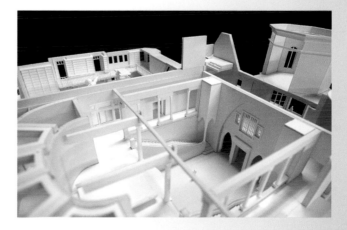

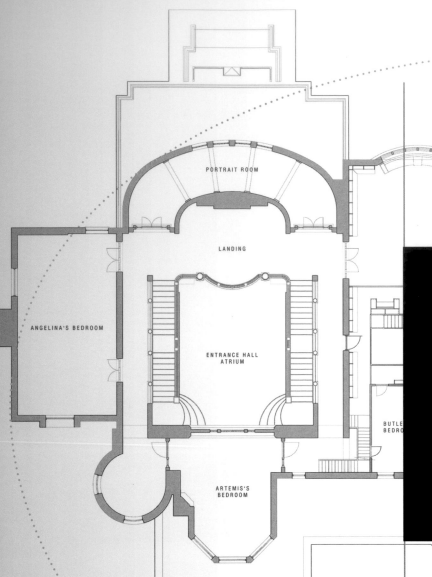

PORTRAIT ROOM

LANDING

ANGELINA'S BEDROOM

ENTRANCE HALL ATRIUM

BUTLER'S BEDRO[OM]

ARTEMIS'S BEDROOM

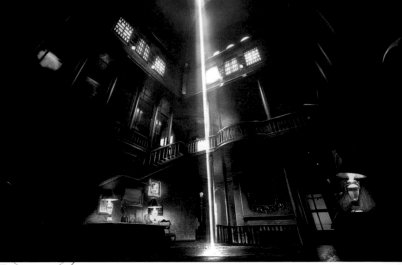

Plan of the upper floor of
Fowl Manor and a view of
the entrance hall atrium.

The interior of Fowl Manor was dictated by the action that takes place within its walls. The script called for various rooms on the ground and upper floors: an entrance hall, ballroom, and a kitchen-cum-living room downstairs, with a portrait room, library, and bedrooms upstairs. "I began," says Jim, "by creating a central atrium with a staircase to the upper story and a huge chandelier that figures prominently in the story. Around that space, we wrapped the other rooms, linked geographically, enabling the characters— and the camera crew—to move effortlessly from one interior to another."

The hub of Fowl Manor is the library: former-ly the study of Artemis's father and, following his disappearance, the place where his son begins masterminding a rescue operation. Nearby are the bedrooms of Artemis and his mother, Angeline. Originally, there was a scene set in Butler's bedroom, but when the action was later relocated to the library, there was no longer any need for a third bedroom. "It's a huge mansion," says Jim, laughing, "and the crew always joke that it's the biggest house they know with only two bedrooms!"

5

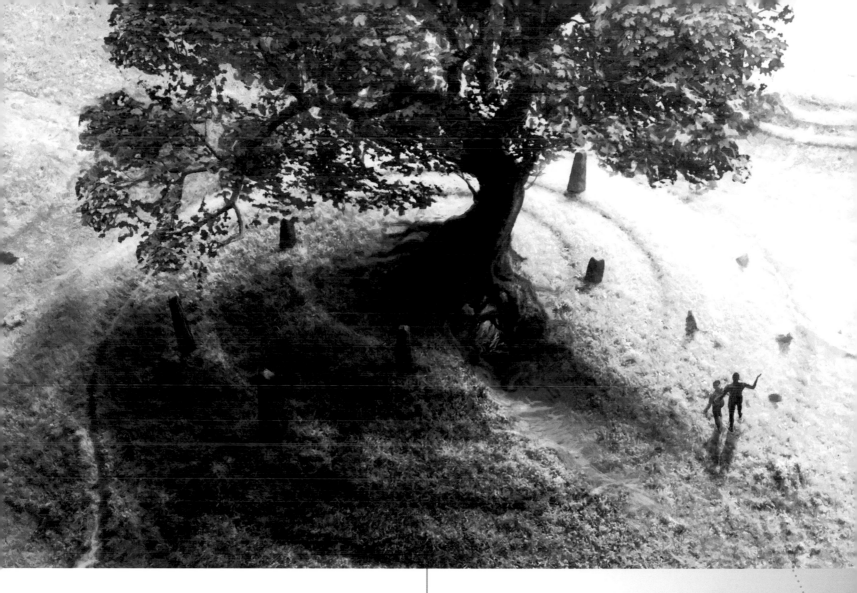

A concept artist's impression of the fairy oak and the ancient standing stones at the Hill of Tara.

Among the remnants of Longcross Film Studios' earlier incarnation as a military base are tank ramps, huge concrete slopes once used for testing army tanks that lead up to a large parking area surrounded by trees. As Jim explains, "This is the area we used to raise our house up onto a cliff, then we turned the tank ramps into sand dunes and created a beach below." The former golf course provided a location for the Hill of Tara that, as Artemis discovers, is a fairy fort and the portal to Haven City and the fairies' underground kingdom.

Another advantage of being able to create Fowl Manor and the surrounding landscape was that it became possible to build the ring of ancient, megalithic standing stones that is visible from the window of Artemis's bedroom. "The idea," says Jim, "was that Artemis would awake every morning to look out at these silent sentinels and, so, always be reminded of just how surrounded he is by the history of Ireland."

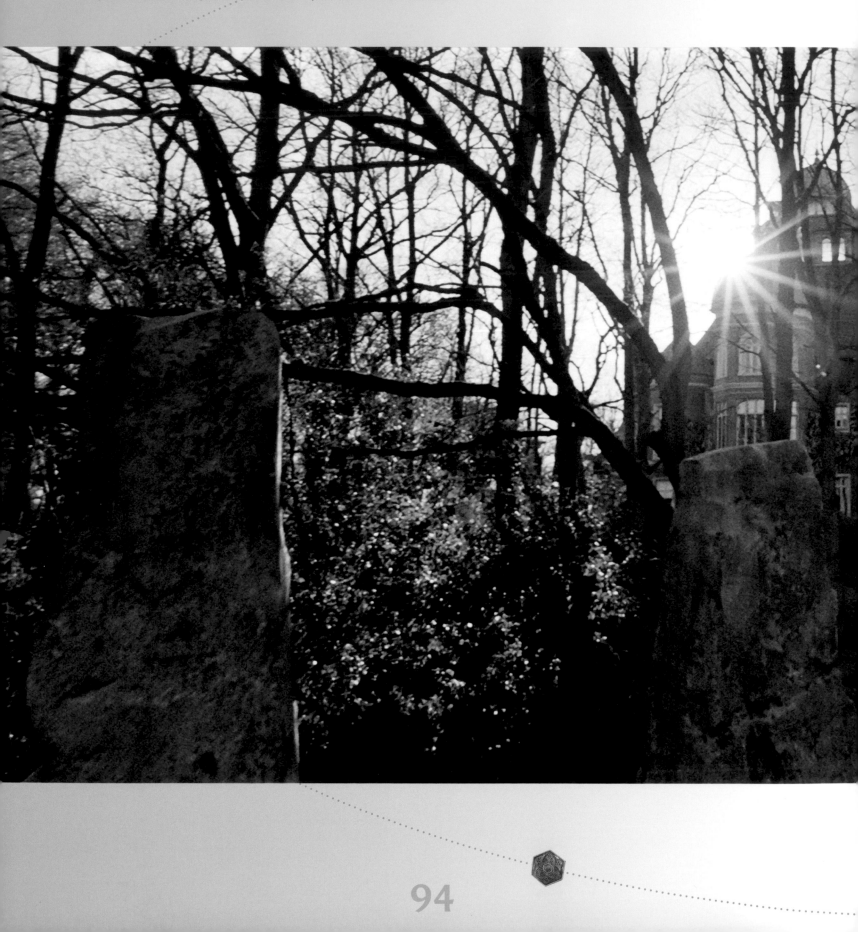

Previous pages: Artemis using the mysterious carvings on the standing stones to decipher the coded message hidden on his father's postcards sent from his travels.

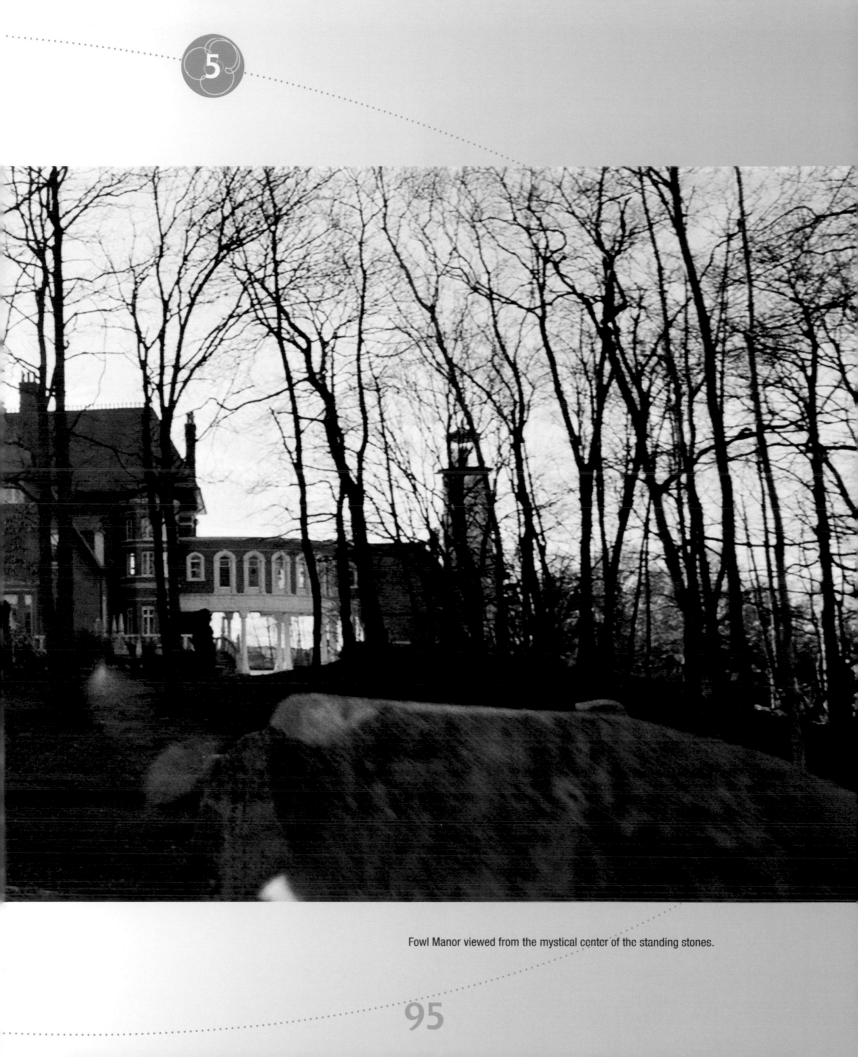

Fowl Manor viewed from the mystical center of the standing stones.

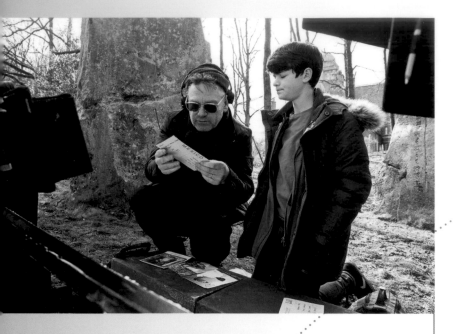

Director Kenneth Branagh
with Ferdia Shaw.

Unlike most movie sets, Fowl Manor has been
built to last beyond the end of filming. However,
since the script calls for the house to be attacked
by a troll that runs amok, ransacking and ravaging
the building, that sequence impacted the con-
struction process, as Jim explains: "Through
detailed discussions with colleagues responsible
for special and visual effects and stunts, we careful-
ly worked out a detailed plan of events where we
knew, in advance, what columns would need to be
removed, what walls and fireplaces would be
smashed through, at what spot on the library floor
the troll would thrust his head through, and which
bookshelves would fall down. Bit by bit we arrived
at a choreographic picture of all the elements that
would be destroyed which would need to be
replaced with breakaway parts." Jim pauses and
then adds, "And, after we had filmed the attack, we
had to be able to put it all back together again as
good as new."

So on February 12, 2018, construction finally
began on what was effectively a real house: a steel
structure, clad with timber and plaster rendering,
within which was a multiroomed soundstage
accommodating state-of-the-art lighting rigs and
everything—hoists, pulleys, and flying equipment—
needed to achieve the kind of physical effects
required by a story where a house is held under
siege by fairies and invaded by a troll! Just four
and a half months later, the imposing edifice that
is Fowl Manor—118 feet long by 123 feet wide and
standing 100 feet high (plus a 72-foot-high light-
house)—had been built and was ready to be
occupied.

Standing in his office at Longcross Studios,
Jim looks out to where the imposing edifice of the
Fowl family home sits on a tree-crowned hill,
dominating the vista seen from his window. "I'm
immensely proud," he says, "of all the different
departments and, especially, the construction
department, who succeeded in creating that
building completely from scratch. It is an incredi-
ble achievement: a house that's heated, insulated,
fully soundproofed, and has running water and
Wi-Fi! How fantastic is that? A film set—and a
real home!"

From Surrey to Ireland:

RELOCATING FOWL MANOR

Having created the magnificent Fowl Manor set, the challenge was then to relocate the physical building erected at Longcross Film Studios in the leafy English county of Surrey to an impressive cliff-top location on the Atlantic coast of Ireland.

Enter Charley Henley, visual effects supervisor, and his team. Charley comes with a vast wealth of experience gained from working on various aspects of classic fantasy films, among them four Harry Potters and two Chronicles of Narnia. His credits for supervising visual effects include *Total Recall* (2012), *300: Rise of an Empire*, and Ridley Scott's *Prometheus* and *Alien: Covenant*, as well as Disney's live-action *Cinderella* and *The Jungle Book*.

Much of the work on a film that heavy with special effects is done long after the final shots of film are in the can, but from the outset, preparation is the key. In the case of *Artemis Fowl*, as Charley explains, that involves making use of the latest cutting-edge technology: "We use a combination of gaming graphics technology and augmented reality tools to create digital sets and characters so we can envisage complex movie scenes on multiple platforms, including tablets and virtual reality headsets, before filming even begins. With this technology we also created a digital previsualization—known as 'previs'—of the house so as to figure a way to 'move' a house built in Surrey to the Irish seacoast and how the action inside the house would work with activity outside, such as the fairies' troops' arrival on the beach below and their siege of Fowl Manor."

Donning such a headset, director Kenneth Branagh was able to move around the interior of the virtual manor and plan his shots for the high moments of drama, such as the troll fight and interaction with Root's forces that would later require the addition of many special effects.

Charley describes the work of the visual effects department as "world building" and points out that two-thirds of *Artemis Fowl* features special effects created from scratch, often without any "real-life" reference to work from. "There's Fowl Manor house built on the edge of a cliff by the sea where there wasn't a cliff or the sea," says Charley, "a fully digital troll, flying fairies, countless squadrons of L.E.P. troops and their crafts, the fairy underworld of Haven City, as well as all sort of magical effects—in fact, pretty much one of everything from the visual effects sweet trolley!"

Chapter 6

"Welcome to Haven City!" says Kenneth Branagh, standing on stage one at Longcross Film Studios. "As you can see from the sign—written in both English and the fairies' Gnommish language—this is the headquarters of L.E.P.recon, the Lower Elements Police Reconnaissance. We're just a stone's throw from Fowl Manor, but a whole world away."

The journey to Artemis's eventual discovery of Haven City begins when he learns from *The Booke of the People* the significance of the ancient magical oak standing on the Hill of Tara, close to Fowl Manor. As he and Butler lower a "parabolic microphone sensitive to three hundred meters" into a hollow of the tree, we—the film audience—meet Captain Holly Short and begin our exploration of her world. Speaking of this sequence, screenwriter Hamish McColl says, "The child in me still loves that moment as we suddenly see Haven City opening up in front of our eyes and we get our first glimpse of this extraordinary place and the busy, crowded working culture that is there."

The Haven City set is another creation by production designer Jim Clay. "What's been so thrilling about working on *Artemis Fowl*," he says, "has been the opportunity to create two amazing worlds: Fowl Manor set in a rural Irish landscape and then, going deep underground, a realm that is unlike any previous depiction of a fairy kingdom." This is a world first described by author Eoin Colfer and then visualized for the screen by Kenneth.

Sketching in the history of Haven City, Eoin explains: "This is where the last of the fairy families fled after the final, great battle with the humans, which, it is said, took place in Ireland ten thousand years ago. The fairies decided that the only way they were going to survive was to escape underground and live deep down beneath the Earth's mantle. Using their dwarfs to dig and tunnel, that is what they did. At first it was just a small settlement, but as their technology grew, so did the place itself until it became a vast underground city."

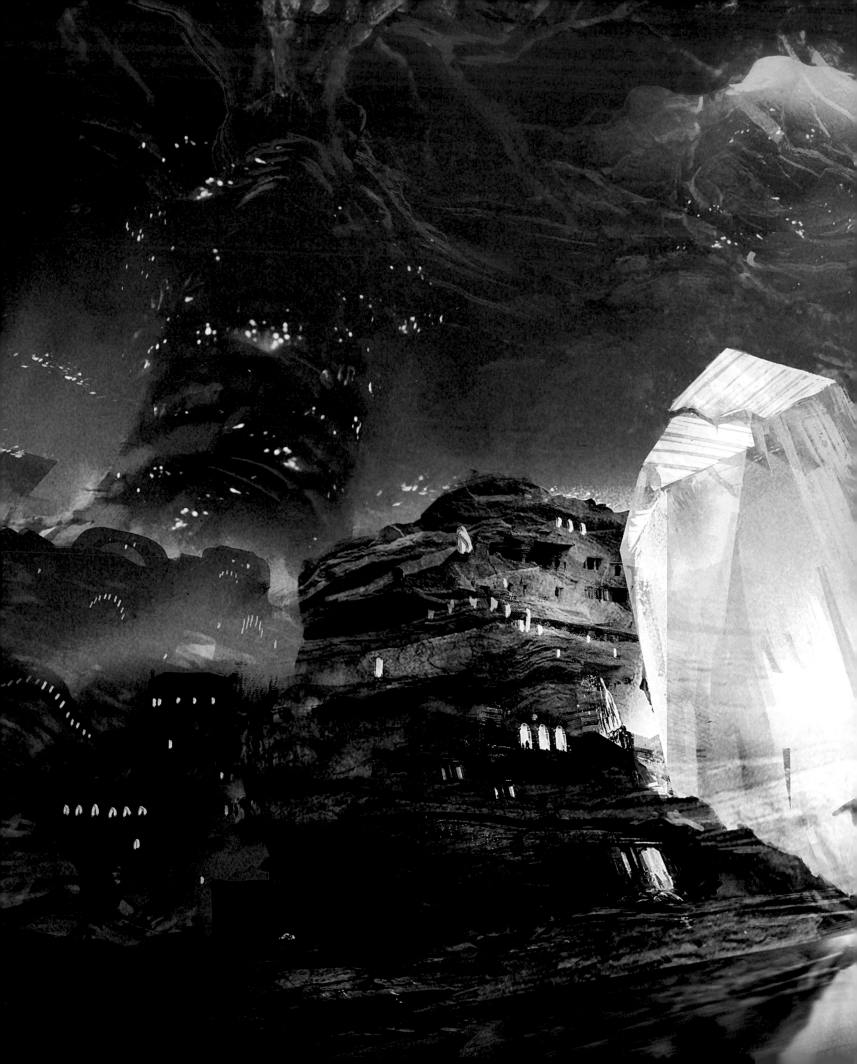

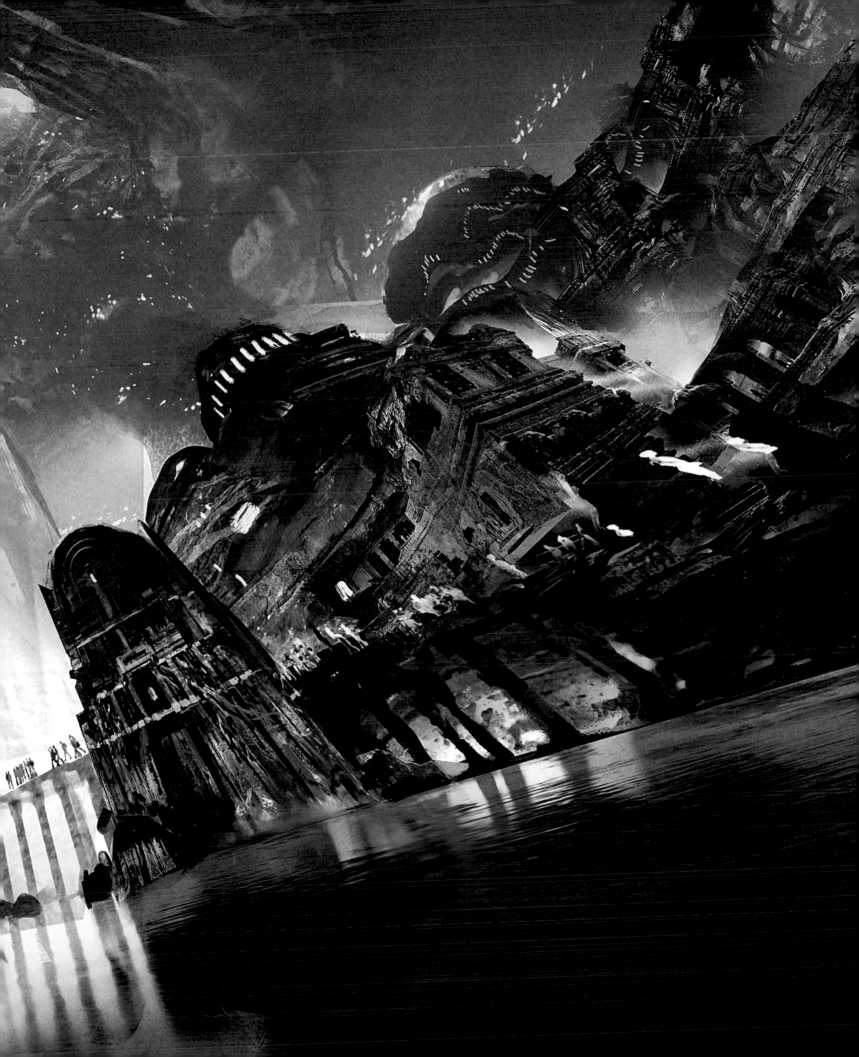

Concept art (previous pages) and a finished film rendering (below) featuring the magnificent natural structures that characterize the underground landscape of Haven City.

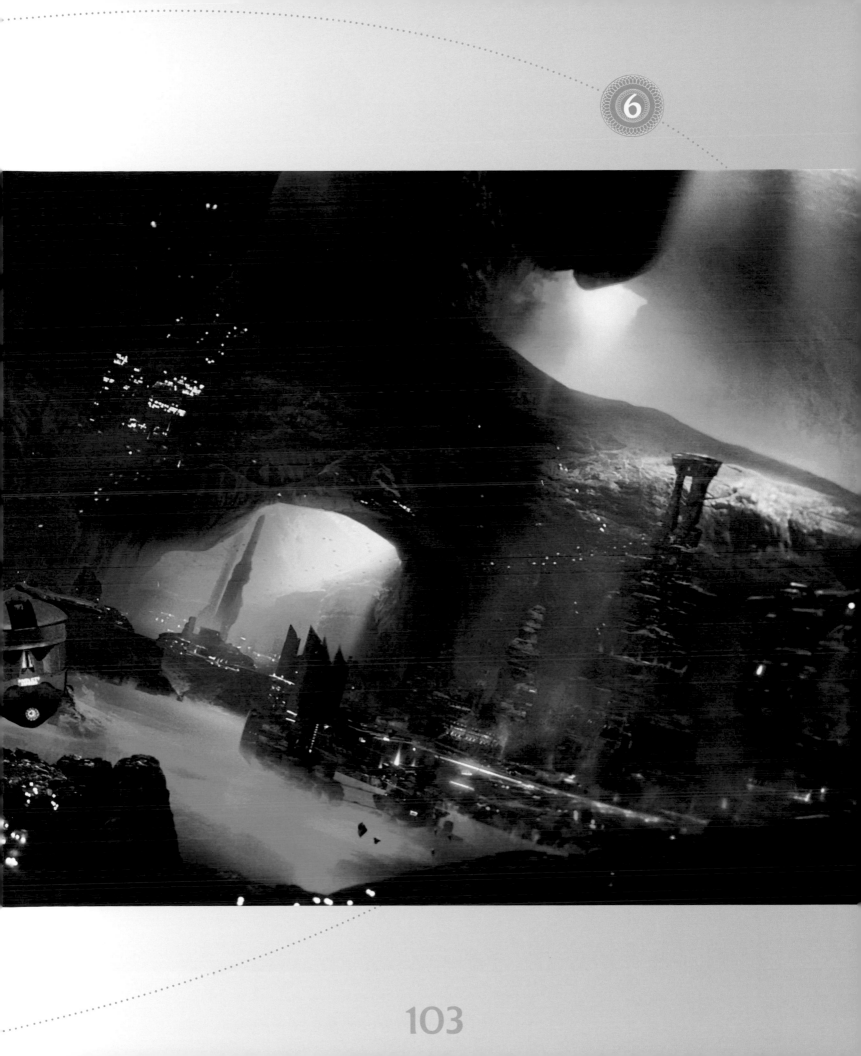

Discussions about the look of Haven City began on the island of Malta, where director and designer were filming *Murder on the Orient Express*. Jim recalls, "The first phrase Ken came up with to describe Haven City was 'a wacky Shangri-la,' and that began a conversation about upside-down worlds and what it might be like to have a deep-ocean environment without any water."

The chief design decision emerging from these discussions was that Haven City should be a setting that intrinsically drew its inspiration from nature, as Kenneth explains: "We began by thinking about earth, stone, and all the materials you might find underground—organic structures and natural forms, such as mushrooms and tree roots growing downwards in the shape of inverted trees. Over the years, with erosion and precipitation, these elemental forms have become quite sculptural in appearance and have then been further transformed by fairy technology into dwellings and means of energy and communication far in advance of current human thinking."

Artistic visualisations of the L.E.P. headquarters building in Haven City.

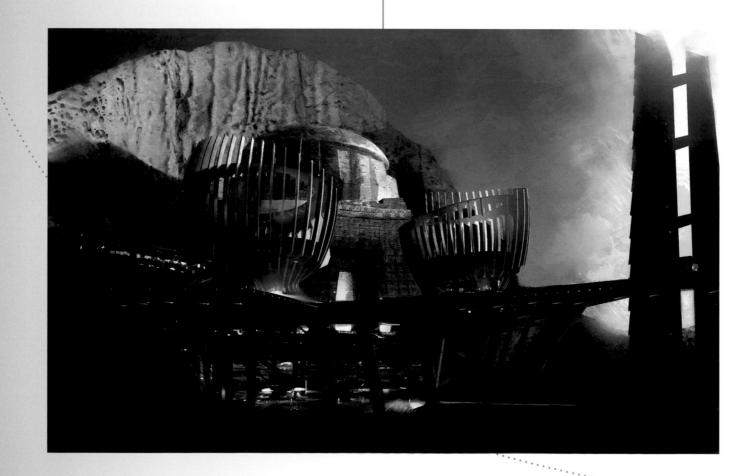

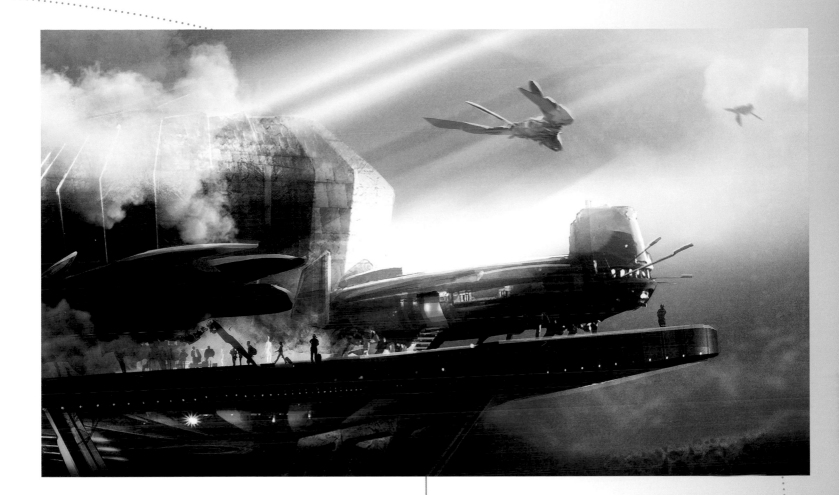

At an early stage of development, Kenneth involved visual effects supervisor Charley Henley, as Jim explains: "It's always important to create a set where actors feel they are in a space where their characters belong, but it is also important to know how much of a set can be physically constructed. Charley was a vital part of this creative process from the outset as we figured out what elements of Haven City we would need to build and how much could be created digitally during postproduction."

A further consideration was how the absence of natural light would impact the look of Haven City. Kenneth reflects, "The fact that the population of Haven City live in a kind of permanent twilight presented a major challenge for our director of photography, Haris Zambarloukos." There were intense consultations to determine how lighting the underground world would impact the color palette used to realize the environment. "We did a lot of research," recalls Jim, "looking at a wide range of colors and textures in a variety of materials, from ceramics to the corals found in tropical oceans."

Overleaf: Cavernous spaces and massive subterranean rock structures dominate the fairy kingdom.

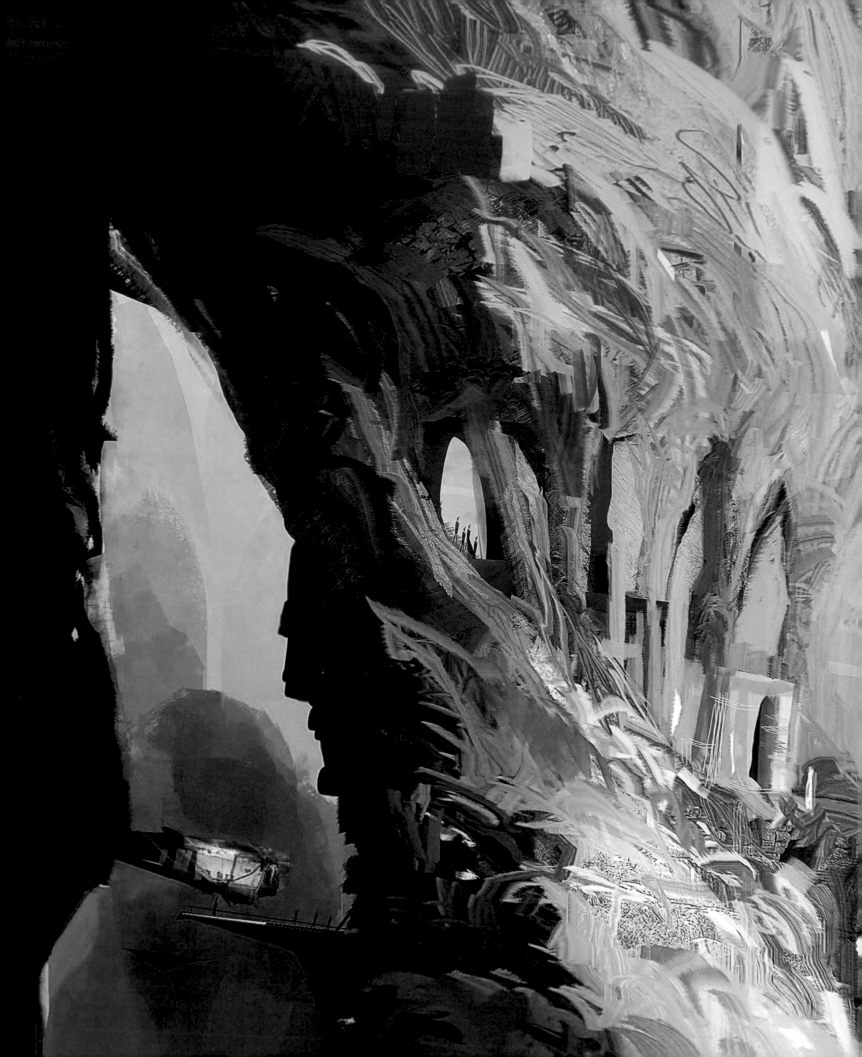

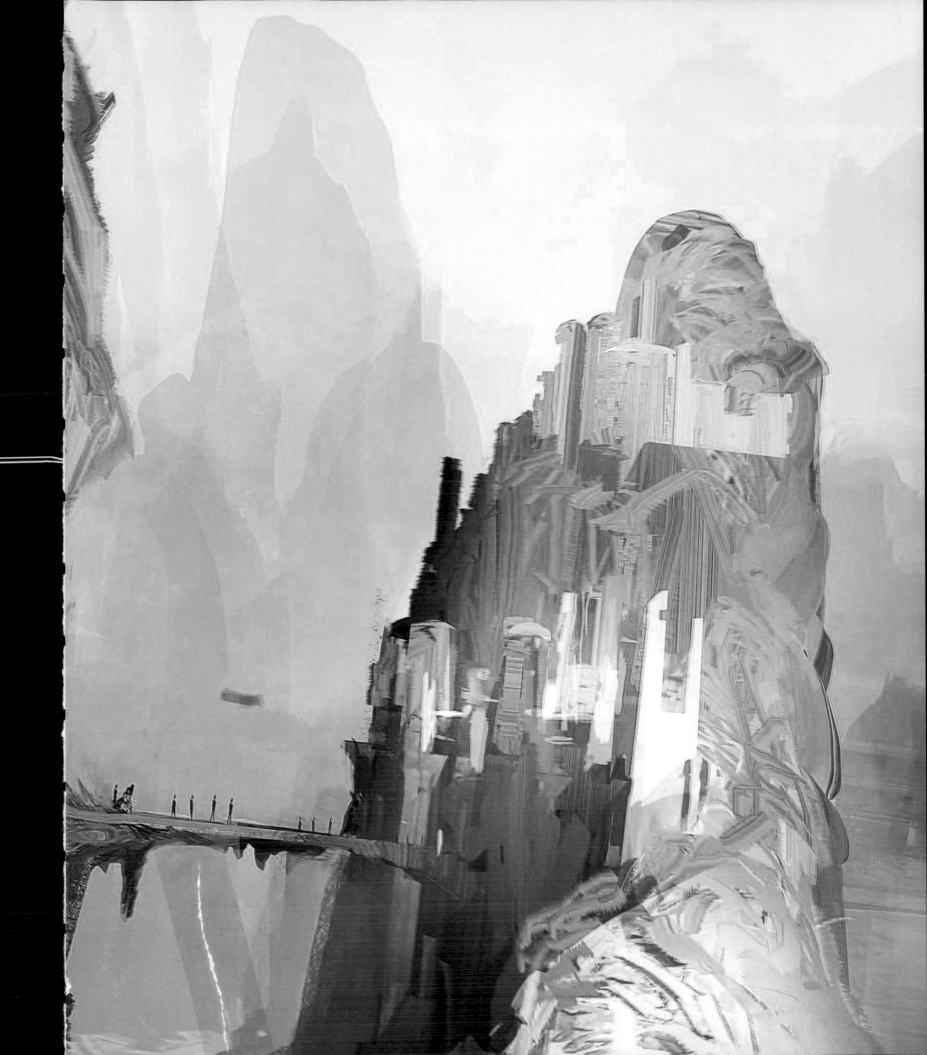

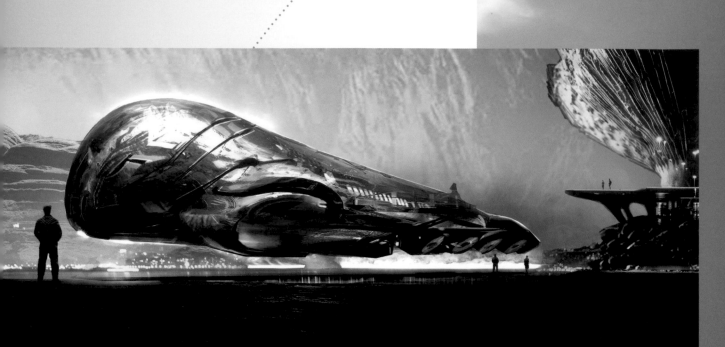

Organic forms such as fungi and corals inspired the landscapes of Haven City, while the fairies' vehicles combine technology with inspiration from the animal kingdom.

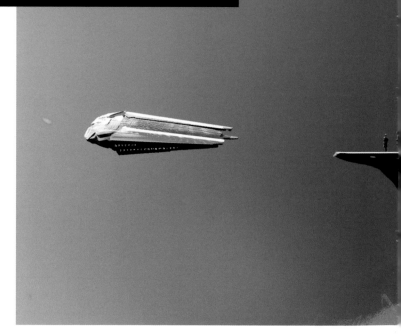

Also explored was the Japanese concept of *wabi-sabi*, an aesthetic appreciation of life based on the acceptance that nothing is perfect, nothing is finished, and nothing lasts, and—from that understanding—learning to accept that beauty can be found in imperfection. "That way of looking at the world," says Jim, "caught our imagination, and after that, the concept of Haven City really came together as a combination of natural materials and appreciation of the fact that a special kind of beauty can be found in the process of aging, deterioration, and decay."

Further consultation, this time with special effects supervisor Dave Watkins, focused on the special effects requirements for the fairies' transport systems, such as the titanium pods invented by L.E.P.recon's technical guru, Foaly, that use naturally occurring magma flares as a fast, efficient—but somewhat perilous—way for fairies to

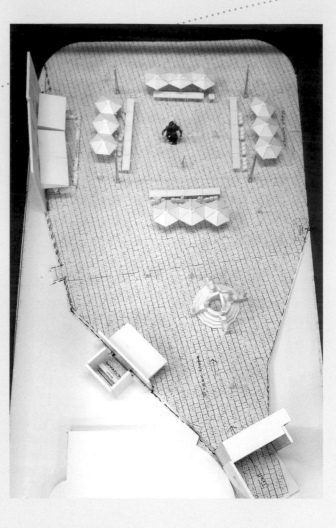

Models for the Italian piazza and restaurant where Holly Short confronts the rampaging troll.

A very different location features in scenes in which L.E.P.recon's Captain Holly Short is given the task of monitoring the activities of an enormous troll (as Foaly puts it, "Very dumb, very angry, always hungry") who has managed to find its way to the surface and is lumbering toward a sleepy hilltop village in northern Italy.

Jim Clay, production designer on *Artemis Fowl*, knew the ideal location for that setting: the walled, medieval town of San Gimignano, which is perched on one of Tuscany's many hills. San Gimignano is romantically known as the "Town of Fine Towers" from the fact that it is crowned by fourteen massive, square stone towers of varying heights, the tallest of which rises to a staggering 177 feet.

Jim had fallen under the spell of San Gimignano in 1989 when he filmed in the city for *Queen of Hearts*, his first movie as production designer. The city has also featured in Franco Zeffirelli's films *Brother Sun, Sister Moon* and *Tea with Mussolini*, and the legendary towers suggested a perfect setting for Holly's reconnaissance flight and the troll attack. However, the city's reputation as a popular tourist destination and the challenge of filming with cranes in steep, narrow streets was too daunting. Hence, the buildings of San Gimignano were scanned to provide a digital extension to the studio set constructed for this Italian interlude.

San Gimignano, Italy.

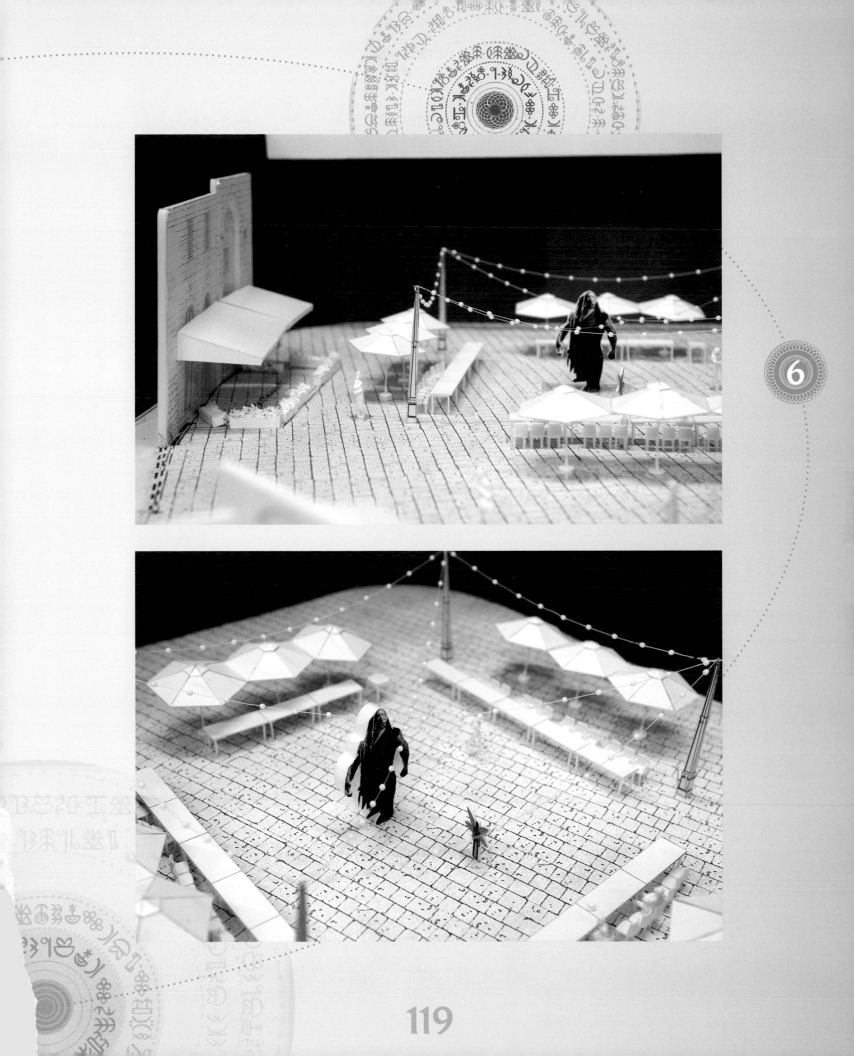

Chapter 7

"In making a movie, there are many collaborators, but for the production designer, a major collaborator is *always* the set decorator," says production designer Jim Clay of his collaboration with Celia Bobak on *Artemis Fowl*. "It was Celia and her team that gave real personality to Fowl Manor and to the people who live there."

Celia, a two-time Oscar nominee (*The Phantom of the Opera* and *The Martian*), is passionate about her work of tracking down the myriad items needed to convincingly transform a movie set into a place where the characters can live out the story being told in the film.

It is an indication of Celia's talent that she received a Primetime Emmy Award from the Academy of Television Arts & Sciences for Outstanding Production Design on the multi-award-winning TV series *The Crown*. Among other productions on which she has worked are Kenneth Branagh's movies *Peter's Friends* and *Sleuth*, as well as his Shakespearean films *Much Ado About Nothing*, *Henry V*, *Hamlet*, and *Love's Labour's Lost*.

"Essentially, it is about trying to keep the eye of the audience focused on and interested in the settings for the story, and you do that by creating **layer upon layer** of the most **intense** detail."

—Celia Bobak, set decorator

8

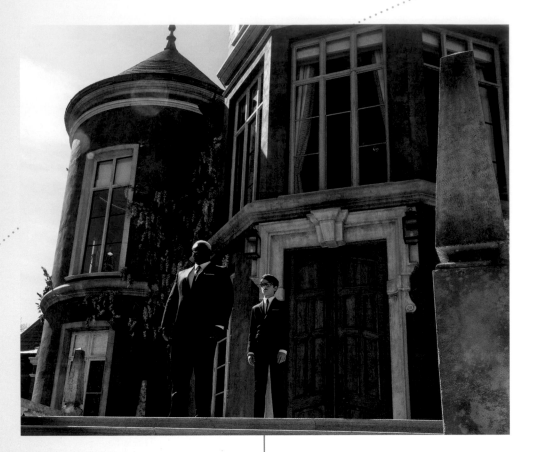

Butler and Artemis stand before the front door of Fowl Manor.

With Celia and Jim as our guides, let's take a tour of Fowl Manor. Mounting the broad steps toward the front door, the visitor is struck by the imposing brick-and-stone, wisteria-robed facade. Above the tall windows, the roof is a riot of chimneys, gables, turrets, and green copper domes.

"You have to understand," says Celia, as we pass through the lobby into the great atrium, "this is a very old house in Ireland—substantially added to in 1870—and, while we have kept the period feel, we've also used modern wallpapers and fabrics to indicate ways in which the family have adapted the house to changing styles and tastes."

On most movie sets the props (or "properties"), furnishings, and fittings may come from a studio's own prop department or be rented for a specific film. Not so in the case of *Artemis Fowl*; with the foreknowledge of the number of books in the series and the possibility that Fowl Manor might, one day, be revisited, Celia had the luxury of buying whatever was needed. The quest took Celia and her assistants to antique shops, fairs, and auctions; the treasure trove of what they acquired is seen everywhere in the house. And where items could not be found they have been custom built by a team of talented craftspeople.

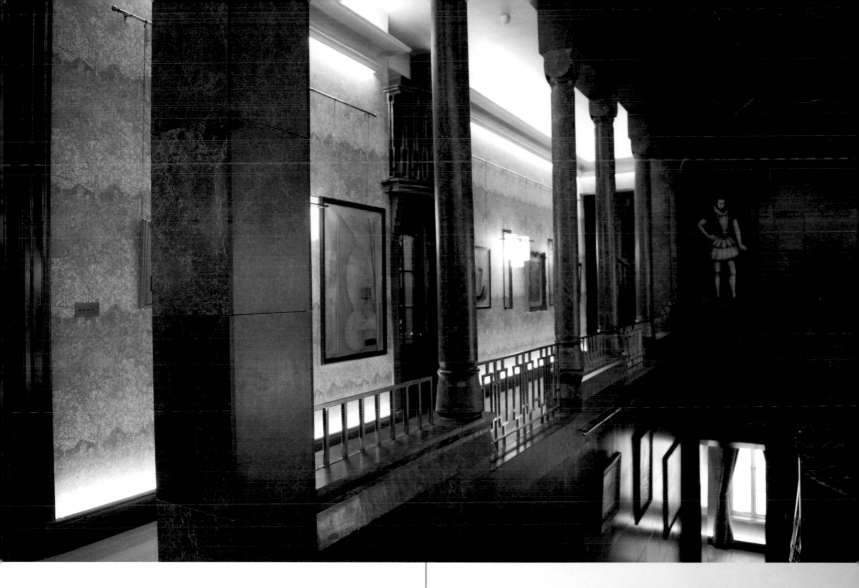

Above: The upper landing in Fowl Manor. Right: The atrium dominated by the huge Frank Lloyd Wright–inspired chandelier.

Dominating the atrium with its geometric-patterned parquet flooring and Indian rugs is a huge chandelier inspired by the much-admired and influential twentieth-century American architect and interior designer Frank Lloyd Wright, who designed a series of cubist light fittings for several of the houses he built. The chandelier, which plays a key role in the film when Fowl Manor is invaded by the troll, is complemented by similarly styled wall lights made in bronzed steel and with parchment shades, creating an evocative atmosphere that is both modern and retro.

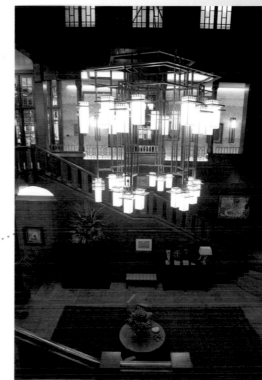

123

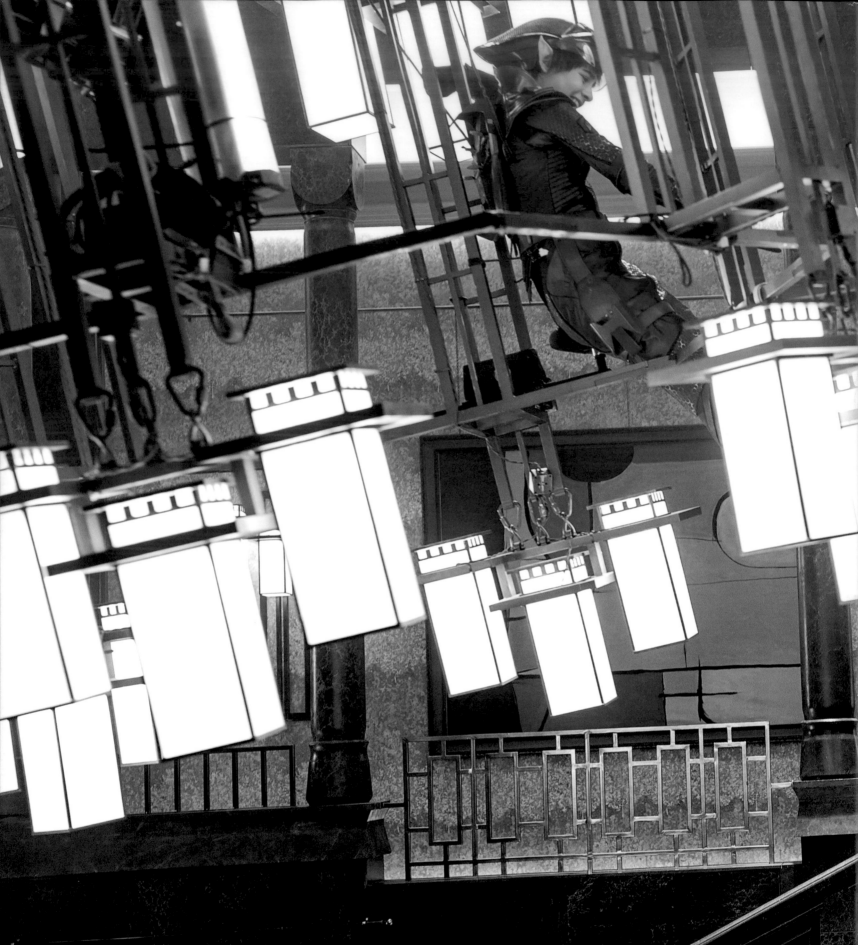

The great chandelier sees some frantic
action when Holly Short and Mulch Diggums
get involved in battling with the troll.

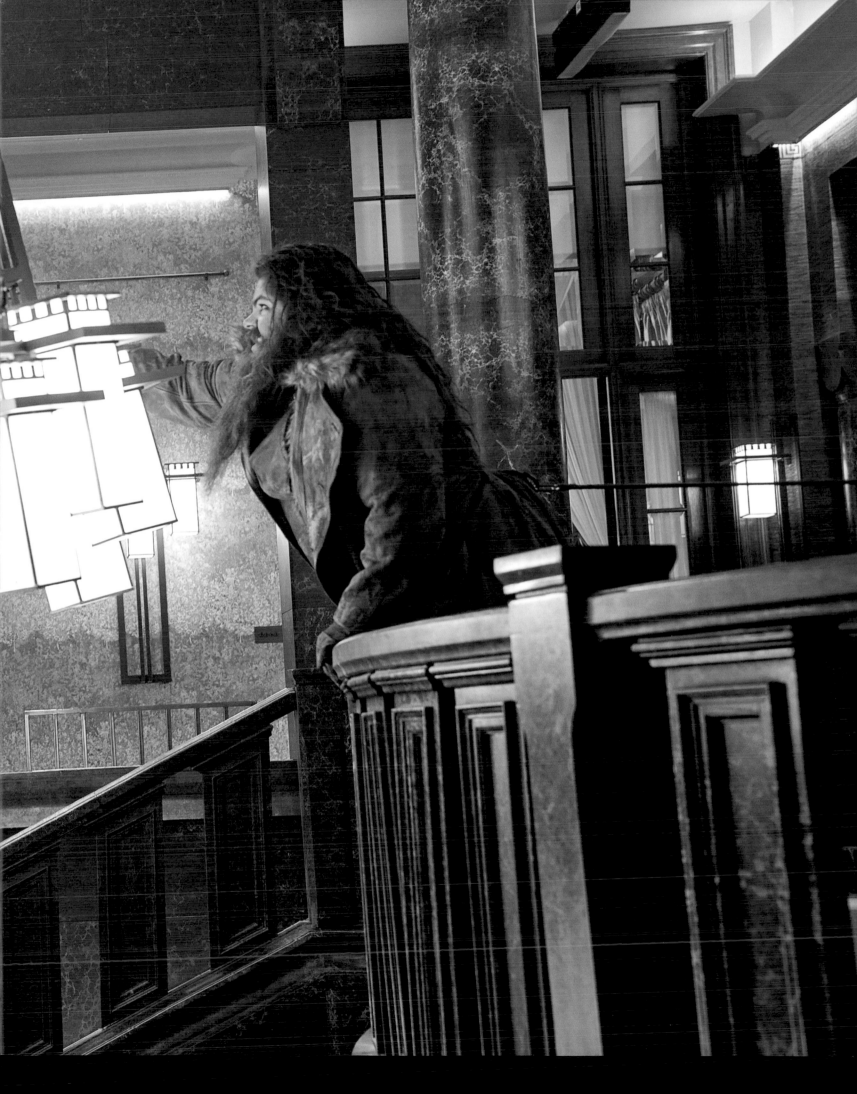

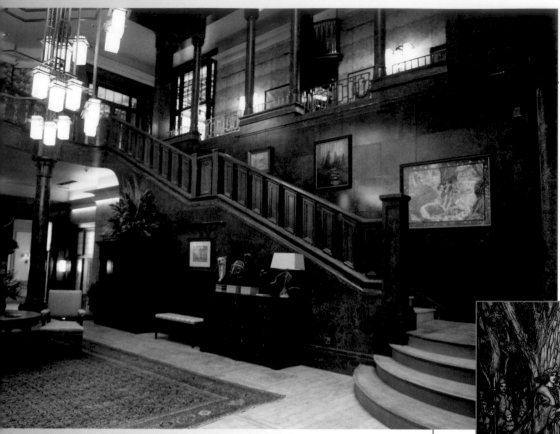

Left: View of the atrium wall in Fowl Manor, with one of the Arthur Rackham–inspired paintings, featuring characters from *A Midsummer Night's Dream*. Below: An illustration by Arthur Rackham for his 1908 edition of *A Midsummer Night's Dream*.

Also featured in the atrium are two large paintings, specially created by the art department to reflect the work of Arthur Rackham, regarded as the leading artist of the golden age of British book illustration. Rackham's best-loved and most widely collected illustrated books included elaborate editions of traditional fairy tales and several plays by Shakespeare. With a nod to Rackham's art and to Kenneth and his long-running connections with the Bard, the paintings depict, on one wall, a scene from *A Midsummer Night's Dream* and, on the other wall, Queen Mab, the sovereign of the fairy world mentioned by Shakespeare in *Romeo and Juliet*.

One of the more eccentric items in the atrium is a magnificent, life-sized figure of a rampaging bull with, built into one side of it, a comfortable sofa for sitting in front of the open fireplace.

The idea came to Jim while on a weekend in Paris: visiting the Musée de la Chasse et de la Nature, a celebration of hunting and nature, Jim discovered many examples of taxidermy and pieces of furniture made in the form of animals. "We had already decided," he says, "that one of the architectural influences on the design of Fowl Manor was the Palau Güell, a mansion in Barcelona designed by the great Spanish architect Antoni Gaudí. That prompted other thoughts of Spain—including bullfighting, which, in turn, led to the idea of the bull sofa. It's as if some early uncle of the Fowls had owned this bull and, when it died, had commissioned a taxidermist to turn it into a piece of furniture!"

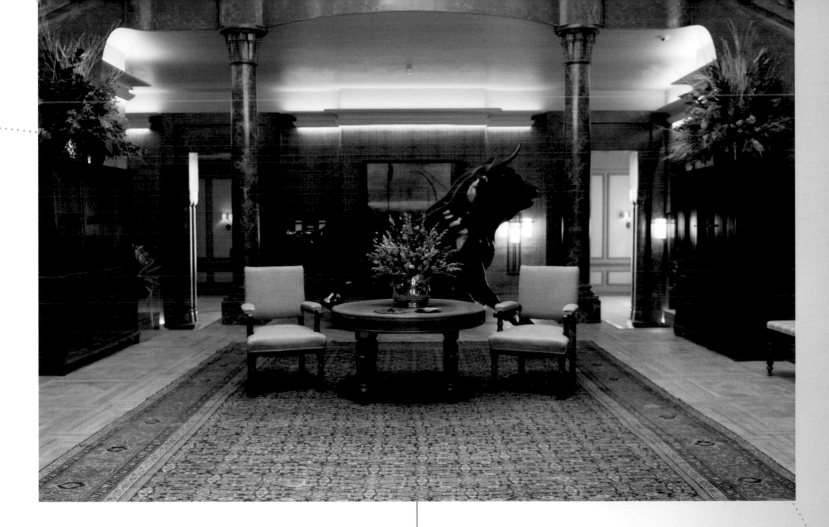

This fanciful sofa became, says Jim, "almost a character in its own right," especially when it gets used as a weapon in the battle with the troll. That, of course, meant that several more bull sofas had to be made, including versions in lightweight fiberglass and rubber.

Navigating our way past this curious bovine settee, we pass through to the ballroom, running the width of the house, with an imposing marble fireplace and a mirrored mantel. French windows open out onto the grounds, and the room is given added length by a ceiling-high mural depicting a mysterious, mist-filled forest scene.

Above: The atrium with its imposing double staircase. Right: The magnificently eccentric bull-shaped sofa.

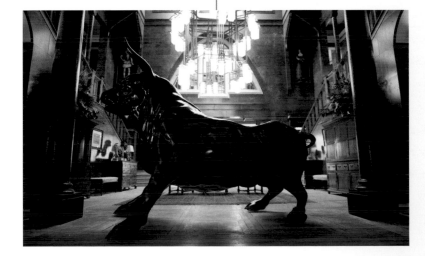

Opposite: Concept art (top) showing Artemis surveying the paintings of his ancestors in the portrait gallery and a view of the gallery wall (bottom) with the sporting-inspired mural that runs along the gallery's length.

the house, they represent the artistic achievements of the gifted Fowl family over many years and range from traditional landscapes to late twentieth-century abstracts.

From either end of the landing, the visitor can enter the portrait room, filled with formal paintings of Artemis's ancestors. "In our thinking," says Celia, "the family has lived at Fowl Manor for several centuries; so, to accentuate that fact, we have portraits of the members of the Fowl and Butler families dressed in the costumes of various periods dating from the Elizabethan era onwards. The work of two of our artists, many of them incorporate Gnommish hieroglyphs to tie them into the fairy world, while all the portrait frames are genuine period pieces chosen to reinforce the longevity of the Fowl dynasty."

Leaving the ballroom, let's pause at the kitchen that, once again, highlights the historic nature of the house and the way life has changed across the centuries. In former days, it would have been a room filled with the hustle and bustle of many servants, and some evidence of that time survives with the shelves of copper kitchenware and the classic AGA range used for cooking. However, the changing needs of the family have led to this area being modernized into a cozy space with a sofa and chairs where the Fowls can eat and relax together.

Back in the atrium, it's time to mount one of the twin staircases and explore upstairs. On the landing with its tree-patterned wallpaper hangs an impressive display of paintings, specially created by the art department. Just part of a large collection of artwork, displayed here and elsewhere in

Above: The cozy breakfast area in the Manor kitchen. Right: The portrait gallery with the central portrait that hides the Fowl family's top secret safe.

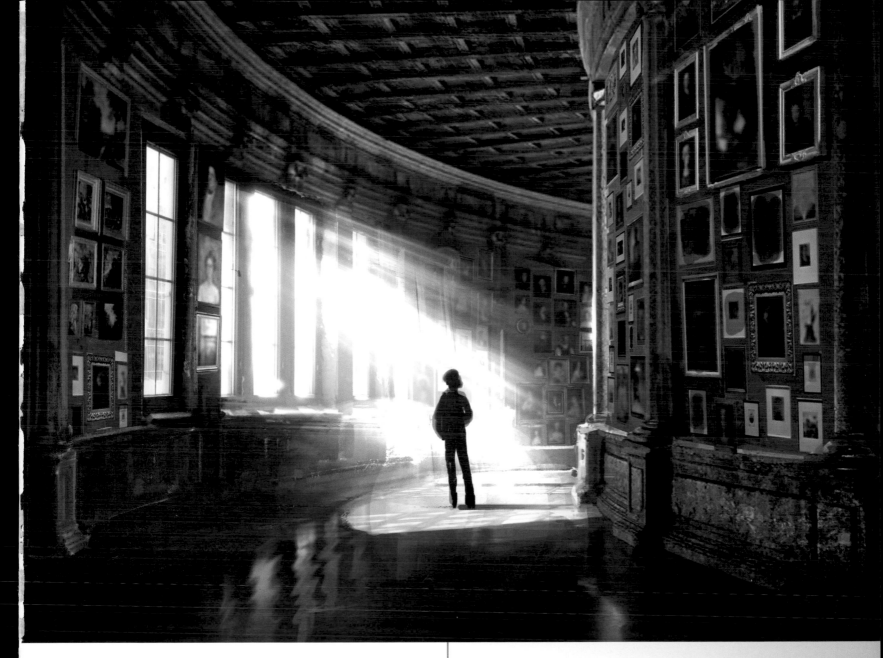

Running across the wall above the portraits is another intriguing work of art: a mural painted by scenic artist Steve Mitchell. This panoramic mural was Kenneth's idea and takes its inspiration from historic sporting prints popular in the Victorian era. With views of Fowl Manor and the standing stones, the piece features riders and horses on a hunt. "The Irish are great horse lovers," reflects Celia, "and there would have been stables on Fowl Manor estate in the nineteenth and twentieth centuries."

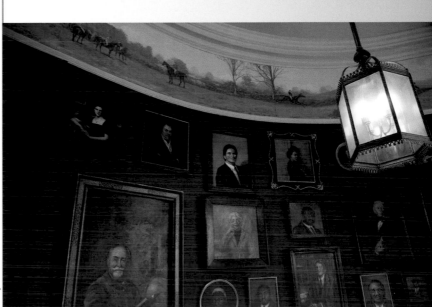

A masterpiece of engineering: the amazing Fowl Manor safe that is concealed behind one of the paintings in the portrait gallery.

One very particular painting in Fowl Manor conceals a vital secret in the form of the hidden safe where Artemis's father has secured the most powerful treasure of the fairy world—the Aculos. This acorn-shaped artifact, glowing with an incredible radiance, is accompanied by a parchment contract making an unexpected link between Artemis's father and Holly's father, Captain Birchwood Short.

The safe, which is eventually discovered by Mulch Diggums (who recognizes it, from his previous criminal activities, as the notoriously impregnable TXTL 5000) is an astonishingly intricate piece of prop making by prop master Barry Gibbs and his colleagues, and comprises a fully working, complex arrangement of turning wheels and cogs.

Leaving the portrait room, we come into the library that serves as Artemis's command center, where he spends many hours working to decipher

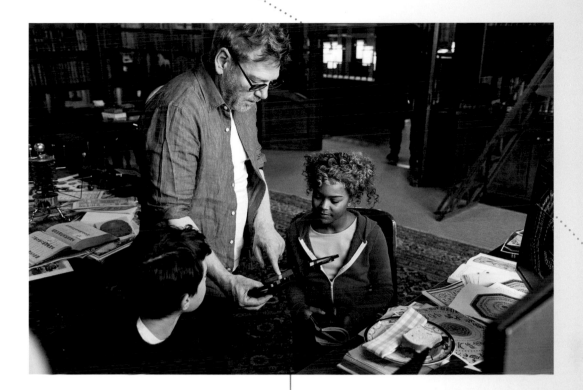

Director Kenneth Branagh with Ferdia Shaw
and Tamara Smart in the Fowl Manor library.

the contents of the fairies' *Booke of the People*.
The library has bookshelves from floor to five-
and-a-half-meter-high ceiling and is designed to
reflect the long history and many interests of the
Fowl family.

Most movie-set bookcases contain shelves
stacked not with books but with fake book spines.
Although obviously cheaper, less heavy, and
considerably easier to handle, there is, Jim main-
tains, a downside: "They never look quite as real
as the real thing. There's just something about
antique, leather-bound volumes that helps give a
fabulous atmosphere to the space. And with real
books there's the bonus that it's possible to pull
any book off any shelf at random without expos-
ing the deceit."

"It was very important to Ken," says Celia, "to
have the option of filming up close against the
shelves with their rich patina of leather bindings
and gilded lettering." Among the over twelve
thousand volumes, Celia has gathered books
about the myths and legends of Ireland, the
Arthurian romances, and many different aspects of
British and Celtic folklore, as well as ethnographic
studies and works by the Irish poet W. B. Yeats.
"All these books," enthuses Celia, "help give a
sense of the history of the place as well as provid-
ing a multilayered illustration of the concept
that the Fowl family has a generations-long
interest and connection with the world of fairies
and leprechauns."

Overleaf: The library is filled with thousands
of rare and beautiful books as well as the
most sophisticated modern technology.

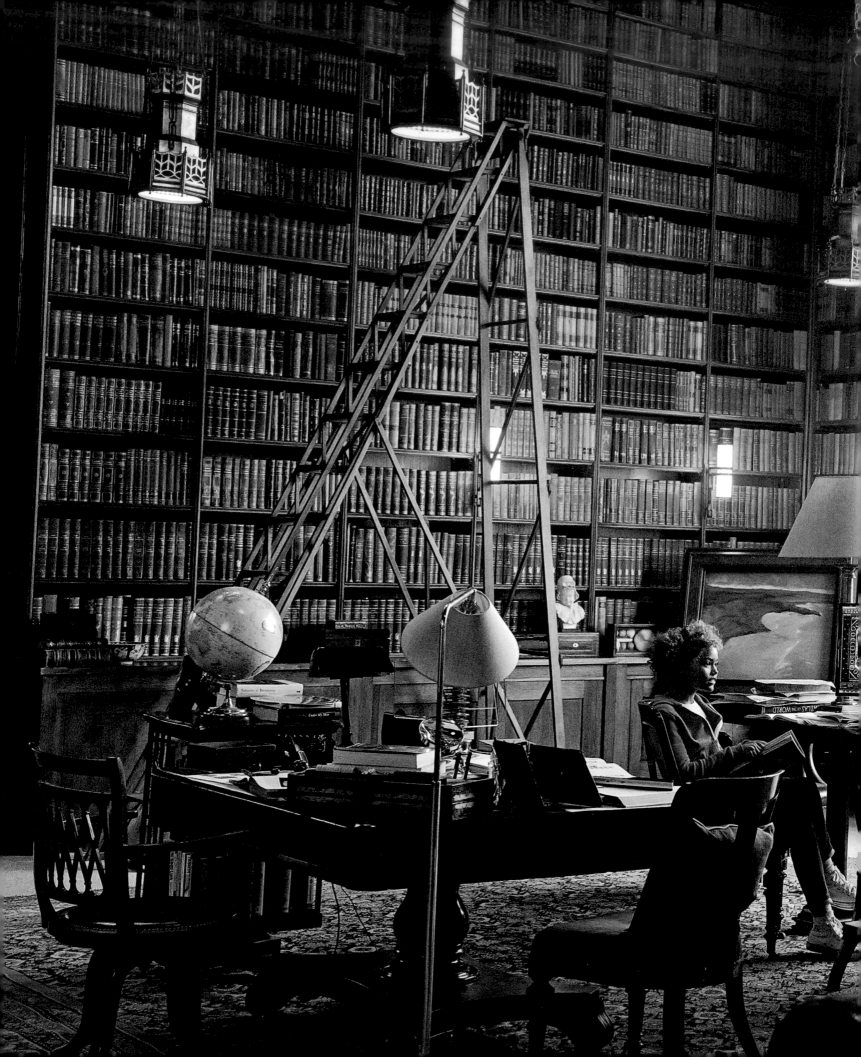

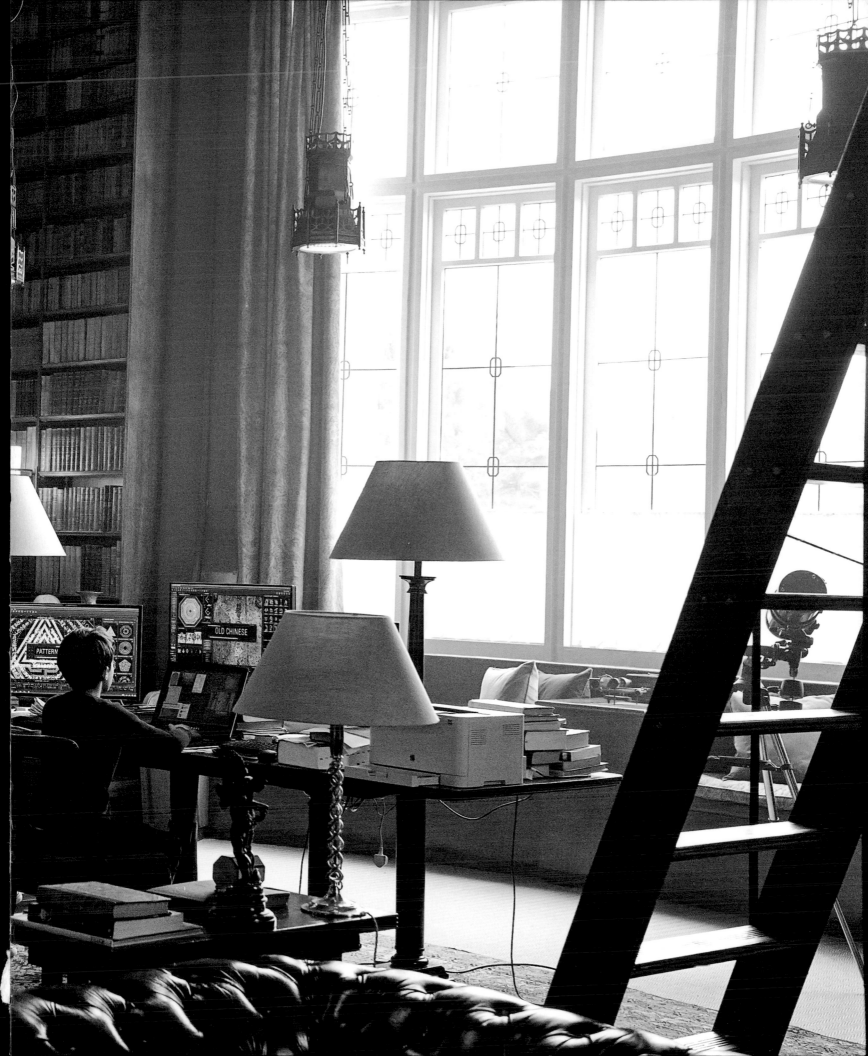

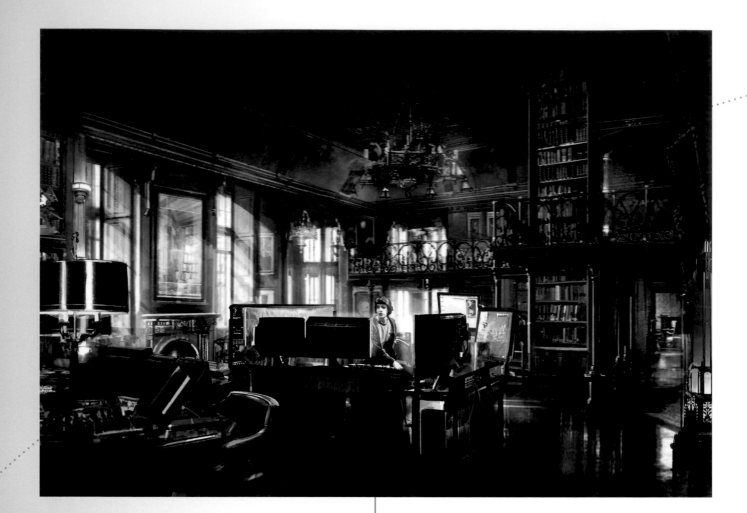

An artist's concept painting showing Artemis in the library.

As elsewhere in the house, the library contains many antique items, including a globe and an orrery—a mechanical model of the solar system illustrating the relative positions and orbits of the planets and moons, according to the sun-centered, heliocentric principle proposed by the Renaissance astronomer Copernicus. Studying this orrery helps Artemis crack the mystery of the Gnommish language.

The library is the heart of Fowl Manor and a key to understanding Artemis's history and personality, as Celia explains: "He is a child of intelligence, enthusiasms, curiosity, and inquisitiveness. Living, as he does, in this old family house that spans several generations, he has inherited many of the passions of ancestors, and the library has lots of examples of those interests." These include a stamp collection and, elsewhere in the house, collections of butterflies, moths, and shells begun by Artemis's Victorian and Edwardian forebears. "With its warm velvet drapes to keep out the cold and rain of the Irish winter," says Celia, "the library represents for Artemis a valued place of peace and calm."

Two other important rooms are to be found on the upper floor of Fowl Manor, the first being the bedroom of the central character, located directly above the atrium. "With his father having disappeared," says Jim, "Artemis becomes the man in command of the house. So, we have a big arch window from where he can look through to the corridors and down into the atrium space. And, of course, cinematically it gives us a wonderful way to observe him in his room."

One wall in Artemis's bedroom has a window looking out onto the atrium below.

Ferdia, playing Artemis, has no doubts about which room in Fowl Manor is his favorite. "The architecture of the whole building is stunning!" he says. "The design is so detailed and elaborate, it's crazy! But, of course, for me, the best room is my bedroom. I was asked early on to tell them what my favorite books, comics, and toys were, and they're all there together with a lot of very cool things!"

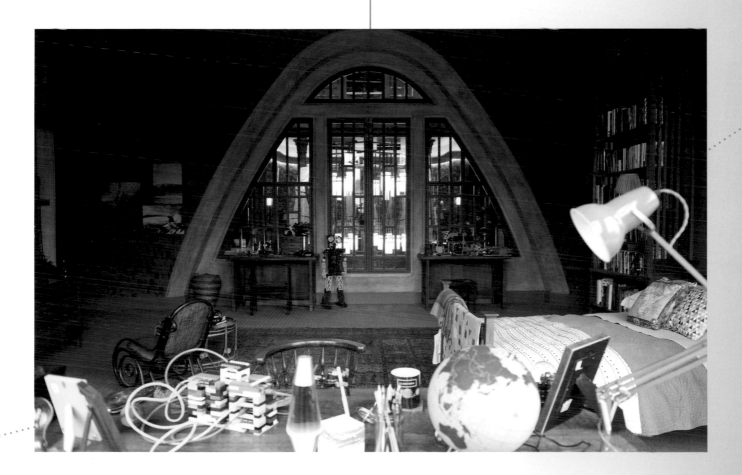

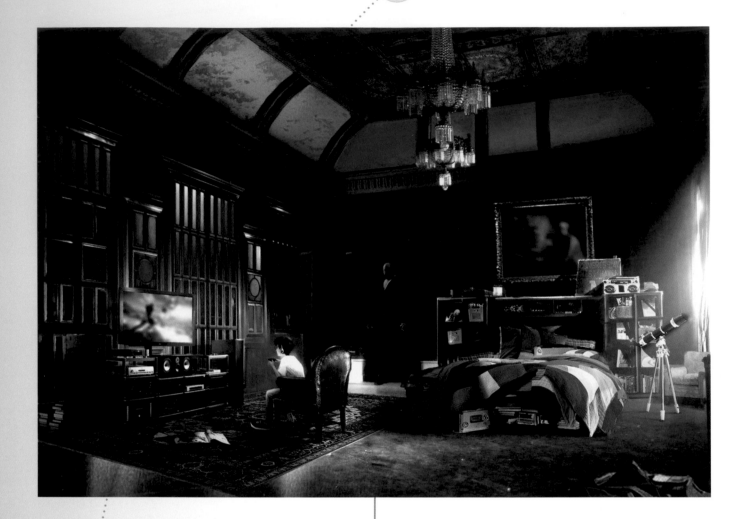

Above and opposite: Preliminary concept designs showing Artemis relaxing in his bedroom.

Celia has taken a lot of care with the content and decoration of the room, as she explains: "I wanted to create somewhere that would really interest youngsters who came to see the film." So the room has lots of *Star Wars* LEGO (Ferdia is a *Star Wars* fan) along with Raspberry Pi project pastimes, all of which Artemis would have built, together with some period items such as a vintage clockwork train, a Meccano set—a popular British construction kit dating back to the nineteenth century that perhaps once belonged to Artemis's father or grandfather—and an antique French automaton. Once again, there are books. "If you scan the shelves," says Celia, "you will find that every one of those books could well have been read by Artemis or have contained something in which he would have taken an interest."

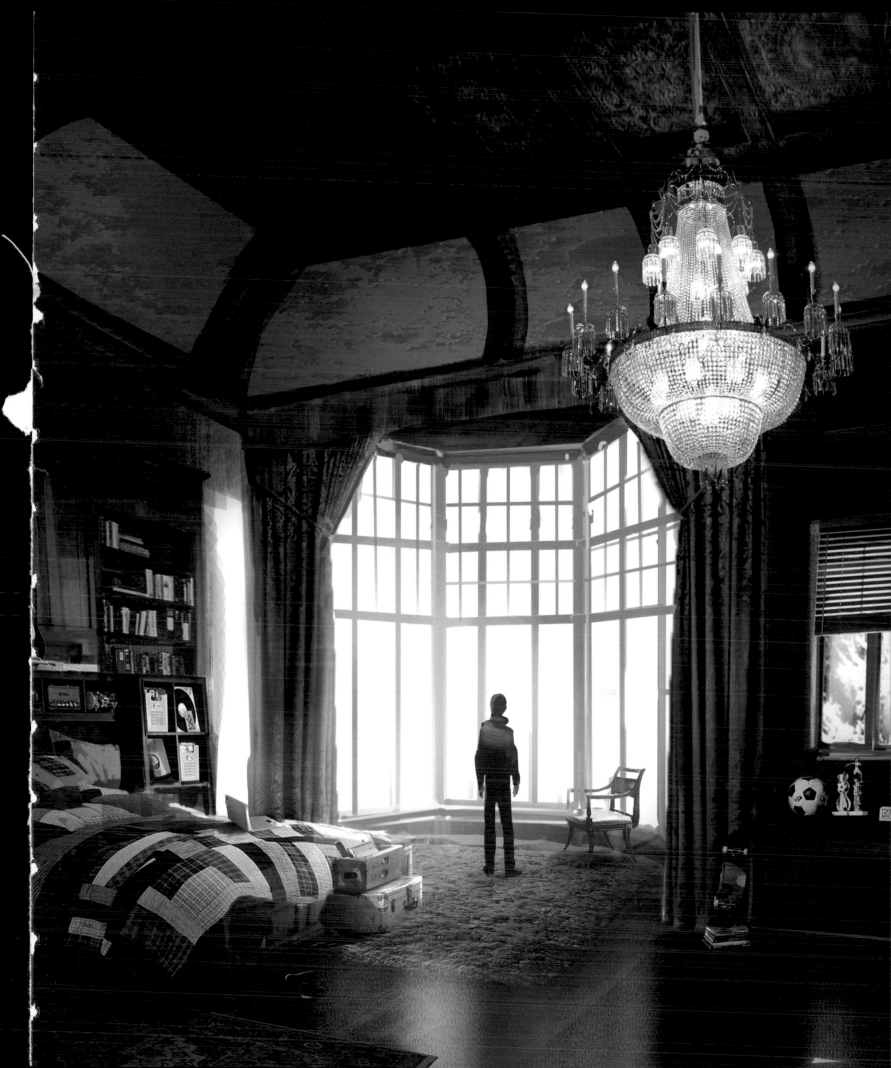

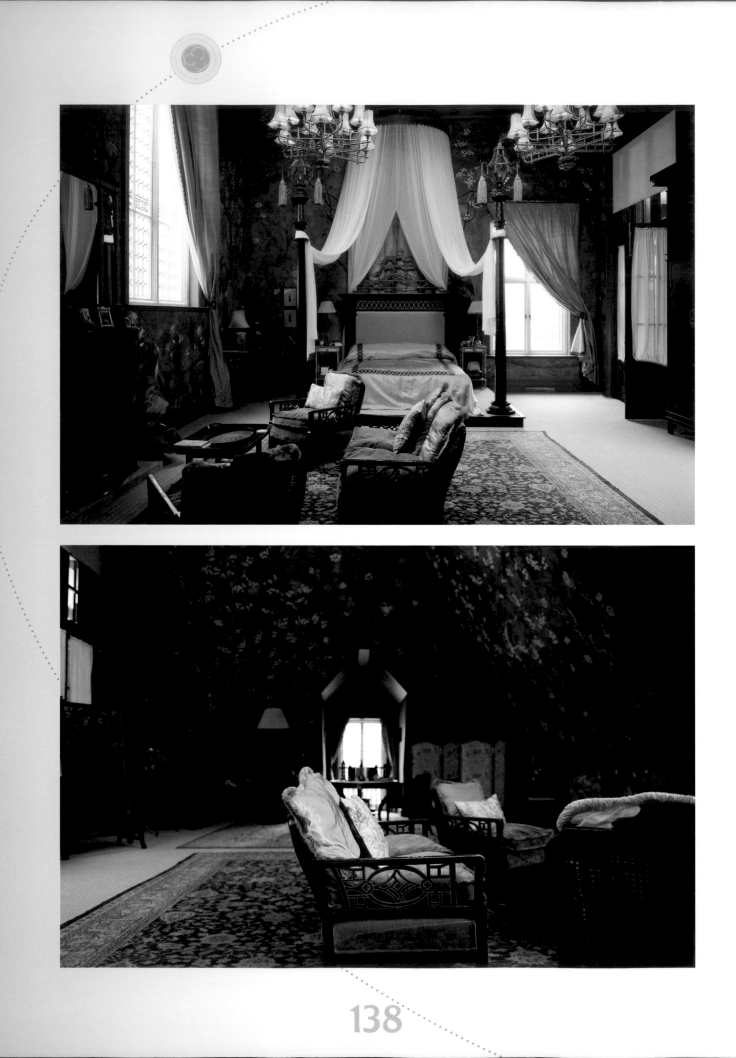

Chinese-style, hand-painted
"wallpaper" helps give a
mysterious atmosphere to
Angeline Fowl's bedroom.

In distinct contrast to Artemis's bedroom is that of his mother, Angeline Fowl. Two things impact Angeline's character: first, the disappearance of her husband and, second, the influence that the fairies begin to exert over her personality. As a result, she becomes increasingly withdrawn and introspective. That mood helped shape the design of her room, which uses a style of decoration known as chinoiserie, a popular fashion dating from the eighteenth century that involved ornamenting furniture and fabrics with Chinese motifs. "The result," says Jim, "is rather brooding and mysterious, and it is definitely the sort of room in which a thoughtful person would be likely to contemplate their situation in life."

Celia takes up the description: "We found antique chinoiserie furnishings, among them an elegant bamboo mirror and an early nineteenth-century period screen that, by sheer coincidence, matched the style of the lights that had been designed and made for the room by our prop department. We wanted to use the type of

Chinese-style wallpaper that was popularly used in country houses in the British Isles, but because of the room's high, curiously angled walls and ceiling we chose to paint the designs directly onto the walls." The result is a shimmering forest of trees with exotic birds flying among their blossom-laden branches.

The studio's craftspeople built accompanying pieces of furniture, including a huge wardrobe and a massive four-poster bed on a raised plinth, while among the fabrics used are fine Chinese silks and exquisite handmade embroidery by the London firm of Hand & Lock, who, since 1767, have been embellishing, embroidering, and monogramming garments for the royal family, the military, and various fashion houses.

Reflecting on the achievement of making Fowl Manor a home, Celia says, "Essentially, it is about trying to keep the eye of the audience focused on and interested in the settings for the story, and you do that by creating layer upon layer of the most intense detail."

GADGETS
AND GIZMOS:
FAIRY
TECHNOLOGY

Chapter 8

"The key to the designs for the various pieces of fairy equipment," says property master Barry Gibbs, "is that everything has its origin in a combination of organic and geometric shapes."

Because the fairy realm in *Artemis Fowl* is a totally unexpected place, it should come as no surprise that the extraordinarily advanced technology that keeps their world hidden and its people safe is like nothing on Earth. One of the most demanding aspects of the film's design has been the devising and making of the gadgets, gizmos, and weaponry employed by the Lower Elements Police.

Barry has a track record for tackling a number of challenging prop-building tasks for the movies; his skill in helping visualize the unusual has been seen in a range of fantasy adventure films, including *Inception*, *Captain America: The First Avenger*, *Guardians of the Galaxy*, and *Doctor Strange*.

One of Barry's most ambitious undertakings was creating the mystical alethiometer, the object at the heart of the 2007 movie *The Golden Compass*, so it is altogether appropriate that he is now heading the team giving reality to another iconic item: *The Booke of the People*, the artifact containing the fairies' history and rituals, which assists Artemis in his ambitious plan to acquire fairy gold.

The bold design concept was for something that looks quite different from any conventional idea of a book. An octagon made of labradorite—a dark yet pearlescent stone—the book's cover is engraved with a complex geometric design and with Gnommish hieroglyphs running around the edges of its eight sides. When opened, the book's text is displayed in a series of concentric circles that can only be read in a spiral from left to right using a key dictated by the orbital patterns of the planets in the solar system.

Geometric shapes are a key design element, as seen in this scale drawing for the L.E.P. aircraft that lands on the beach below Fowl Manor.

Similar shapes predominate in the design of all aspects of fairy technology; for example, L.E.P. officers have mobile computers based on a series of coaxial octagons that can be manipulated into a number of positions to suit a variety of options, such as being used at a desk or carried as a hand-worn mobile device. In a radical design feature, these computers use holograms as opposed to the LCD or LED screens familiar to us in our world. Summing up these significant technological advances, Barry says, "The fairies are a 'paperless society,' with all essential information being stored on USB crystals."

L.E.P.recon officers have various items of equipment specifically designed for the demands of their world. Among these are binoculars that take their inspiration from the type of eyes common to many insects, where thousands of tiny,

closely packed light-detecting mini eyes work as what is called a compound eye with an exceptional range of perception. Barry explains, "Fairy binoculars give the user both wide-angle peripheral vision and an ability to scan everything that's going on at a far greater distance and at a much faster rate than the capability of human eyesight."

They are used by Briar Cudgeon when controlling the troll attack on Fowl Manor. "As an actor," says Joshua McGuire, "you can't actually see through the binoculars, but they give Briar a really unique look in the scenes when he's tracking what's going on inside the house."

Right: Oh, to be a fly on the wall wearing these fairy binoculars. Opposite: Artemis and Butler wield variants of the Neutrino (top and bottom); concept art depicting the tech-savvy L.E.P. forces planning their siege of Fowl Manor using a high-tech 3-D representation of the house (middle).

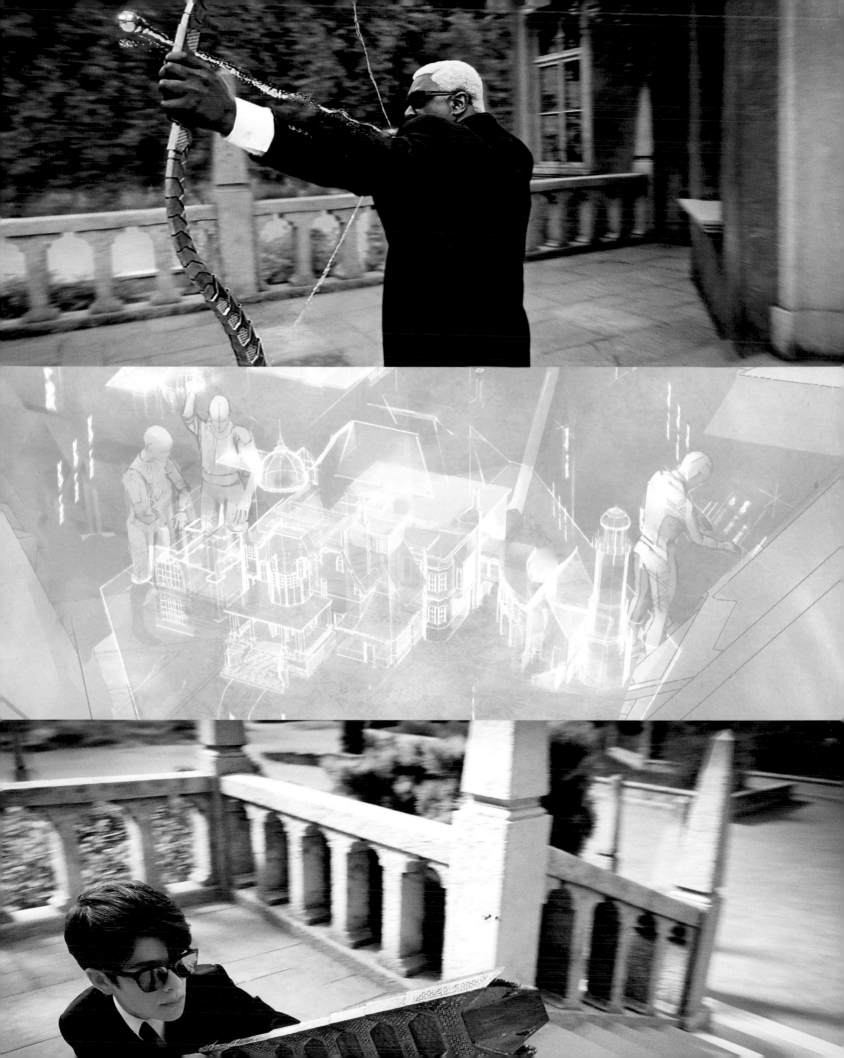

When arresting troublemaking goblins and felons such as Mulch Diggums, the L.E.P. operatives have access to magnetic handcuffs and leg shackles that snap around the criminal's wrists and ankles. Equipment is stored in containers that are a far cry from our human idea of a box. "Loosely inspired by the principle of an infinity cube," says Barry, "they disclose, when folded open, compartments that, in turn, reveal containers for binoculars, digipads, and other devices. Others are octahedron-shaped with multifaceted opening options, creating an imaginative Pandora's box effect."

Whether quelling goblin riots or planning an assault on Fowl Manor, the fairies have their own style in weaponry, the most adaptable of which is the Neutrino. "In its design," explains Barry, "the Neutrino is not a predictably gun-shaped weapon, and instead of employing ballistics, it is a device that emits a wave of electromagnetic pulses. Kenneth Branagh wanted it to be multifunctional, so we've built into it a variety of elements suited to the specific needs of a diverse range of L.E.P. requirements."

As Holly Short demonstrates when we first encounter her in the film, the Neutrino has the capability of being quickly and efficiently adapted, expanding from a close-range weapon to one with a far greater reach. Describing its multifunctionality, Barry says, "Twist the dial and it can both change the direction of fire and the strength of the pulse emitted. But the Neutrino can also become a swordlike weapon, or can be operated like a boomerang, to throw its pulse emissions further. Other iterations include being able to use it like a staff as a blocking weapon in an attack situation, with the additional capability to send pulses from either end, and an archery-inspired form where it functions in a similar way to a bow being drawn to loose an arrow."

As with every aspect of fairy life portrayed in *Artemis Fowl*—including their interactions with the inhabitants of our world—the technological hardware and software have been inventively envisaged by the film's design and production team to match the inspired creativity of the original book.

The highly adaptable Neutrino weapon carried by Holly Short and other L.E.P. operatives transforms into a multitude of forms including (from far left) handgun, rifle, boomerang, spinner, bow, and sword.

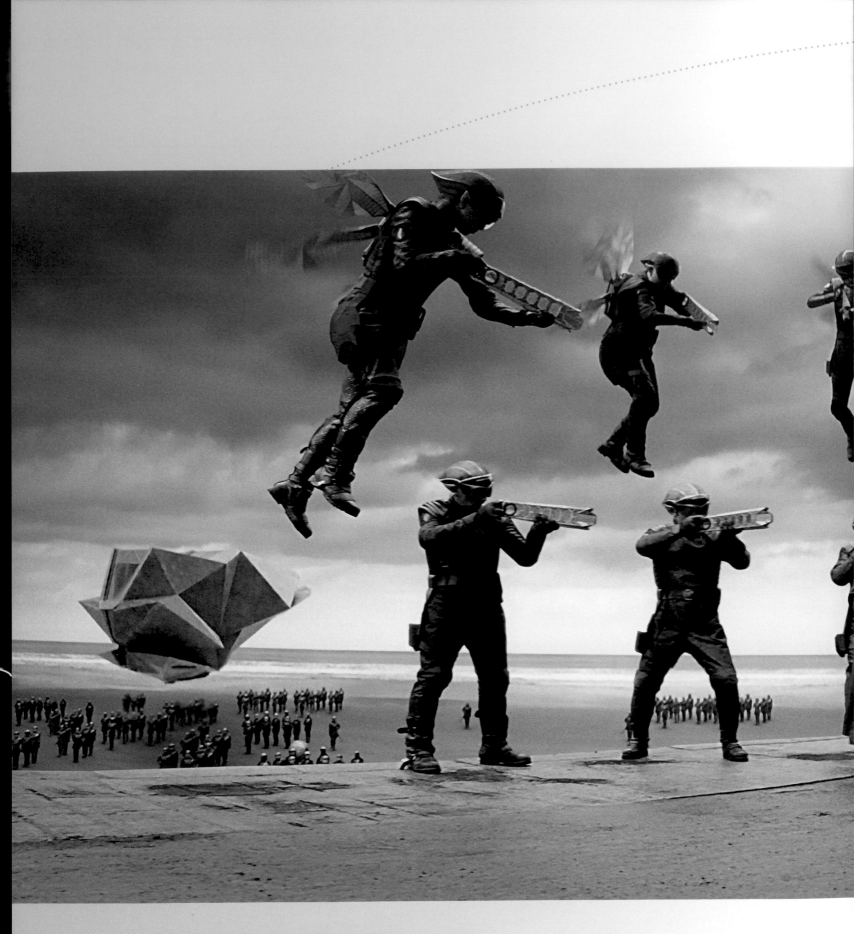

In a sudden plot twist, the L.E.P. turn their multipurpose weaponry on one of their own.

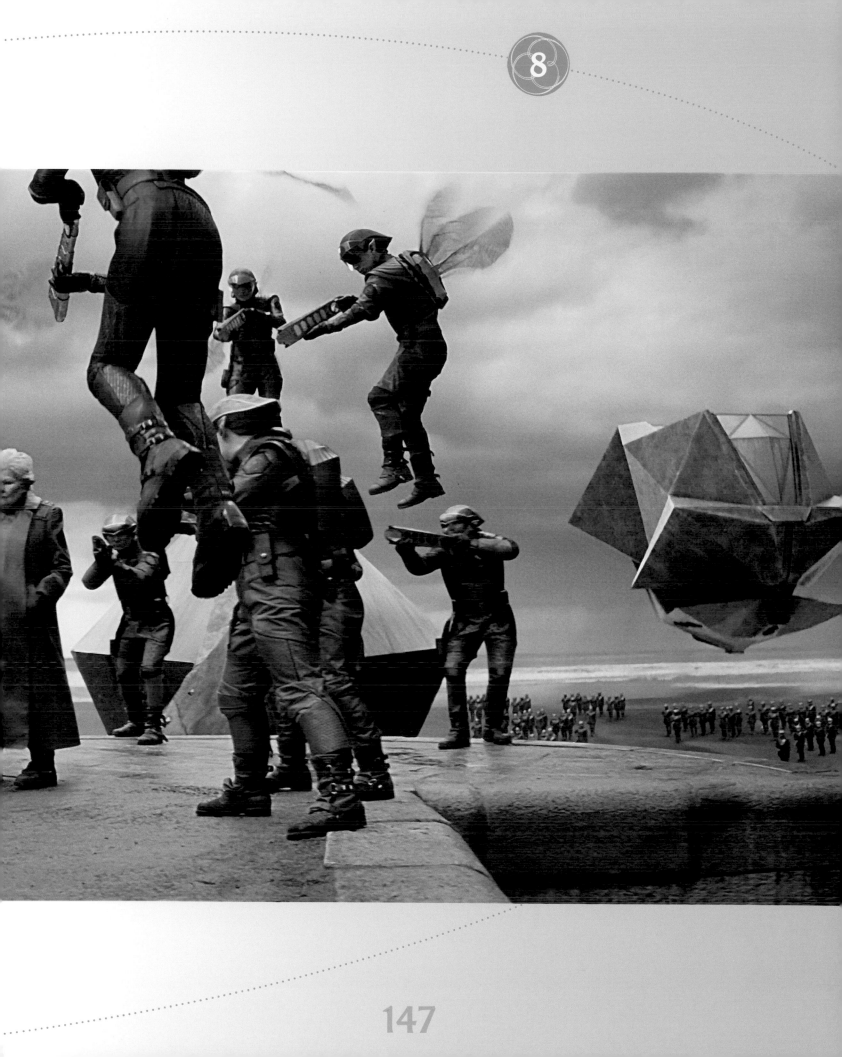

The Booke of the People

In the novel *Artemis Fowl*, author Eoin Colfer introduced the idea that every fairy carries a handbook containing the history of their race and the rules governing how and when they can use their various magical powers. "I thought," reasons Eoin, "that if there were such a manual, then it would be something Artemis would try to get a hold of, and that was the origin of the *Booke*."

The author originally described the book as a tiny golden volume about the size of a matchbox with wafer-thin pages written in the old fairy tongue, Gnommish. The choice of language was partly motivated by the fact that Elvish and Dwarvish were very closely associated with the fantasy realms of J. R. R. Tolkien and his successors. "In my mind," says Eoin, "and as they are depicted in subsequent books, the gnomes were seen as being inherently scholarly, and therefore it was natural that Gnommish should be the language of commerce and education among the fairies."

While Eoin's manuscript included Artemis's decryption of the *Booke's* content as an important plot point, it did not include an actual Gnommish language. "The concept," says Eoin, "was developed at the suggestion of my editor, who thought it would be an interesting extra feature for readers if we were to create a Gnommish alphabet." The suggestion immediately appealed to Eoin, who, as a youngster, had been a fan of a popular 1970s children's comic, *Warlord*, which ran a "Warlord Secret Agent Club" for readers that included, as part of its membership, a secret code with which to decipher a weekly message in the pages of the magazine.

A Gnommish alphabet was created using logographic symbols (similar to those used in Egyptian hieroglyphs) and was based on a variety of natural or geomantic shapes, including a leaf, a mushroom, a snail, a dragonfly, and an acorn.

Gnommish first appeared on the original cover of the first novel in the form of an inscription from the opening words of *The Booke of the People*.

Translated, it reads:

> *Carry me always, carry me well.*
> *I am thy teacher of herb and spell.*
> *I am thy link to power arcane.*
> *Forget me and thy magick shall wane.*

In adapting the novel for the screen, the filmmakers—aware of the tremendous strides made in human technology over the eighteen years since original publication—reasoned that the fairy culture would be even more advanced and decided to present the book as a device that is designed to be both a beautiful artifact and a piece of highly sophisticated equipment. The hexagonal *Booke* in the film differs quite a bit from the original matchbox-sized golden volume conceived by the author, as do the symbols comprising the Gnommish alphabet, but its importance in Artemis's adventure remains the same.

MAKING UP ARTEMIS FOWL:

ELF EARS AND DWARF TEETH

Chapter 9

It's a fact of fantasy filmmaking: you simply can't have a film that features elves without talking about elf ears. On this film, ears were the responsibility of award-winning, Oscar-nominated hair and makeup designer Carol Hemming, whose films include Kenneth Branagh's *Cinderella* and *Murder on the Orient Express*.

Carol's work on *Artemis Fowl* began with in-depth research into the rich history of fairy imagery in art and popular culture, and alongside those inspirations, there was Kenneth's very specific take on the look he wanted to achieve for this magical community. "Ken is the bible!" says Carol. "What Ken wanted to see was a richly varied society, much as our contemporary human society is filled with variety and diversity. The denizens of Haven City—which include elves, pixies, sprites, dwarfs, centaurs, and goblins—reflect the fact that these are a people from a mixed, organic culture that live underground in a place that is very much part of the natural life of the Earth."

Getting down to specifics, Carol provides a few ear facts: "We made individually designed prosthetic ears for every one of the fairy characters—including a huge number of extras—and each pair was custom-made to suit the distinct personality of the wearer. In total we produced one hundred and fifty original ear designs, but because every actor required a new set of ears for each day's shooting, we got through a staggering total of four thousand pairs of ears."

Each character offered his or her own combination of challenges and opportunities, and none more so than Commander Root. "Having worked with Ken before," says Carol, "I know that he is someone who has long embraced diversity in terms of ethnicity and gender. Judi Dench was very keen—as was I—to give Commander Root a sense of androgyny in the fairy world. We individualized her ears with green tattoo markings and, since we drew much of our inspiration from nature, we referenced the very particular look of a silver birch tree whose gray-white bark led to a hair styling that has what might be described as a David Bowie/David Lynch vibe that, happily, Judi fully embraced."

Although ear tattoos are a popular feature of facial decoration among L.E.P. officers, one of their number—the troublemaking Briar Cudgeon—opts for something rather less obvious. "Cudgeon is ambitious, vain, and tricky," says Carol, "so we gave him a pattern of subtle markings shaved into the hair on the back of his head as a hint at his devious, undercover character." A rash of freckles, however, suggests that he is not quite as cool and, perhaps, rather more nerdy than he would like to believe!

A very different creature is the old fairy in Vietnam from whom Artemis and Butler first obtain sight of *The Booke of the People*. "Our brilliant prosthetics team," says Carol, "spent two to three hours disguising the beautiful actress Hong Chau with prosthetic makeup, lenses, and teeth to create the character's ancient appearance." Hong Chau's natural beauty is, of course, restored when the fairy is transformed and age drops away to reveal her as a youthful and reinvigorated spirit.

Foaly the centaur, played by Nikesh Patel, has a very particular look (apart from his obvious equine features) in the form of a pair of distinctly horse-inspired ears and a unique hair-and-makeup design, as Carol explains: "Having taken Nikesh's hair right down on one side, we shaved in various fairy markings and then added a long, black, luxuriant hairpiece that falls down on the opposite side of his head to create the look of a mane."

As readers of the books will be aware, Foaly suffers from acute paranoia, convinced that he is being constantly monitored by human intelligence agencies. "In our interpretation," says Carol, "we have given him an elaborate silver decoration on his forehead, reminiscent of the blaze that is seen on the heads of some horses. We created this embellishment by giving Nikesh a prosthetic skin addition to his forehead into which we laid in liquid silver to give the marking a three-dimensional effect. Plus, the metal is a nod to the tin hat he wears in the book, which he believes makes him resistant to mind reading!"

Haven City's diverse—and often curious—population includes mushroom and tree people. Carol's team created the latter by applying a mix of real earth and clay to the bodies of tall actors and then adding appropriate tree-bark markings to their new skin. However, the most demanding makeup regimen involved creating the physical appearance of Mulch Diggums the dwarf.

"Mulch is really *very hairy*!" says Carol, laughing. "And a lot of hair takes time. So, in order to get him ready without having him sit in a makeup chair for many hours, I and a team of six or seven artists simultaneously worked on actor Josh Gad before the beginning of each day's shoot. Someone would be putting on his wig, someone else applying his beard, others taking care of his hairy ears or adding hair to his hands and chest. Josh had a wonderful rapport with the group—nobody stopped laughing while he was around—and at the end of his shoot, he presented all his makeup artists with hats carrying the slogan 'Team Mulch'!"

Mulch presented a further challenge on account of his miraculous knack for unhinging and extending his jaw to turn himself into a dwarfish tunneling machine with three extra rows of powerful, rock-chomping teeth. Josh wore false teeth for those moments when he reveals his dental equipment, and a scale model was built of Mulch's head in his mining persona—complete with wild hair, furious beard, and multiple molars—so as to provide a reference point for the visual effects department, who were to take over from the actor and complete

the dwarf's on-screen transformation. Similarly, some of the hairs in Mulch's beard and ears were made from wire so they could be pulled out to serve as his unique lock-picking tools, their animation being subsequently created by the visual effects team.

Despite Mulch being generally filthy in appearance, Carol decided that Mulch's teeth should never be less than pearly white, as she explains: "His teeth are his profession—he is a tunneler—so it seemed logical that with the vast amount of dirt that he would eat in the process of digging, it would act as a natural abrasive to keep his teeth pristinely clean."

9

Josh Gad received serious attention from the artists in the hair and makeup departments in order to transform him into Mulch Diggums.

Apart from the many curious and exotic characters in the film, there are the humans who become entangled with the inhabitants of the fairy realm. Nonso Anozie, playing Butler, was keen to have a different look from what he felt was his usual screen persona. The inspiration for Butler's highly individual look came from new scientific research, published early in 2018, based on the one-hundred-thousand-year-old fossil remains of a man who once lived in the West Country of Britain. Known as Cheddar Man, the fossil possesses DNA suggesting that—contrary to earlier theories—the first modern Britons were dark skinned with curly hair and blue eyes. Fired by this revelation, Nonso was given blue contact lenses and white, tightly curled hair. "We shaved Nonso's head," says Carol, "and, rather than a wig, his hair was laid on piece by piece—an operation that required three or four makeup artists working as a team."

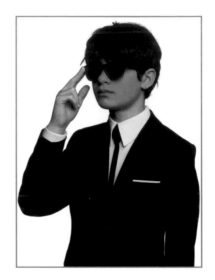

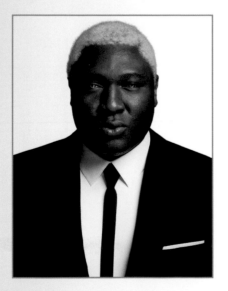

As for Artemis, Carol took her cue from the fact that, as the story unfolds, a kinship develops between him and Holly Short. "During my early research," she says, "I explored many depictions of Celtic fairies and referenced the popular imagery of blue- and green-eyed fairies with skin tones of alabaster through to dark. I tried to show similarities between Artemis and Holly and again, some diversity." As a result, the two protagonists, later compatriots, share a subtle similarity of look that hints at a shared beauty and intelligence.

There is, it's clear to see, much more to fantasy film makeup than just thousands of elf ears!

Artemis (Ferdia Shaw) confronts the imprisoned Captain Holly Short (Lara McDonnell) in her improvised cage in the Fowl Manor kitchen.

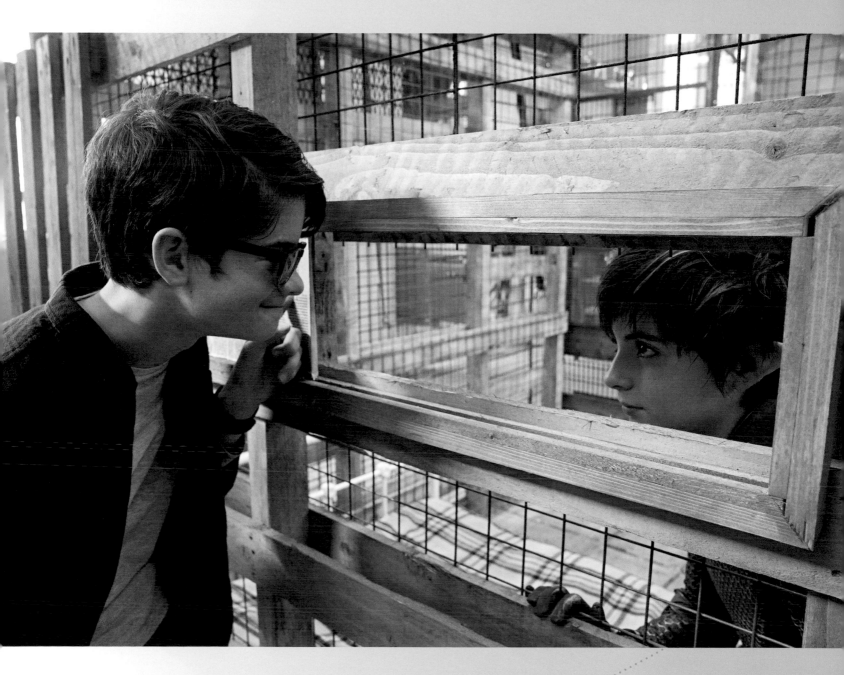

Overleaf: Enemies or friends? A rare moment of understanding between fairy and human.

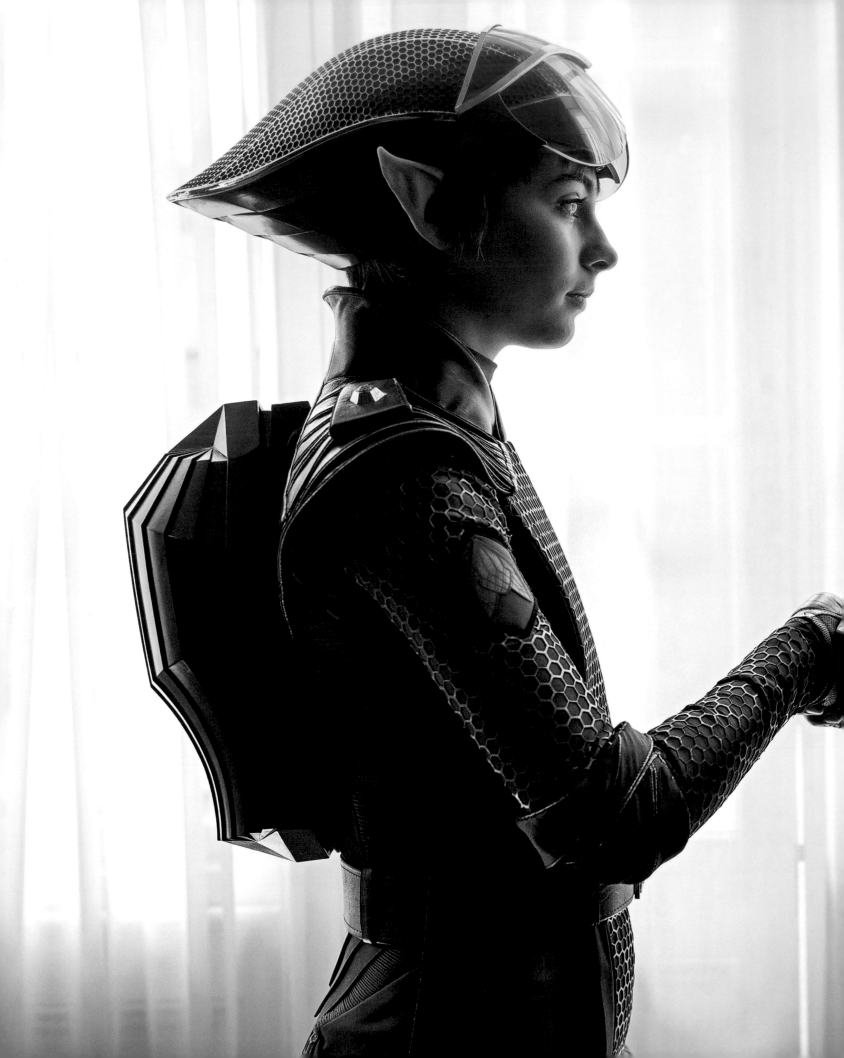

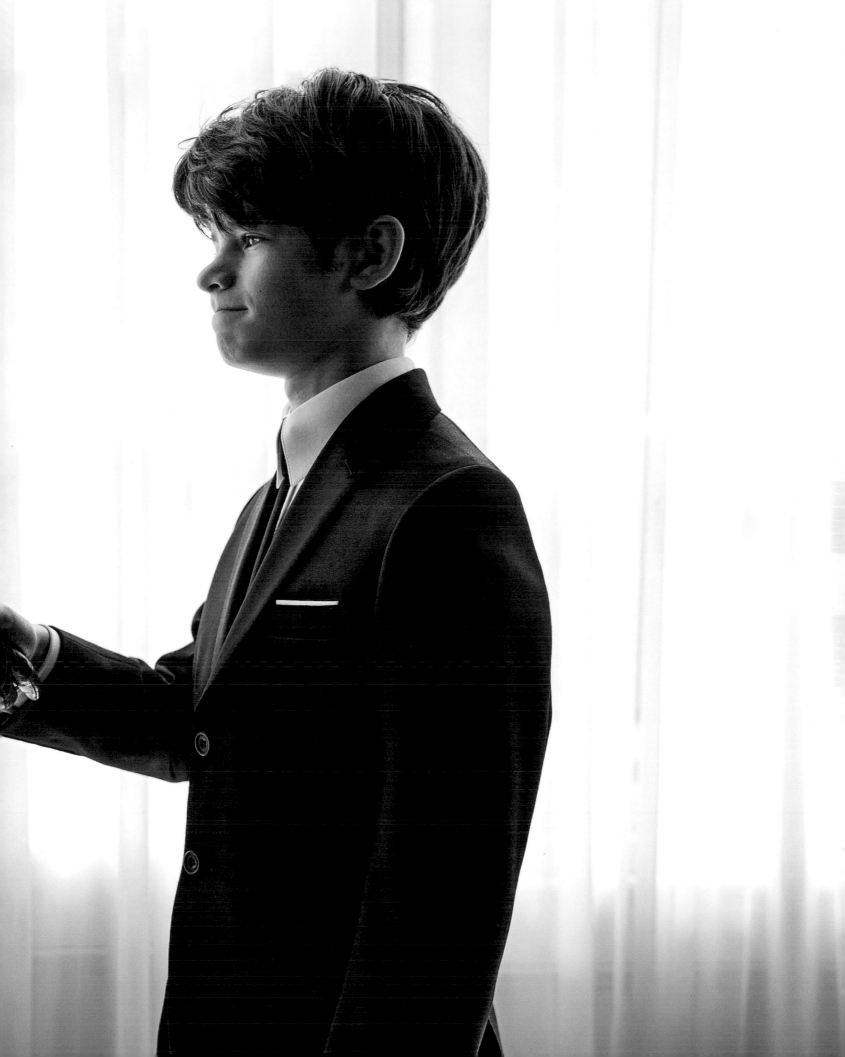

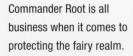

Commander Root is all
business when it comes to
protecting the fairy realm.

No Stamping Feet:

EQUIPPING AND TRAINING FAIRY FORCES

According to Richard Smedley, there's a simple rule about training fairy fighters: "It's a thing where everybody involved really has to focus—you just cannot do things together unless you are all *absolutely focused*." Richard should know; he is a former captain in the United Kingdom's Parachute Regiment who has spent the past three decades working as a military and technical advisor on movies, including *Artemis Fowl*.

Richard was responsible for training and coordinating the Greek and Trojan armies in the 2004 epic *Troy*, and he has been personal trainer to, among many others, Pierce Brosnan's 007 in *Tomorrow Never Dies*, Daniel Day-Lewis's Hawkeye in *The Last of the Mohicans*, and Richard Armitage's Thorin in the Hobbit trilogy. "Whatever the period or genre of the film," says Richard, "if it features an army, then it's my job to make it look authentic."

Of course, no two armies are alike—especially in a fantasy realm; so what are the basics when it comes to a military force such as that under the control of Commander Root? "The drill's slightly different," explains Richard. "To start with: no stamping feet. Fairies don't make noise; their whole ethos is 'Do not disturb.' And the accent is always on natural movements, so if a group were making their way through a forest, they would behave as you might expect fairies to do: disappearing behind one tree, then appearing from behind another. Not quite British military, but there are elements of it—plus a little imagination."

Richard collaborated on *Artemis Fowl* with actress Pip Jordan, associate choreographer on Kenneth Branagh's theatre productions of *The Winter's Tale* and *Romeo and Juliet* and movement advisor on his films *Cinderella* and *Murder on the Orient Express*. "Pip comes from a dance background," says Richard, "and we work closely together. There was only one former soldier among the supporting artists on the film, and it was really much easier to teach movement to nonmilitary people in terms of dance cues—especially where you've got to get everyone to do something at the same time. It's still drill, but they learn it like dance."

Richard describes the unconventional armaments employed by the Lower Element Police as "shape-changing weapons," but however unorthodox, it is still important that said weapons be handled in a way that looks as if the characters employing them have been trained in their use. "You have to make sense of the weapons that feature in the film," explains Richard, "so there has to be a precise way to hold and handle them when going into action. When it boils down to it, fairy weapon handling is pretty much the same as that of a professional soldier, simply because that's the best way of doing it." Richard pauses and then adds, "So, you see, it seems the fairies have discovered the same basic rules as the British Army!"

Overleaf: Concept art depicting the fairy troops' arrival on the beach below Fowl Manor. Pages 162–163: The L.E.P. task force enters the manor's troll-trashed hallway.

9

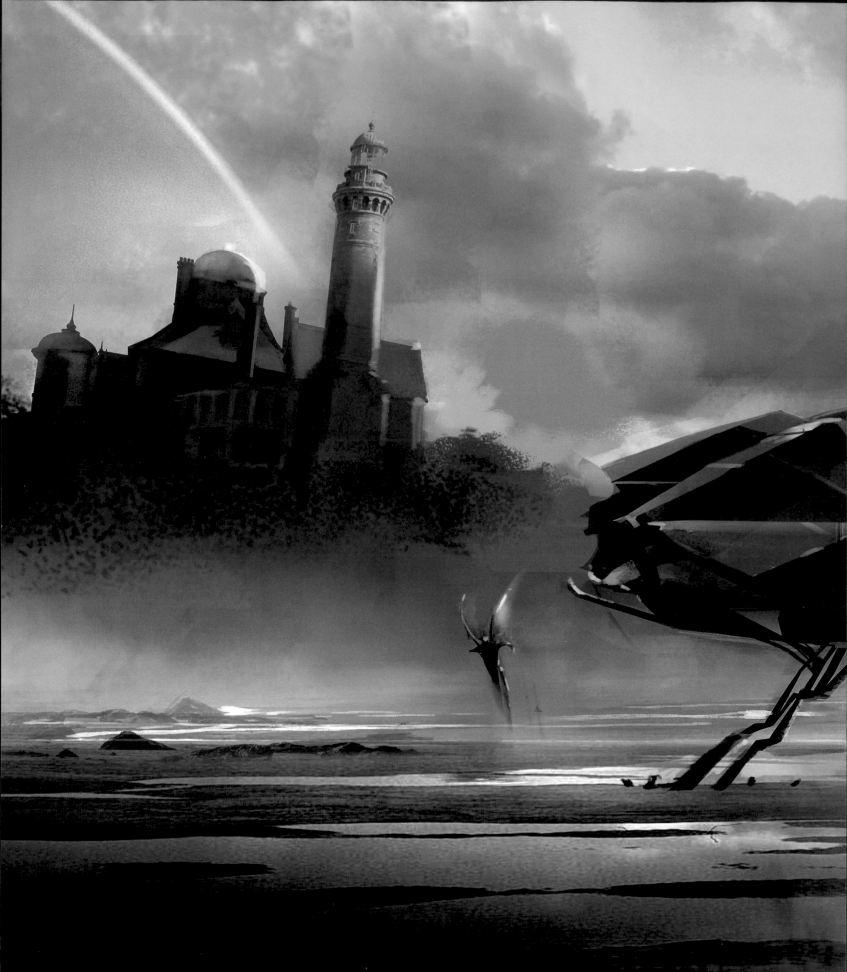

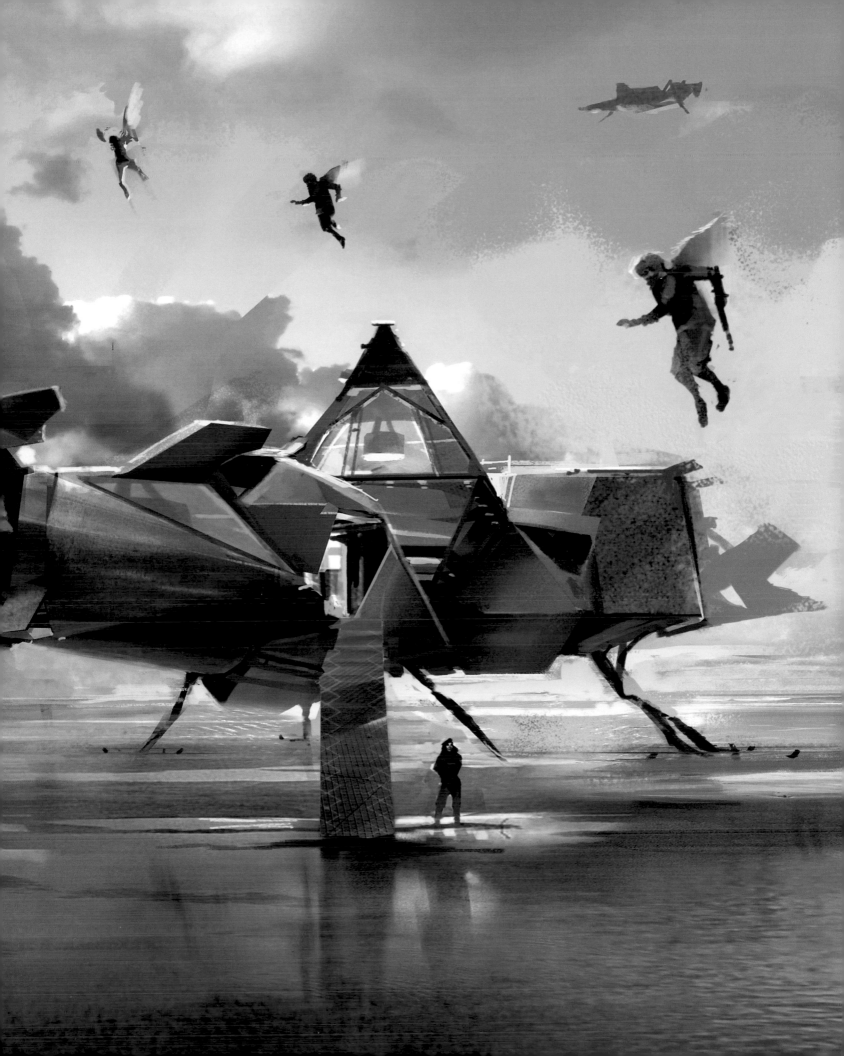

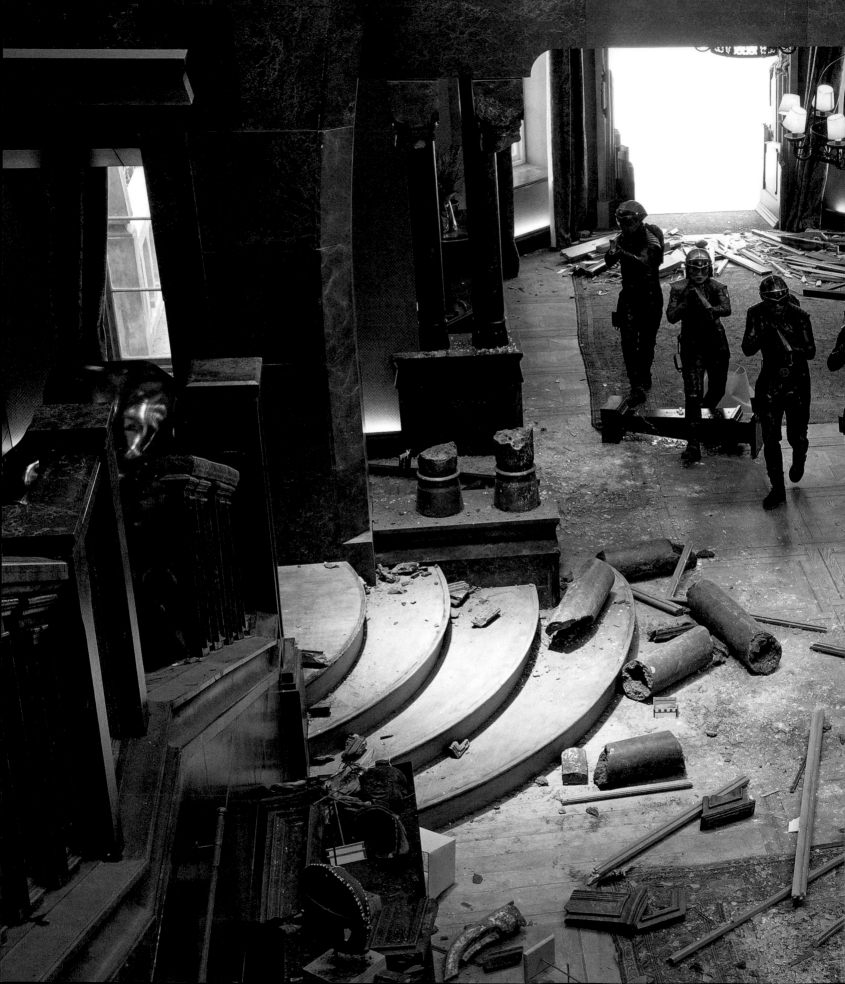

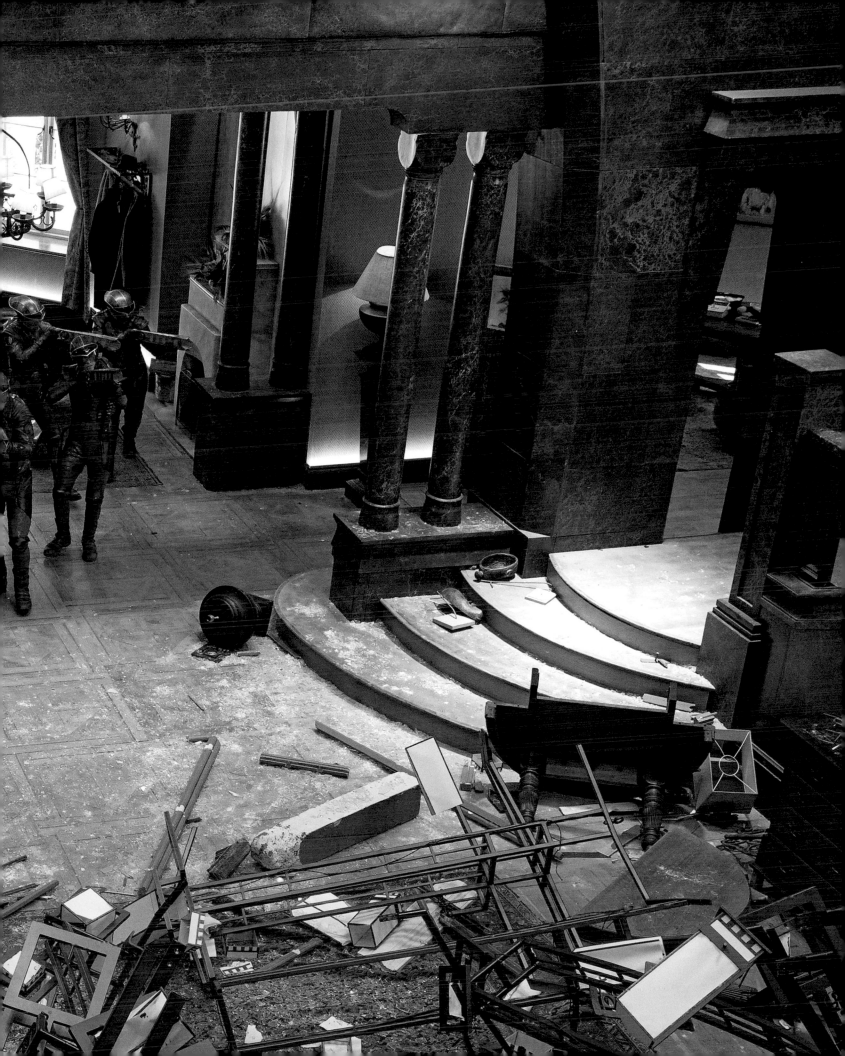

DRESSING ARTEMIS FOWL:
FAIRY UNIFORMS, TROLL GEAR, AND COOL SUITS

Chapter 10

"I know it sounds a bit of a cliché," says Lara McDonnell, talking about the process of becoming her character, "but the first time I had the uniform and the helmet on, I just felt like Holly! Everything came together, and I knew I was in control of the puzzle that is Holly Short. That was amazing, satisfying, and rewarding."

The person responsible for creating that transformation was Sammy Sheldon Differ, the film's costume designer, who has a formidable list of credits, including *Kinky Boots*, *V for Vendetta*, *The Imitation Game*, *Jurassic World: Fallen Kingdom*, and Kenneth Branagh's forthcoming *Death on the Nile*. Discussing the uniforms worn by Holly and the other L.E.P.recon officers, Sammy says, "We played a lot with different greens, and our designs have an organic geometry that occurs in the natural world, with a bit of added tech."

A constant throughout the design process has been the use of fluid rather than straight lines, from the sleek aerodynamic helmet down to the leather boots. Also integral to the uniform is the iridescent, hexagonal, honeycomb-patterned fabric that is an important design element of the tunic. "The story of that fabric," says Sammy, "represents a very long journey. The inspiration came from a line in the first book describing the L.E.P. uniform as being made from a technical fabric with a mesh covering that protected the body from heat and cold. That led us to look at structures in nature and from there on to the hexagon, a shape which appears in a great many forms: rocks, beehives, crystal and plant growth, as well as in the human concept of sacred geometry."

The uniforms were created with a base layer of green shot silk overlaid by the mesh, which was variegated from bottom to top to give a shift in color as the body moved. "I wanted to give the impression," says Sammy, "that there was an energy of some kind running across the surface without having to use lights and batteries wired into the suits."

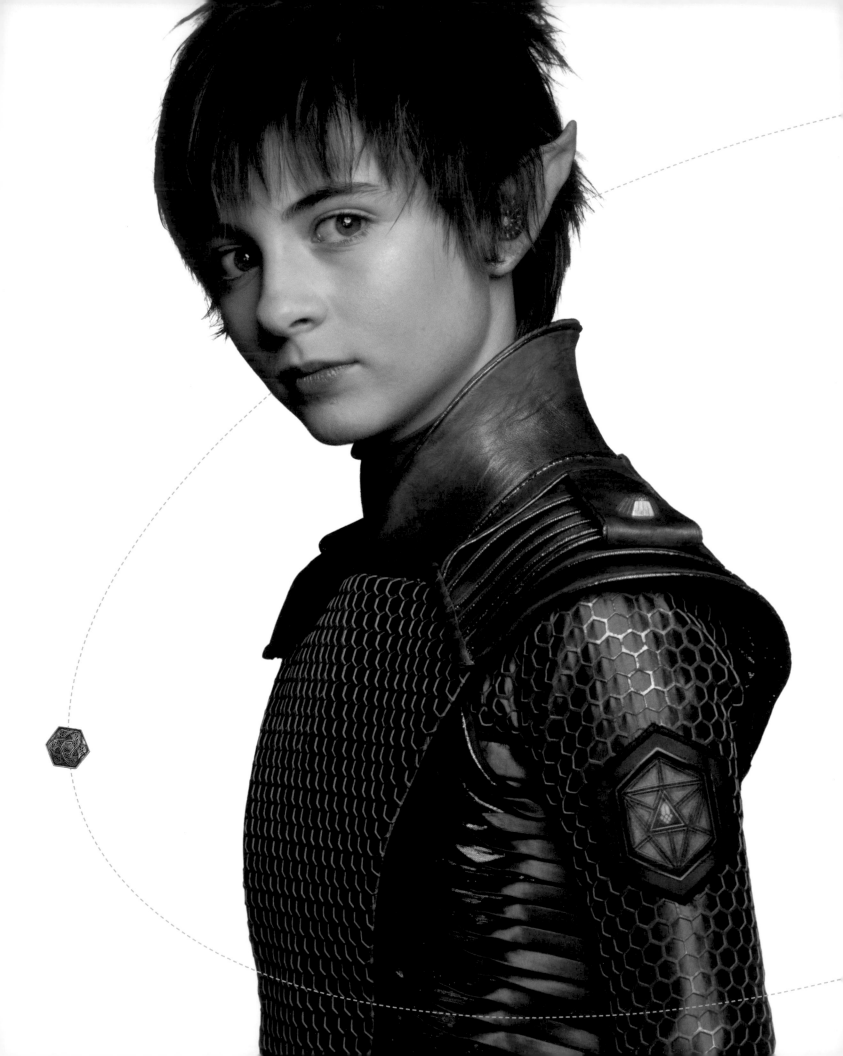

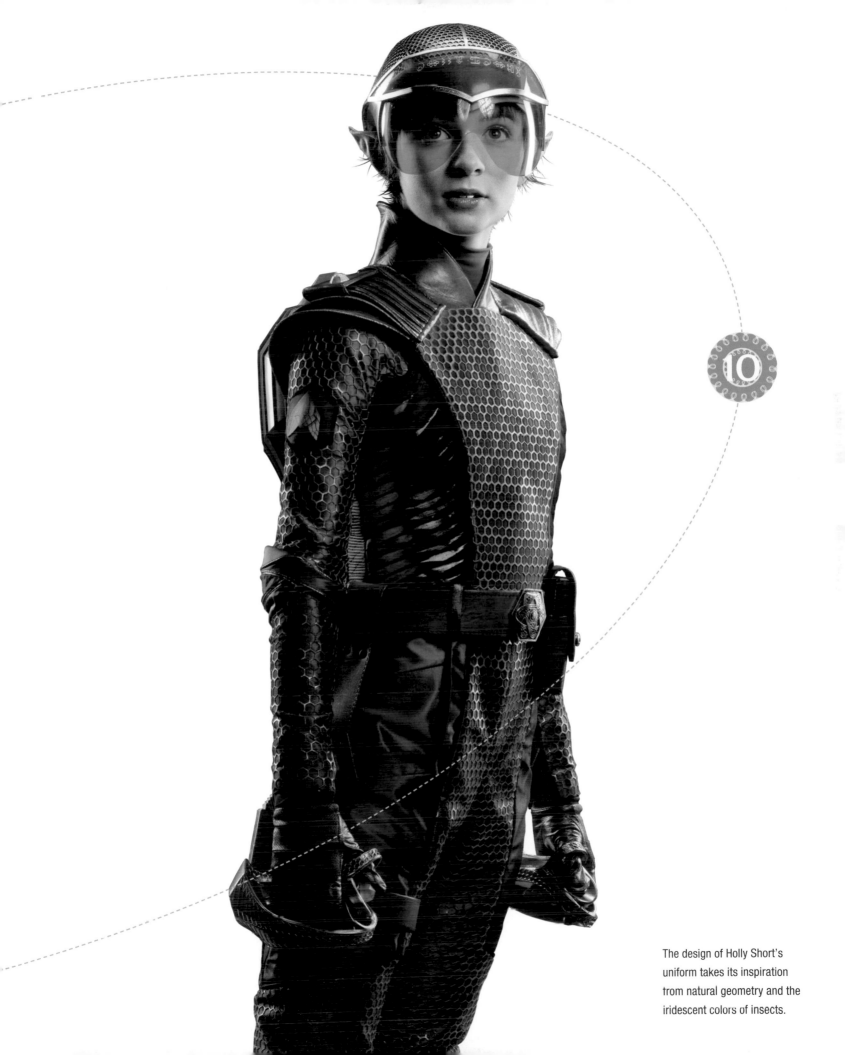

The design of Holly Short's uniform takes its inspiration from natural geometry and the iridescent colors of insects.

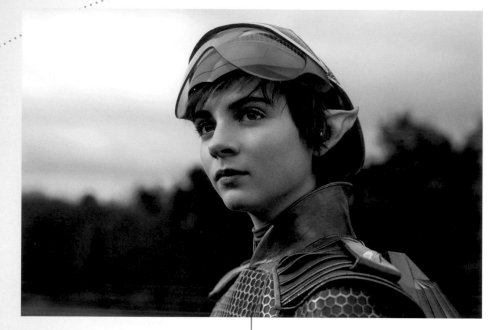

Left and bottom: Holly and Root in L.E.P. uniform. Below and opposite top: Costume sketches illustrating the L.E.P. uniform with butterfly-esque wings.

Another feature of the uniforms is the leather shoulder parts, whose design was based on the segmented bodies of insects. Sammy explains, "We studied a great many macro photographs of insect life in order to capture something of their colors and textures."

Wanting to get away from the standard military cap, Sammy came up with a conical shape of tapering concentric circles that took its inspiration from the ancient leaning oak on the Hill of Tara that is so important to the fairy world. All the uniforms have a common embellishment in the form of a recurring acorn motif featured on buttons, studs, belt buckles, and the lenticular L.E.P. badges that denote the wearer's name and rank.

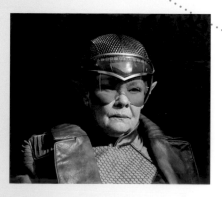

When in action, a fairy operative wears a helmet with a design inspired by a curious deep-water fish called the barreleye, which has a transparent head and has evolved to live in the pitch-black environment of deep sea, unreached by sunlight. The vivid green visor on the helmet not only provides protection but also has built-in technology enabling the wearer to view maps, diagrams, and data displays, as well as providing communication with the L.E.P. command center.

The rather more sinister L.E.P. Retrieval unit is more heavily armed and dressed in black. The scheming Briar Cudgeon is one of their number. "Cudgeon's look," explains Sammy, "is designed to reflect his ambition and pomposity. His shoulders are very sculptured to give him some much-needed gravitas, and the fact that it is also very tight-fitting reflects his fastidiousness and his controlling, uptight nature."

Joshua McGuire, playing the character, was especially pleased with the design for his costume. "My black greatcoat," says Joshua, "with its padded shoulders and big, thumping black boots, were a definite nod to Cudgeon's villainous personality and certainly helped me with creating the physicality needed for the role."

Left: Digital rendering of a winged Holly. Right and below: Costume sketches of L.E.P. operatives with a militaristic leaning.

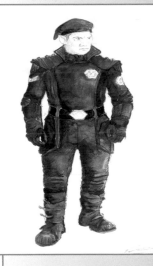

Discussing the design of the wings used by Holly and her colleagues when they need to fly, Sammy reveals that research sources ranged from origami, the Japanese art of paper folding, to the way the solar panels on NASA space vehicles fold in and out. "We put all that together," she says, "and came up with a transparent, 'techie' version of wings that the fairies control with Bluetooth handles that emerge from their backpacks when required."

Distinct from other members of fairy-kind when it comes to costume is the ancient Vietnamese fairy Artemis and Butler encounter in Ho Chi Minh City. Sammy explains, "Our vision for her was to devise something that has a feeling of woodlands and fungi. Her many layers of robes, rich in hand embroidery, give her an appearance of being thousands of years old." Those robes, in earthy autumnal colors, spread out around her, giving the impression that she has grown out of the ground. And with her wizened face topped by a typical Vietnamese conical straw hat, or *nón lá*, the fairy has the appearance of a living mushroom.

However, following her encounter with Artemis—and having drunk a vial of water brought from a stream beneath the Hill of Tara—the aged fairy regains her former youth. "For her look following the transformation," continues Sammy, "we took our inspiration from the beautiful translucency and bioluminescence found in jellyfish and deep-sea creatures."

There are also dwarfs and, in particular, the light-fingered giant dwarf, Mulch Diggums. The costume styling for Mulch and his smaller relatives was inspired by the kind of heavy, drab clothes that would have been worn by laborers, miners, and factory workers in the early 1900s. "Essentially," says Sammy, "they're practical and sturdy, and we've made them look well-worn and work-weary."

Artemis Fowl also features a dangerously enraged troll whose costume seriously exercised the imaginations of Sammy and her colleagues. The troll would ultimately be realized by the visual effects department, but the process began with a physical costume to aid in understanding how this towering, thirteen-foot-high creature would interact with the Fowl Manor environment and to provide the visual effects artists with the textures and colors to use in their digital realization.

Costume concepts for the wizened Vietnamese fairy (left) and Mulch Diggums (above).

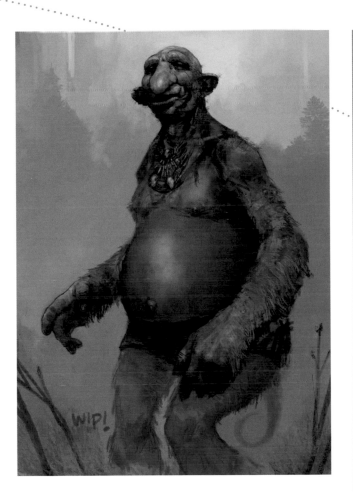

Work-in-progress developmental artwork for the rampaging troll.

"We've lived with that troll for a long time," Sammy says, laughing, "and we really love him. His costume is made of natural fabrics—textured Indian silks, cotton, wool, and sacking—in warm browns, dark reds, orange, rust, and ochre yellow. These were then enhanced with rope, wool, and silk threads woven, plaited, and embroidered to create thicker textures. We also added in antique pieces of cloth with embroidery to give him a really ancient feel and gave all the materials a well-traveled, weather-beaten look. The ultimate effect was to make him look as if he had lived in his clothes forever, just constantly adding to his attire throughout his lifetime."

Having created this many-layered costume, Sammy and her team further enhanced it with festoons of hanging knickknacks and gewgaws to give added movement—*and sound!* "We collected all kinds of trinkets and amulets, scouring antique markets for strange items: among them giant African seedpods; Northern European cowbells; a handheld Victorian fire hydrant; little African wooden dolls; metal cups on a handle; plaited ropes, stones, and pieces of wood. He has quite a collection!"

Apart from dressing the assorted fairies and beings from Haven City, Sammy also had the responsibility of costuming the humans of Fowl Manor. For Juliet Butler, with her love of combat sports, wrestling, and martial arts, the costume choices were simple and colors muted. "She is a very practical and energetic teenager," explains Sammy, "a leggings-and-tee sort of girl, so we chose sporty and comfortable rather than overly pretty."

As for Artemis, his costume undergoes a subtly choreographed transition as the film unfolds. At the outset Artemis has the appearance of a typical twelve-year-old boy: he wears jeans and a hoodie, and there is certainly nothing too edgy about him. But from the moment Artemis begins hearing negative stories about his father and learns that he has been kidnapped, it impacts him both emotionally and practically. From that point on, his decisions become calculated, and in terms of his costume, his look is more serious and structured: his choice of colors is more subdued and confident, and the hoodie-and-tee look gives way to a combination of crewneck sweaters layered over shirts and T-shirts.

And then, of course, there is the suit—or, rather, the matching pair of iconic black suits worn by Artemis and Butler. These were specially created by Chris Kerr of the oldest bespoke tailoring company in London's Soho, which has regularly served the film and TV industry with suits for such stars as Tom Cruise in *The Mummy*, Donald Sutherland in the series *Trust*, and Matt Smith, the Eleventh Doctor in BBC's *Doctor Who*.

Artemis sports his power suit and matching shades, appearing cool as a cucumber despite the urgency of his mission in Ho Chi Minh City.

If, after seeing the film, you wonder how, despite all the exertions Artemis and Butler undergo during their energetic visit to Vietnam and in their later struggles to defend Fowl Manor, there is never so much as a crease or crinkle in those suits and never a tie askew, Sammy reveals a final costume department secret: "The challenge was to make the suits look as fitted and neat as possible, where nothing moved out of place and there was as little wrinkling as possible. The suits were tailored super tight while the shirts were made out of a stretch fabric and fasten up the back so that the knotted neckties could be permanently fixed in place. The result was a look that was the *Artemis Fowl* equivalent of the classic sculpted body armor of the movie superhero!"

Whether finding ways to kit out an entire fairy army, dress a troll, provide mining clothes for a dwarf, or design a sharp suit for a hero, the costume department played a pivotal role in helping clothe the fascinating people and beings in *Artemis Fowl* and make them into believable characters.

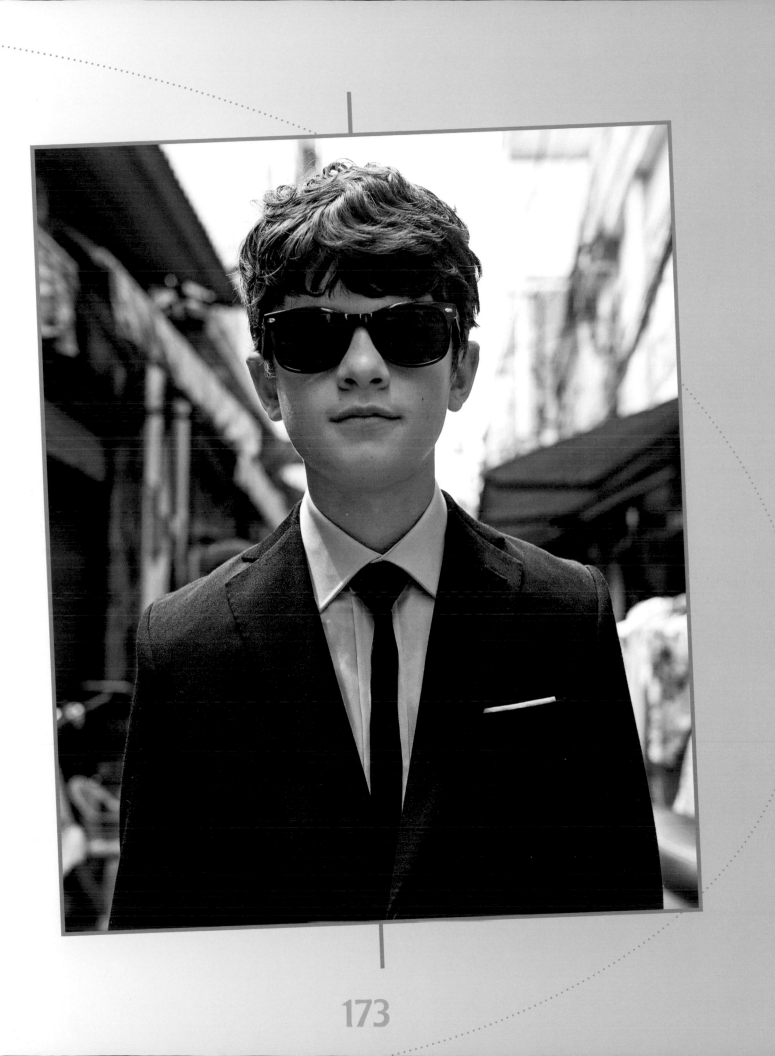

Epilogue

TAKING THE JOURNEY ONWARD

Artemis Fowl is just the first of eight books featuring the adventures of Eoin Colfer's young hero, and the series has earned itself a passionate readership. How will those readers respond to the film version of that book? "I hope," says production designer Jim Clay, "they'll find the world that they began to imagine when reading the books and, maybe, we'll have been able to take their journey a little bit further. And, of course, there's a whole new generation of readers coming that is just in time for the movie."

The book's author speculates on how those moviegoers will react. "I think," says Eoin, "people will come out of the cinema with a big smile on their face and possibly turn around and go right back in and watch it again! I'm sure that's what I will do. I'll just hide in the back of the theatre—except, of course, since no one really knows what I look like, I probably don't really *need* to hide; so it'll be fine!"

The three young actors—all of them fans of the book—reflect on the story's progress from page to screen. Lara McDonnell says, "In the book you read about lots of things that you don't find in real life—like the lava chute that Holly rides to get to the Earth's surface. You have to use your imagination to picture them, so it's weird and wonderful seeing things brought to life that we've only ever previously imagined. It is mystical and magical, and I think the books' readers will be impressed. Disney has done it justice—*and more!*"

Tamara Smart, playing Juliet Butler, focuses on the unique quality of the film: "It feels nothing like what Walt Disney films have done before. It's something that is new and different, and I hope viewers will love it and want to see more of Artemis's adventures."

Ferdia Shaw, playing the film's title character, agrees with these assessments but adds a cautionary thought: "It's a lovely idea that there's a world going on right beneath our feet that we've never seen before. But let's hope it *stays* hidden. We honestly don't want humans to ever meet up with fairies, because that would probably be a really bad idea!"

However, there remains a tantalizing hope that, in film terms at least, there may yet be further encounters with the People of Haven City. Director Kenneth Branagh ponders, "Well, the film cannot but leave a whole number of questions unanswered or at least provide the potential for speculation, such as who kidnapped Artemis Fowl's father, where and why they took him, what they are going to do with him, and will he ever escape? We also know that Artemis's curiosity is insatiable; that Holly Short's determination to lead a different kind of life in the L.E.P. as a trailblazer, a pathfinder, is passionate and unrelenting; and that the two of them interact with each other in an electric way. So, everything is set and ready to answer the curiosity that the film engenders in its audience."

Thus, this may well be less of an ending than a beginning. "Once Artemis has engaged with the fairy world," Kenneth continues, "he discovers, as a fairy with whom he deals in Vietnam tells him, 'There's no going back.' I very much hope—for our audience and filmmakers of the future—that for *Artemis Fowl*, there will be no going back."

Meanwhile, moviegoers have an opportunity to join Artemis on his first extraordinary adventure into the secret world of one of the oldest and certainly most mysterious races to ever live on—or *under*—the Earth.

Image credits:

Photo of Eoin Colfer on page 12 by Mary Browne.

Final frame and film poster on pages 18 and 19 courtesy of the Walt Disney Archives Photo Library.

Nuada the High King painting on page 28 courtesy of Jim FitzPatrick, copyright © Jim FitzPatrick.

Artemis Fowl series cover art on pages 20 and 22–23 by Owen Richardson, copyright © 2009, 2010, 2012 by Owen Richardson.

Artemis Fowl cover art on page 29 by Goni Montes, copyright © 2018 by Disney Enterprises, Inc.

Excerpts from the *Artemis Fowl Graphic Novel* on pages 24–25, 30–32, 36–37, and 148 by Michael Moreci and Stephen Gilpin, copyright © 2019 by Disney Enterprises, Inc.

Artwork on pages 1–5, 8–11, 14–15, 38, 40–41, 43, 45, 47–55, 57–58, 60, 62–65, 67–69, 71, 73–74, 76–77, 79, 81–96, 99–113, 115–119, 121–138, 141–149, 151, 153–158, 160–163, 165–171, and 173–175 courtesy Walt Disney Studios, Franchise Management.

Painters / Alamy Stock Photo: 126

Inge Johnsson / Alamy Stock Photo: 118

Published by Disney Editions, an imprint of Disney Book Group. No part of this book may be reproduced or transmitted in any form or by any means, electronic or mechanical, including photocopying, recording, or by any information storage an retrieval system, without written permission from the publisher.

For information address Disney Editions, 1200 Grand Central Avenue, Glendale, California 91201.

Editorial Director: Wendy Lefkon
Editor: Jessica Ward

Produced by Welcome Enterprises, Inc.
6 West 18th Street, New York, New York 10011
www.welcomeenterprisesinc.com
Project Director & Designer: H. Clark Wakabayashi

This book's producers would like to thank Albert Park, Alicia Chinatomby, Alison Giordano, Bryan Kulik, Dale Kennedy, Elena Blanco, Gegham Vardanyan, Humaira Shaikh, Jessica Clark, Kevin Daley, Kim Knueppel, Kori Neal, Lauren Burniac, Max Calne, Megan Granger, Meredith Lisbin, Michael Buckhoff, Michael Freeman, Miki Carter, Monica Vasquez, Monique Diman, Muriel Tebid, Rachel Rivera, Sarah Huck, Sarah Sullivan, Scott Piehl, Stephanie Lurie, Therese Ellis, Tim Ballou, Tyler Nevins, and Wendy Thompson.

Author's Acknowledgments:
My sincere thanks to the cast and creative team for their generous assistance and participation in the making of this book, with special appreciation to director Sir Kenneth Branagh, and to Artemis Fowl's original creator, Eoin Colfer. Personal gratitude goes to my long-suffering (but wonderfully patient) editor, Jessica Ward; to Clark Wakabayashi for his exciting design; and to Wendy Lefkon, editorial director at Disney Editions, for the invitation to write about *Artemis Fowl* in the first place.

ISBN 978-1-368-04379-3
FAC-041115-19121
Printed in Canada
First Hardcover Edition, June 2019
10 9 8 7 6 5 4 3 2 1
Visit www.disneybooks.com